THE PENLAND BOOK
OF CERAMICS

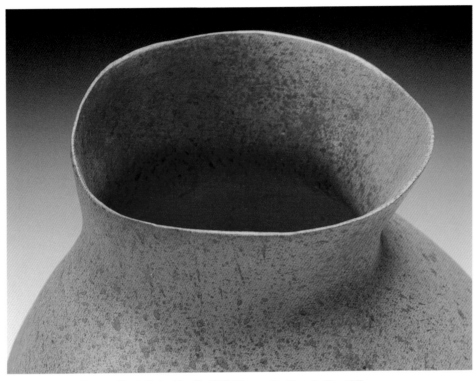

CLARA "KITTY" COUCH, *Earth Series* (detail), 1999. Terra cotta. *Photo by Tom Mills.*

THE PENLAND BOOK OF CERAMICS

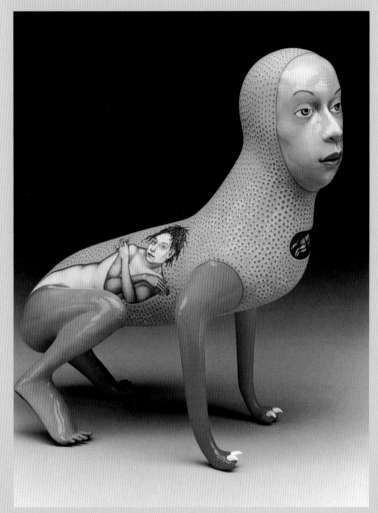

SERGEI ISUPOV, *Remote Likeness*, 2001. 11½ x 10 x 6 inches (29.2 x 25.4 x 15.2 cm). Porcelain.

Master Classes in Ceramic Techniques

LARK BOOKS

A Division of Sterling Publishing Co., Inc.
New York

Editors: DEBORAH MORGENTHAL AND SUZANNE J. E. TOURTILLOTT

Art Directors: KATHY HOLMES AND DANA MARGARET IRWIN

Photography: How-to photos by EVAN BRACKEN; others noted on page 206

Assistant Editors: VERONIKA ALICE GUNTER AND RAIN NEWCOMB

Assistant Art Director: HANNES CHAREN

Cover Photo: TIM BARNWELL

Production Assistant: SHANNON YOKELEY

Editorial Assistance: DELORES GOSNELL

Editorial Intern: NATHALIE MORNU

Proofreader: VALERIE S. ANDERSON

Library of Congress Cataloging-in-Publication Data

The Penland book of ceramics : masterclasses in ceramic techniques / [editors, Deborah
Morgenthal and Suzanne J.E. Tourtillott].
 p. cm.
 ISBN 1-57990-338-x
 1. Pottery, American–20th century. 2. Pottery–Study and teaching–North
Carolina–Penland. 3. Penland School of Crafts (Penland, N.C.) I. Morgenthal, Deborah,
1950- II. Tourtillott, Suzanne J. E. III. Penland School of Crafts (Penland, N.C.)

NK4008 .P395 2002
738.1'4–dc21

 2002066652

10 9 8 7 6 5 4 3

Published by Lark Books, a division of
Sterling Publishing Co., Inc.
387 Park Avenue South, New York, N.Y. 10016

Distributed in Canada by Sterling Publishing
c/o Canadian Manda Group, One Atlantic Ave., Suite 105
Toronto, Ontario, Canada M6K 3E7

Distributed in the U.K. by Guild of Master Craftsman Publications Ltd.
Castle Place, 166 High Street, Lewes, East Sussex, England BN7 1XU
Tel: (+ 44) 1273 477374, Fax: (+ 44) 1273 478606
Email: pubs@thegmcgroup.com, Web: www.gmcpublications.com

Distributed in Australia by Capricorn Link (Australia) Pty Ltd.
P.O. Box 704, Windsor, NSW 2756 Australia

If you have questions or comments about this book, please contact:
Lark Books
67 Broadway Street
Asheville, NC 28801-2919
(828) 253-0467

Manufactured in China

ISBN 1-57990-338-x

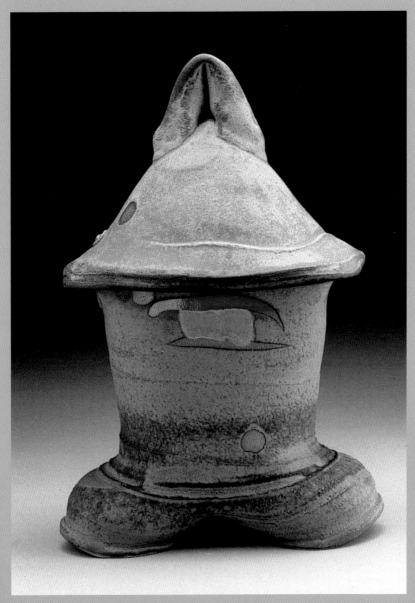

NICK JOERLING, *Hut Jar*, 1999. 12 x 4 x 7 inches (30.5 x 10.2 x 17.8 cm). Thrown and altered stoneware; bisque cone 08; glaze cone 10. *Photo by Tom Mills.*

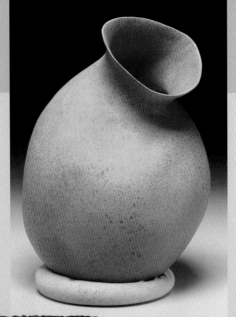

TABLE OF CONTENTS

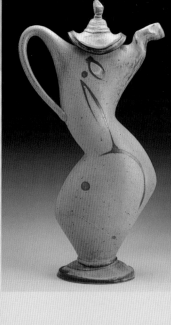

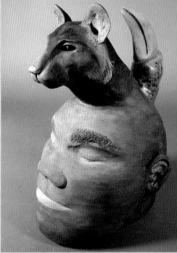

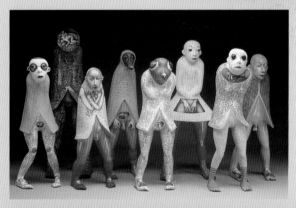

INTRODUCTION

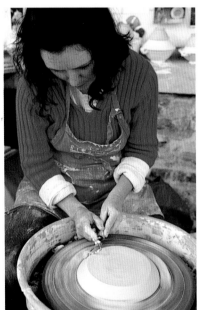

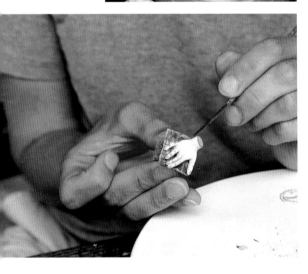

The Penland Book of Ceramics is the product of a collaboration between Lark Books, a long-time publisher of fine craft books, and Penland School of Crafts, a leading institution in craft instruction. Lark and the Penland School are located just 50 miles apart, neighbors in the region of the Appalachian mountains of Western North Carolina. The book, which will be one of a series, brings together the fundamental resources of these two institutions: Lark has years of experience producing books to inspire and guide artists, and Penland is the nexus of a national community of artist/teachers.

For this book, we identified ceramists associated with particular techniques or ways of working, each of whom has also taught at Penland. Each was photographed demonstrating the method they use in their work, and they have written explanatory captions to accompany the photographs. They also wrote essays discussing their interest and affinity with their particular kind of work, and they selected work by other artists which complements theirs.

The result is a strong technical and inspirational resource for intermediate to advanced practitioners. The book also serves to document a range of artists and ideas important in contemporary ceramics. The essays which introduce each chapter retain the individual voices, personalities, and eccentricities of each of the artists. Their selection of additional images will broaden the reader's understanding of the ideas presented.

The variety of approaches to clay in this book also represents the diversity of Penland's educational program. Penland has two clay studios, and a typical summer session might feature a class in teapot construction concurrent with one in handbuilt sculptural forms. Two weeks later we might host a workshop on wood-fired, wheel-thrown stoneware and one on handbuilding with colored porcelain. Lark Books Publisher Rob Pulleyn has been a student in a number of these workshops and it was that experience that led him to propose this series of books.

Ceramics was one of the first media taught at Penland, and the field has evolved considerably since the school's founding in 1929. In the early years, the emphasis was on functional ware of various kinds. Functional work remains central to Penland's clay program, but the offerings also include sculpture, glaze painting, surface patterning, narrative work, tile mosaics, glaze chemistry, and mold making along with workshop topics as specific as majolica decoration, raku firing, mask forms,

china painting, and ceramic musical instruments. Our program acknowledges craft as a vessel for cultural information by presenting classes based on the traditions of Europe, Asia, Africa, and America, as well as North Carolina's own ceramic heritage.

Penland attracts students and instructors from all over the country, and our clay classes are taught by some of craft's finest practitioners. These instructors value the retreat atmosphere, the egalitarian relationship between instructors and students, the intensity of the classes, and the teaching/learning model of the workshop. Penland offers classes in ten media, and our instructors frequently comment on the importance of interacting with colleagues working in other crafts and the opportunity to exchange ideas and information. It's interesting to note that several of the chapters in this book include images of pieces by artists working in media other than ceramics.

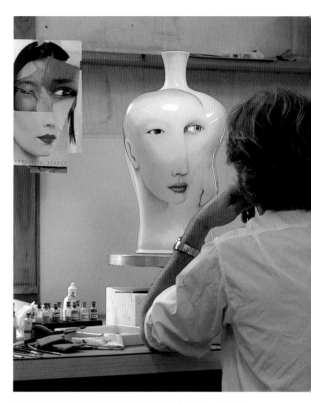

More than anything, it is the breadth of contemporary ceramics, as embraced by the Penland program, which makes a book like this possible. Consider the approaches represented by the gestures of Nick Joerling's pots, the exquisite lines of Clara Couch's vessels, and the sensuality of Michael Sherrill's plant forms. Or look at Linda Arbuckle's exuberant brushwork, Mary Barringer's monochromatic patterned surfaces, and Sergei Isupov's intricate narrative painting. Although no single publication could represent what Cynthia Bringle refers to as clay's "never-ending possibilities," almost anyone working in ceramics should find ideas and inspiration here, no matter where their work exists within the spectrum of this amazing material.

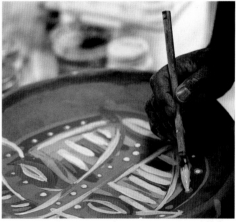

We are grateful to the artist/authors for their knowledge, their thoughtful writing, and their stunning work. The contributions they have already made to ceramic education by teaching and by example will be extended through this publication. Thanks also to Dana Moore who guided content and served as Penland's point person, and to Rob Pulleyn, Deborah Morgenthal, Suzanne Tourtillott, and the staff at Lark Books who put it all together.

It is my hope that *The Penland Book of Ceramics* will become an important resource in your studio and will enhance your exploration of this wonderful material.

Jean W. McLaughlin
Director, Penland School of Crafts

CLARA "KITTY" COUCH

Deeply glowing and

profoundly meditative,

Clara "Kitty" Couch's

coil-built vessels enfold

volumes. The hand of the

maker appears to hover

over the sinuous surfaces

that breathe around the

presence of the space

held within each pot.

Earth Series, 1999. 20 x 16 inches (51 x 41 cm).

Terra cotta. *Photo by Tim Barnwell.*

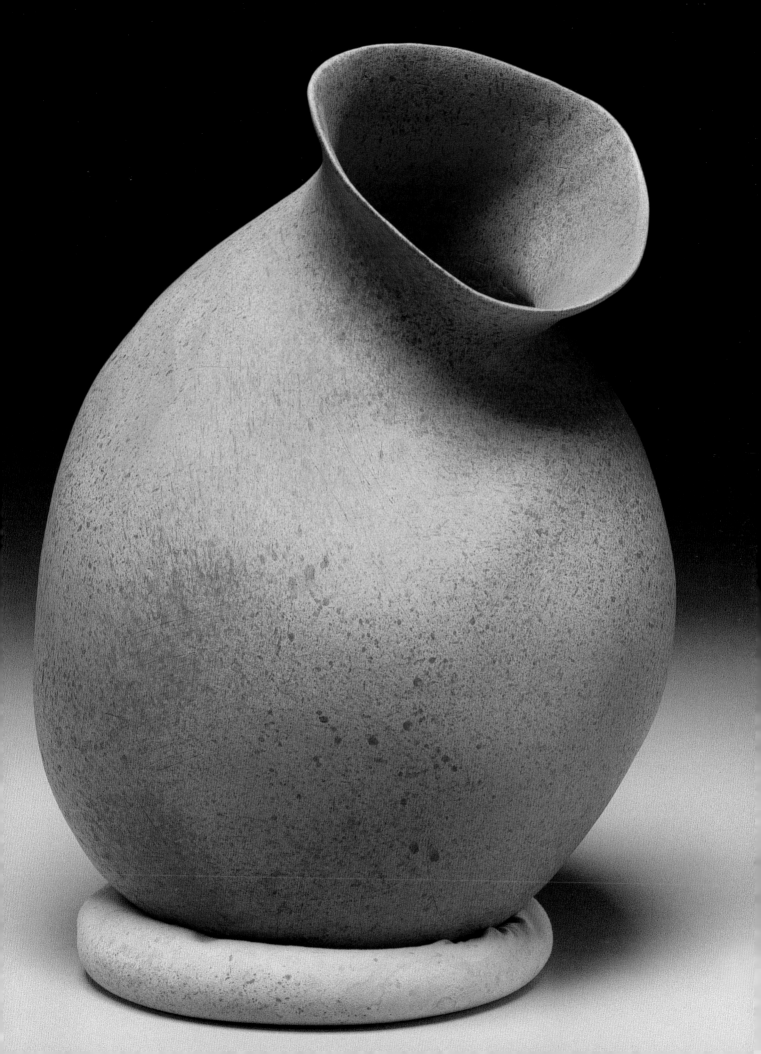

Earth Series (detail),
1999. Terra cotta.

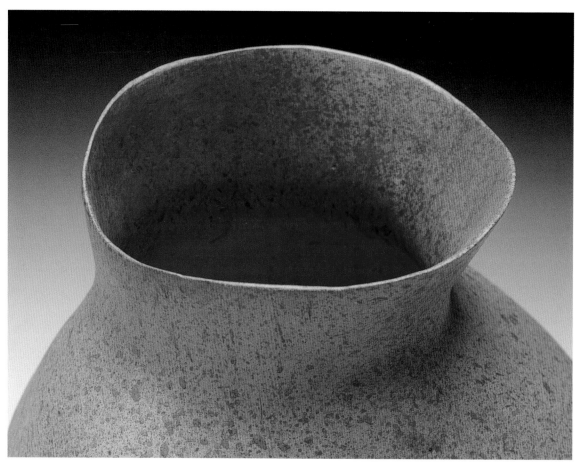

CONTEMPLATIVE COILINGS

My romance with coiled pots goes back to the first Giotto that I saw in Italy in the 1960s. The large, generous shapes of the Italian women that he painted made my hands itch. I came home knowing that I would make art. I needed desperately to repeat that sensual line and create that sense of volume. At the time, the medium I would choose was not so clear, but intuitively I found clay, and then coiling. And I have learned so much since then about life *and* pots.

In China and Egypt, as early as 20,000 B.C., man was coiling pots for utilitarian and religious purposes, later adding surface decorations, such as incising and coils. It is even thought that the movement of coiling came from basket making, which was one of the earliest container forms. But expediency soon

brought about the potter's wheel. I find it interesting too, as author Daniel Rhodes observes in his book *Pottery Form* (Chilton/Haynes, 1976) that animal architecture predates man in the use of clay, notably in the nests of mud wasps and certain birds. Every culture has used the coiled method to make container forms for storage of water, grain, beans, and countless other things considered necessary for living. Most ancient cultures used clay forms as icons or symbols for worship as well. Some peoples have even made their homes of coiled clay, burning the dwelling from the inside for vitrification.

Coiling is a versatile building method: it can be used to form very large sculptural pieces and can be combined with other methods of clay construction. What appeals to me most is its

slow meditative process. The quiet, slowly evolving nature of building with coils of clay gives time to contemplate shape, form, planes, movement, and curves. There is a sense of feeling organic or whole while building a piece in this way. The rhythm of coiling is like a dance or the earth's movement as it spins on its axis.

When I am coiling a pot, I am in sync with my center, stripped of all outer layers. The process feels almost primordial—before time and space were named. It forces me to slow down, to let go. Other methods may be made by hand, but for me the coiling is "felt by person." I am once again connected to my past and personhood.

There is usually a beginning vision for a piece that I am constructing. Although my vision and the finished work are seldom the same, they are in the same family—the vision leading the way. I am so grateful for the looseness of this method of making for it allows me the time and energy that is so necessary for the final resolution of the vision.

I begin by pinching a base or rolling out a slab that I place in a plaster form, or *puki*, for support. I use a clay that is a combination of one-half red and one-half white terra cotta. It is a lovely, warm, soft color that I fell in love with the first time I saw it. It has little grog or tooth, yet holds its own beautifully. After the circle is supported in the base, I securely cover its edges and all subsequent coil edges with a 2- to 2½-inch (5.1 to 6.3 cm) strip of thin plastic. Not only does this keep the edges from drying out as I wait until the work has "set up," stabilized, or firmed up, but the plastic gives body to the edge so it can be manipulated.

In the meantime, I have rolled out on a flat surface a number of fat coils, usually 2 inches (5.1 cm) in diameter, depending on the size and shape of the piece I envision. I store these coils in a plastic bag. (I do not wedge the clay. It comes straight from the bag. The rolling motion seems to take care of any air bubbles.)

When the base has become firm so that it can support itself, I then add my first coil.

To prepare for this, I dip a toothbrush in a jar of water and massage the edges of the base so that they are moistened and rough. I take the first coil from the bag, lay it on the table, and use my thumb to press small ovals along one of the edges of the coil where it meets the table. I then wet my toothbrush and carefully wet and roughen these ovals. The coil is typically about 14 inches (35.6 cm) long. I place it on the edge of my base, usually placing the ovals on the inside edge, depending on the shape I envision. I've discovered that the ovals tend to better integrate the edge with the coil. I do not put on more than one row of coils at a time because I can mix the clay better this way. Also, I find the slow evolution is essential for shaping the piece and for the realization of the total unity of the work.

Openings I,
1998. 16 x 18 inches (41 x 46 cm). Terra cotta. *Photo by Tom Mills.*

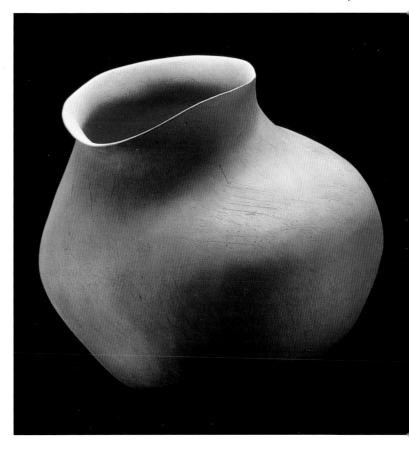

The diameter of the coils is integral to the piece. As I said, I use fat coils; but when, for instance, I am moving the piece out, or the wall is cantilevered out, I use thinner coils so that the weight and drying can be better controlled. The way the coils are attached, their size, and placement determines the movement of the vessel. This is one of the advantages of coiling compared to other methods. The walls can be teased or manipulated to realize your design more easily. Since I am always inclined toward large rhythmic evolving designs, I need to be aware of balance, weight, and drying.

As I place a coil on the first edge and subsequent edges with the ovals on the inside, I gently but completely integrate them and the other side of the coil (where it meets the edge). It is necessary, I have found, to press gently from the top of the coil against the edge to encourage the escape of air bubbles, which are prone to be incorporated at this juncture. As I massage and smooth these joinings together, I am always vigilant about air bubbles; I use a needle tool to puncture any that show up below the surface. In the past, I lost too many pieces because the walls were not well integrated. When I first began working on large coiled pieces, I would usually lose two pieces for every finished piece. It was like a death. After two weeks of working on the pieces lovingly and hopefully, the loss was so painful. As a result, I have learned to be very aware of the possibility of loss. Now when there is any question of air bubbles or other problems, I needle tool the base in various places.

After joining the edges and the coil well on each side, I pull a ¼-inch-thick (6 mm) wall, using a metal scraper to tease and manipulate the joined area. Depending on how humid or dry the weather is, I cover the edges with plastic strips and/or large pieces of plastic to allow for the setting up, which is so crucial when working with clay. I average about two coils a day in the area where I live.

After the wall can just hold its own, I find it helpful to mark the clay, in a visible place, to indicate the movement that I envision for the piece. From this point on I am committing myself to the final movement of the work, and I find with my dyslexic tendency, I forget where I am going. Each coil addition narrows my options.

Now that the wall can support itself, I am ready to place the piece on a stable base, and scrape it with a Surform tool so that the wall is even and smooth. Next I scrape it smooth with a metal scraper to erase the marks of the Surform tool. This saves me much work later when the piece has dried. I then invert the piece over a padded hump. (I use a wide-mouth gallon jar covered with a thick folded towel.) Next I Surform the back or underside, and once again smooth it with the metal scraper. I am attentive to the evenness and thickness of the wall so that it has a feeling of flowing movement.

Depending on the state of the wall, I am ready once again to roughen and wet the top edge, press out the ovals, and put on another wet and roughened coil. This may sound very dull, this repetitive placing of coils, but it is just the opposite. It is the time I like best, for I am truly building and designing with each movement. This is one of the creative parts of making art. It is a time of great excitement for me, because the fear that is inherent when I give up control is balanced with my trust in the process.

It is during this time, as I wait for the wall to set up, that I place the evolving piece on the sculpture stand and observe it as I go through my day. I find that my paddle is a handy tool to have nearby—just a casual tap may make a world of difference in the movement that I wish to explore. This observing time is truly an exploration and a necessary part of designing. Use a light hand with the paddle—the wall can easily be broken. It's essential to be attentive and aware at this stage of creating: one is in a holy place.

As I move up or out with the coils, I prepare for the shoulder and the lip of the piece. I use much more care and time at this point, realizing this finishing moves the work from a utilitarian piece into the field of art or metaphor. I spend much time viewing the piece. As I have said, it is on the sculpture stand as I go about my daily tasks, so that I can absorb and refine its message.

When I am ready to work on the piece some more, I scrape and Surform the edges, tending to move in from the outside as the movement of the lip moves in, and the reverse as the lip moves out. The final sanding is done with a green plastic foam piece or sandpaper. I do not spend an inordinate amount of time on this, but it is important that this finishing seem a part of the whole. By the time the piece is completely finished, it is well on the way to drying. At any time during the drying process, I spray on several light coats of red terra sigillata and lightly polish the surface with a soft cloth after each spraying.

Here's my recipe for terra sigillata:

Water	42½ ounces (1.1 L)
Sodium silicate	1 teaspoon (5 mL)
Redart clay (dry)	1¼ pounds (.57 kg)
Clear gallon (4 L) jug	

Mix the sodium silicate in the water, and slowly sprinkle the Redart in, mixing well. Allow the mixture to set up for at least eight hours. Then use a turkey baster to siphon off the top two-thirds into another jar. This is your terra sigillata. Discard the remainder (the heavier particles that have sunk to the bottom).

I keep terra sigillata on hand as it seems to increase its silkiness with age. Another advantage to the medium is its tendency to adsorb smoke. I smoke my pieces a great deal—particularly the functional ones. After firing in an electric kiln at cone 06 or 04, having used a

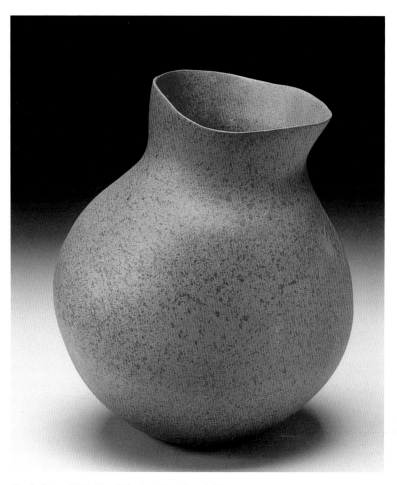

Earth Series, 1999. 20 x 16 inches (51 x 41 cm). Terra cotta. *Photo by Tom Mills.*

good coating of terra sig, a sawdust or pit firing tends to give a good smoking.

When I have sprayed and polished the piece, and it has dried, I fire it in an electric kiln. I am very conscious of the firing—doing it slowly, and imagining the clay changing as the piece heats up or later loses heat. Since I bought an electronic kiln, I always fire on slow. If I am using my large, oval, electric manual kiln, I fire a piece for two days, with the top open; I warm on low, prop the top on medium, and only close the kiln on high. I seldom lose a piece these days. Early on, my pieces were so large and heavy, and since I prefer to work alone, I rigged a "come along" with a canvas saddle to lower and raise the large pots in and out of the kiln. Rarely do I use it these days, since my work has somehow become lighter and more manageable.

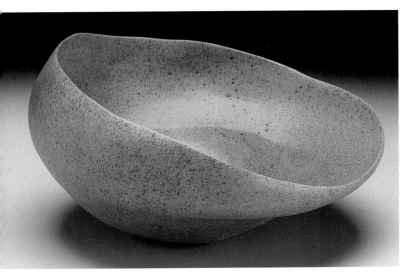

After firing, the cooled piece is brought to the studio, and once again I study it, reacting to its shape and nature so that I can plan the final finishing. For me, this is an integration problem that I need to solve—how to create a piece that works with the natural world in color and movement and feeling. I use watered-down acrylics in a sprayer as my medium. Early on, I was attracted to the illusionary quality of watercolors, yet because of their soluble nature, I could not use them on clay. Consequently, I found that if I watered down acrylics, they could be overlaid like watercolors, and yet the color was permanent. This was a great discovery for me since I have never been a fan of glaze coverings. The clay surface is beautiful enough.

I choose the brightest and earthiest colors of nature—reds, oranges, yellow, yellow-greens, and greens. It is easy to integrate these colors with a background of Redart terra sigillata to create a feeling of lightness and joy. Next is the question of how to give a sense of movement. So I find myself almost doing a dance with each color as I move around the piece as I spray. As I work, I am constantly reminded of the phrase "less is more." This realization has always stood me in good stead, since I am a minimalist at heart. Suggestion is my aesthetic. And as I spray, I am aware that my purpose is to have the colors give a sense of moving in and out. I am trying for a three-dimensional effect as I layer color upon color.

As I grow older, I increasingly see my work as a metaphor for my life. When I moved to Burnsville about 20 years ago at the time of my husband's death, I started making larger, simpler forms—I had found my center when I moved here alone to live on the side of the mountain. And as I simplified the way I worked—terra cotta instead of porcelain, little surface decoration, and one firing instead of multiple ones, I found I was letting go, just as I was letting go of parts of my life. It is all about what I can get along without and still keep the energy high. Another way of saying this is that I became more discriminating and made conscious choices.

Now my work in life and clay is about patience and contemplation. Also I see a great correlation between the balancing of my round bottom pots with the balancing of my conflicting energies. Writing this piece caused me to directly contemplate my relationship to my work in order to communicate it in words. I see once again how our life-spirit is mirrored in our work; I understand that my attempt to create joy and lightness in my pieces is a means of assuring myself that life is good, worth living, and also that I am capable of great openness.

Another great revelation came to me when I collaborated with my photographer friend Pinky Bass, when we mixed clay and photography into a single medium. I realized that clay can be as big and versatile as my imagination. All I have to do is be willing to unlock that place in me and let it go.

But to return to coiling...I think if people realized the power that they have to work simply and purposefully with whatever material attracts them, they can get real joy from the experience. But if they spend their time being constrained by the technique and rules, they will be missing out on life. Even something as simple as a coil pot can be worth giving your life for if you bring yourself honestly to it.

HANDS ON

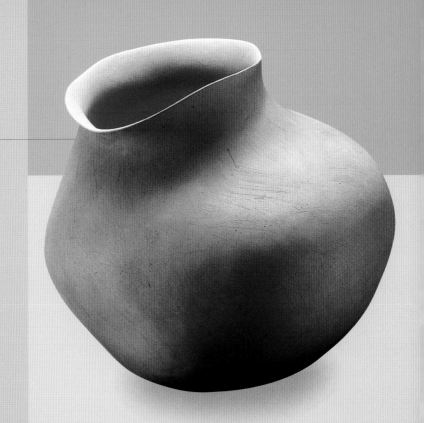

*H*ere Kitty creates one of her signature large, coil-built pots. She demonstrates a method that begins with a press-molded slab base, to which she adds and smooths clay coils as she plans the movement of the form.

1. Rolling out the slab

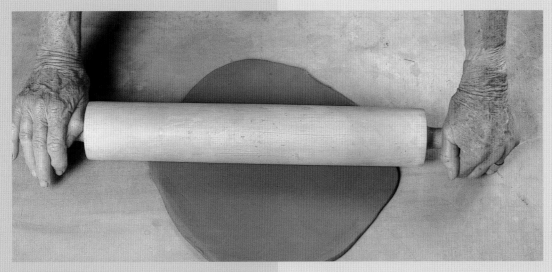

2. Placing the rolled-out slab in a *puki*

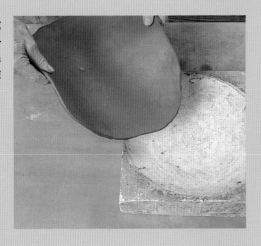

3. Trimming the slab

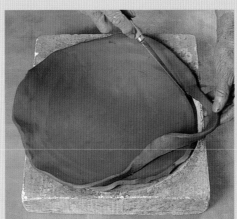

4. Covering the edges with plastic to keep them pliable, while allowing the rest of the slab to set up

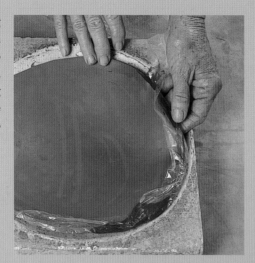

7. Attaching the first coil on the inside of the slab

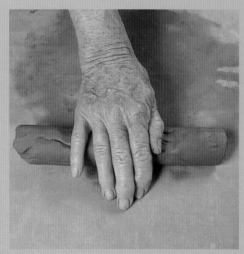

5. Rolling out a fat coil

8. Wetting the second coil

6. Using thumbs to press the edge of the coil down to create oval indentations

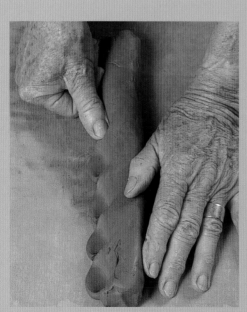

9. Attaching another coil to the inside

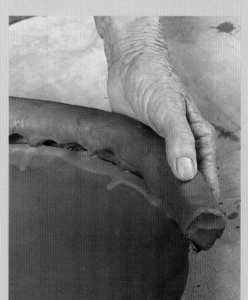

KITTY COUCH

10. Using the scraper to smooth the joined area. The slab will be turned over onto a padded round surface.

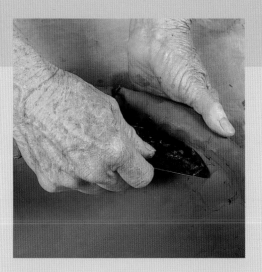

13. Paddling the back side

11. Attaching a thin coil and pressing the ovals on the inside of the pot

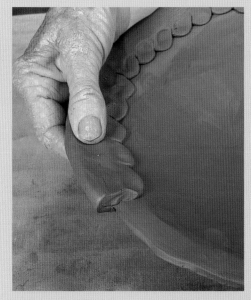

14. Setting the shoulder and lip by putting pressure on the front with the scraper while pushing up on the bottom with my hand

12. Marking the inside to show the desired movement of the piece

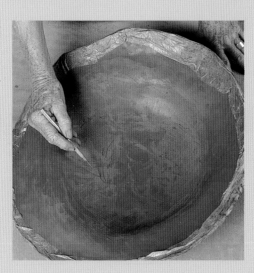

15. Using a Surform tool to scrape bottom

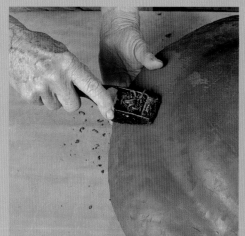

16. Adding another fat coil to set the shoulder and lip

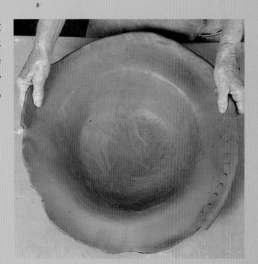

17. Using the scraper again to smooth the surface

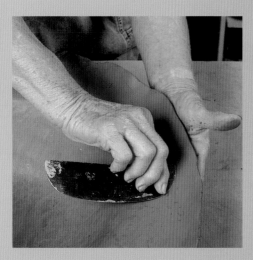

18. Using the Surform tool to clean up the lip

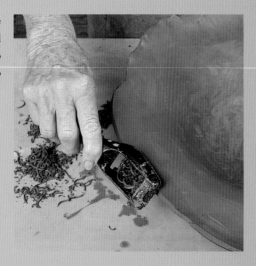

19. Using the scraper to clean up the leather-hard vessel, onto which terra sigillata has already been sprayed

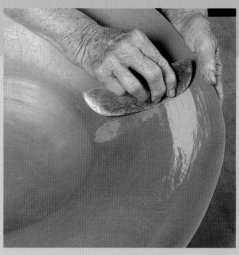

ABOUT THE ARTIST

KITTY COUCH has been working as a studio artist in Burnsville, NC, for many years. She has been the recipient of numerous awards, several of which have nourished her love of international travel, such as the U.S. Recipient of the International Invitational to the Resen Ceramic Colony, Resen, Macedonia; and the Lila B. Wallace/Reader's Digest Award to Ecuador. She has been an artist in residence in Cortona, Italy. Her one-person exhibits include "Clay Forms," Greenhill Center for North Carolina Art, Greensboro, NC; The Penland Gallery; and Headlands Center for the Arts, Sausalito, CA. Her creative collaboration with photographer M.M. "Pinky" Bass has resulted in several exhibits, such as "Clay Bodies/Vulnerable Wills" at The Light Factory in Charlotte, NC. Her group show credits include NCECA, Winthrop University, Rock Hill, SC; "Nature: References and Allusions," Penland Gallery, Penland, NC; and "Women of a Certain Age," Zone One Contemporary Gallery, Asheville, NC. The Mint Museum of Craft and Design, Charlotte, NC, The First Union Bank of Charlotte, NC, and Federal Reserve Bank of Richmond, VA, feature her work in their permanent collections. She has been profiled and reviewed by several publications, including *Ceramics—Art and Perception*, 2001.

GALLERY

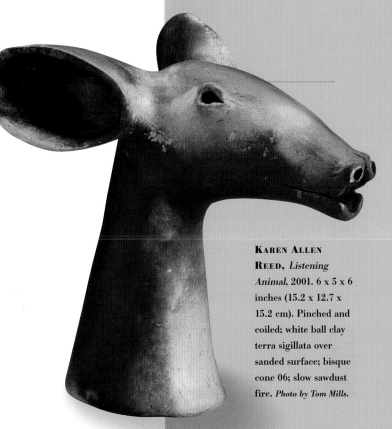

*I*t's a pleasure to have these artists' work—which I admire a great deal—appear here. I invited each one because of his or her unique approach in clay. I'm inspired by Jimmy Clark's shapes; his large, bulbous forms are reminiscent of primitive pots. This same echo of form is in Alice Munn's sculptures, and I like the fact that she uses coils in the exact same way I do. Although Kathy Egan uses a construction method different from mine, I'm drawn to her use of the spiral as a decorative motif. The mystery inherent in Becky Gray's work intrigues me, especially the faces hidden in foliage and flowers. And I find Karen Reed's creative and meditative way of working—pinching and coiling—intriguing. The results, such as her doll dresses, are often playful.

KAREN ALLEN REED, *Listening Animal,* 2001. 6 x 5 x 6 inches (15.2 x 12.7 x 15.2 cm). Pinched and coiled; white ball clay terra sigillata over sanded surface; bisque cone 06; slow sawdust fire. *Photo by Tom Mills.*

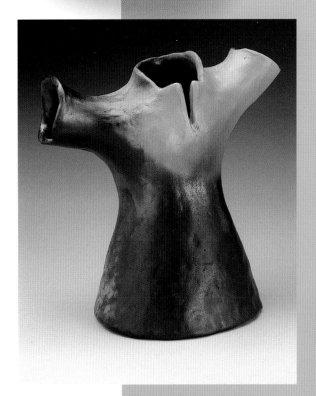

KAREN ALLEN REED, *Small Coat,* 2001. 6 x 6 x 3½ inches (15.2 x 15.2 x 8.9 cm). Pinched and coiled; pink (ball clay and crocus martis) terra sigillata over sanded surface; bisque cone 06; slow sawdust fire. *Photo by Tom Mills.*

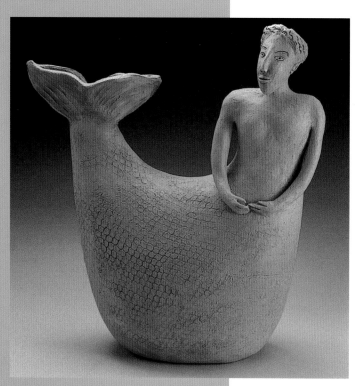

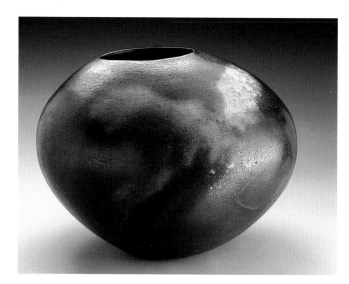

KAREN ALLEN REED, *Night Jar*, 2001. 7 x 9 ½ x 9 inches (17.8 x 24.1 x 22.9 cm). Coiled, pinched, and paddled; white ball clay terra sigillata over sanded surface; bisque cone 06; slow sawdust fire. *Photo by Tom Mills.*

KAREN ALLEN REED, *Mermaid Vessel*, 1998. 10½ x 10 x 4 inches (26.7 x 25.4 x 10.2 cm). Thrown, altered, coiled, and pinched additions; terra sigillata over textured (imprinted) surface; single fire cone 05. *Photo by Tom Mills.*

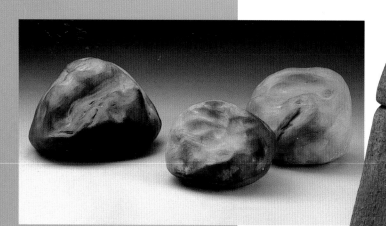

KATHLEEN T. EGAN, *Rocks*, 2000. 3 x 3 inches (7.6 x 7.6 cm). Pinched and altered earthenware; burnished; bisque cone 010; unglazed; placed in sagger containers with dried banana peel; sawdust fired. *Photo by Tom Mills.*

KATHLEEN T. EGAN, *Lidded Box with Triskele*, 2001. 2¾ x 2 inches (6.9 x 5 cm). Slab-built stoneware; stamped image, hand-textured surface applied; bisque cone 06; layered underglazes over the surface and sanded off in places; fired cone 06; oxide washes and glaze; fired cone 05. *Photo by Tom Mills.*

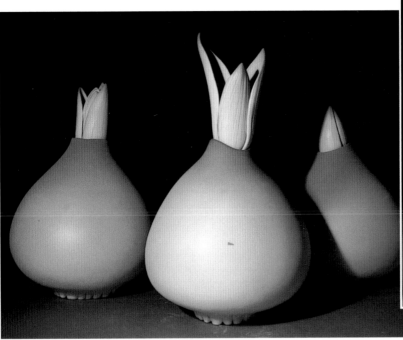

ALICE BALLARD MUNN, *Hyacinth Bulb Trio*, 2000. 9½ x 8 x 8 inches (24.1 x 20.3 x 20.3 cm); 11 x 8 x 8 inches (27.9 x 20.3 x 20.3 cm); 13 x 8 x 8 inches (33 x 20.3 x 20.3 cm). Coil-built white earthenware; surface- and airbrushed with terra sigillata; cone 06. *Photo by artist.*

ALICE BALLARD MUNN, *Large Bulb III*, 2001. 18 x 13 x 12 inches (45.7 x 33 x 30.5 cm). Coil-built white earthenware; surface- and airbrushed with terra sigillata; cone 06. *Photo by artist.*

ALICE BALLARD MUNN, *Small Crocus I*, 2001. 10½ x 10 x 11 inches (26.7 x 25.4 x 27.9 cm). Coil-built white earthenware; surface- and airbrushed with terra sigillata; cone 06. *Photo by artist.*

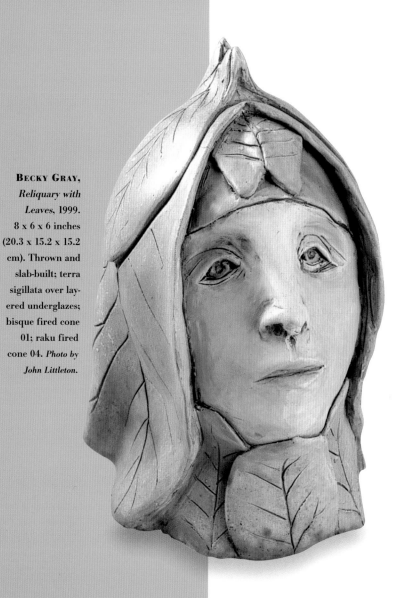

BECKY GRAY, *Reliquary with Leaves,* 1999. 8 x 6 x 6 inches (20.3 x 15.2 x 15.2 cm). Thrown and slab-built; terra sigillata over layered underglazes; bisque fired cone 01; raku fired cone 04. *Photo by John Littleton.*

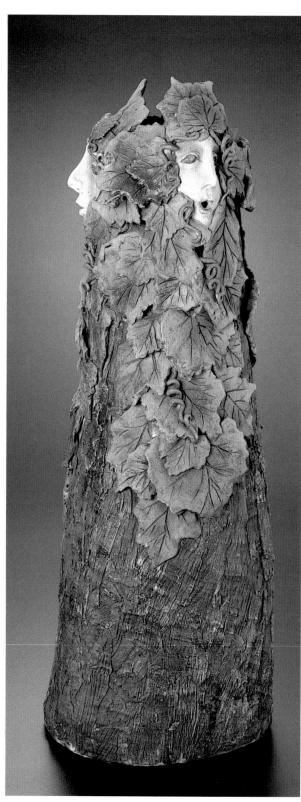

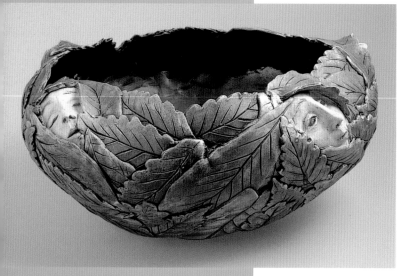

BECKY GRAY, *Autumn: Leaf Bowl,* 1999. 20 x 24 x 24 inches (50.8 x 61 x 61 cm). Slab-built from separate elements; terra sigillata over layered underglazes and oxides; bisque fired cone 01; glaze fired cone 04. *Photo by John Littleton.*

BECKY GRAY, *Summer Tower: Fox Grape,* 1997. 22 x 9 x 9 inches (55.6 x 22.9 x 22.9 cm). Slab-built with scraped clay and slab-built elements added; terra sigillata over layered underglazes; bisque cone 04; glaze cone 01. *Photo by John Littleton.*

JIMMY CLARK,
Leda, 2001.
16 x 11 x 11 inches
(40.6 x 27.9 x 27.9
cm). Pinched; saw-
dust fired with salt
and sulfates; slate
stand. *Photo by John
Carlano.*

JIMMY CLARK, *Amphora,* 2000.
18 x 4½ x 4½ inches (45.7 x 11/4 x 11/4 cm).
Pinched; sawdust fired with salt and sulfates; wood
and slate stand. *Photo by John Carlano.*

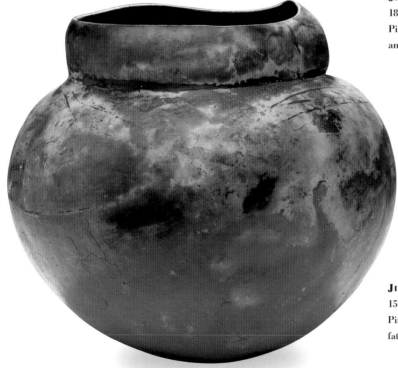

JIMMY CLARK, *Gaya,* 2001. 14 x 15 x
15 inches (35.6 x 38.1 x 38.1 cm).
Pinched; sawdust fired with salt and sul-
fates. *Photo by John Carlano.*

ANGELICA POZO

Whether flatly smooth or built in high relief, Angelica Pozo's tiles have lively surfaces that immediately engage the viewer. Her imagery, a *lingua franca* built from the vernacular—vegetables, foliage, or cavorting icons of modern technology, rendered in saturated color—belies the formalism inherent in her tiled mosaic installations.

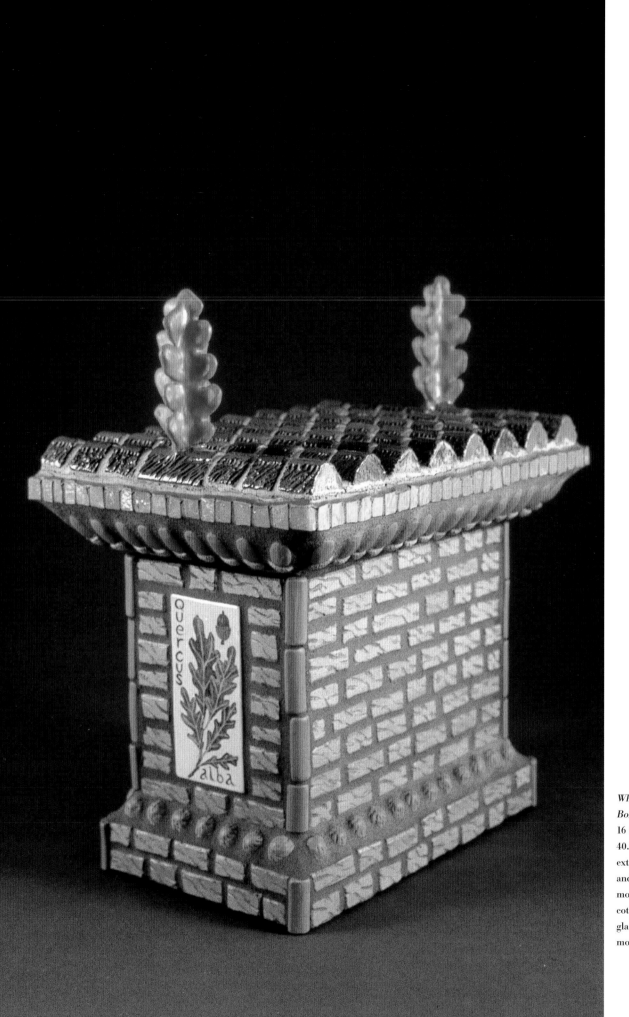

White Oak Temple Box, 1997. 17¾ x 10¾ x 16 inches (46.6 x 27.3 x 40.6 cm). Cut, carved, extruded, press-molded, and hand-formed mosaic tile from terra cotta; terra sigillata; glaze cone 04; glass mosaic. *Photo by artist.*

TILE MAKING: ONE APPROACH, PLUS A RECIPE FOR POTATO SALAD

Sassafras Tree Shrine, 1995. 26½ x 22½ x 5 inches
(66.3 x 56.5 x 12.7 cm). Terra cotta and commercial
white bisque tile; coil-built central form surrounded
by mosaic and tile; glazes cone 04; oxides cone 022;
lusters. *Photo by artist.*

As with many other ceramists that I know, I began my artistic studies as a painter. I then took my first clay class and have been with it ever since. But I do continue to incorporate much of what I learned as a painter, such as the use of color, and drawing and painting skills, into my clay work today.

I began with and still do a lot of handbuilt sculptural work, mostly in coil. However, through the years I have found that the tile and mosaic work I do has opened a whole new world for me, the world of public art. With tile and mosaic I am able to make pieces that are monumental in size, while still working with elements that are very intimate and human in scale. Having many components to a piece also provides me with a multitude of opportunities to alter color, shape, size, depth, and texture. I am able to work with a rich and varied palette of surfaces as I move between relief, painted images, textured surfaces, or mosaics.

Architecture has always fascinated me, and I enjoy the challenge of designing public art pieces that work with and enhance the architectural features of the given site. It's my way of dealing with the issue of function. I see myself as designing pieces that function in their space and that function for the people who use that space. As I work toward relating my public pieces to the contexts and/or histories of their specific sites, I have been led down surprising paths to many unexpected new discoveries.

With each project I have done, I have tried to take an approach that is unique to that site. At times that has involved handmade tiles for majolica glazing, or hand-sculpted tile forms in relief or coil, and at other times I have used techniques that are best implemented with commercial tile. When what I am doing demands flat color and smooth, even surfaces, such as working with ceramic decals, I prefer to use glazed stoneware or unglazed porcelain commercial floor tile. Clay may be cheap, but when I'd rather be spending my energies on some other more exciting and challenging part of the project, I have found that using whole-sale—priced commercial tile can be cheaper still. It's true that time is money, and no amount of cash can ever buy it back. So I have to prioritize and decide what I'd rather be spending my precious time doing. Therefore,

ANGELICA POZO

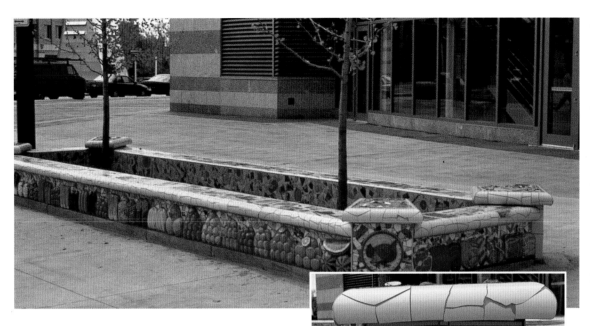

ANGELICA POZO IN COLLABORATION WITH PENNY RAKOFF, *Marketplace/Meeting-place: An Urban Memorial* [Downtown Cleveland, Ohio], 1994. 18 inches x 25 feet x 7 feet (45.7 cm x 22.5 m x 6.3 m). Sculpted terra cotta relief frieze, 1½ inches (3.8 cm) thick, formed solid and partially hollowed out in back; underglaze decoration; bisque cone 01; glaze cone 04; mosaic and commercial glaze floor tile with ceramic photo decals; fired cone 017. *Photo by Penny Rakoff.*

in many of my projects I use both: commercial tile for the large field areas, and hand-formed elements for the focal point details.

Another reason I have opted for commercial tiles in the past has been a functional one. There have been times when I have preferred to use a tile product that has been tested by ASTM (American Society for Testing Materials) procedure to check if it meets specific ANSI (American National Specifications Institute) standards. This avoids the cost of having to pay for that testing myself, and also avoids risking the liability of using an untested product. This came up specifically in a piece I designed for the exterior sidewalk and lobby area of a Transit Authority station in Cleveland. In this case I had to be sure that the surface was slip resistant under wet and snowy conditions and also would hold up to heavy foot traffic. So I used unglazed porcelain paver tiles that have the clay colored all the way through them. To create my design with these I had them water-jet cut by the tile company. In this process they take your design, hook it up to a computer that directs a thin, high-speed stream of water to cut through the fully fired porcelain tile. The various colored pieces are then fitted together to create the total image or design. It's an expen-

sive process, but in this instance it was the only way to meet the physical and time constraints.

Despite my preference for commercial field tile on many of my major public art pieces, there are times when only the funky look of a hand-made tile will do. In the first part of this chapter, I demonstrate my own process for making a limited mass-production of tile. In the second part, I take those nice, flat tiles and make them bumpy—that is, I add relief.

Have you ever noticed that, except for that generic storebought variety, no two homemade potato salads ever taste alike? Everyone has her own special recipe for the perfect potato salad. Some use just vinegar, for others it has to have mayonnaise, yet for others only Miracle Whip will do.

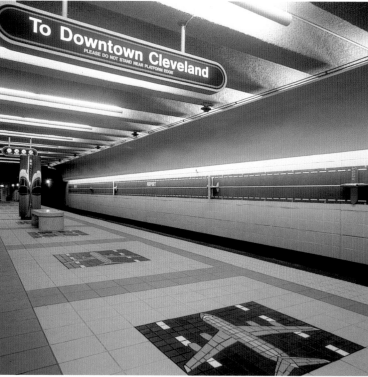

Personally, I make my potato salad with just enough spicy mustard and mayonnaise to make it all stick together. Then I add a couple of dashes of apple cider vinegar and some horse-radish. I insist on using red-skin potatoes, preferably those baby-sized ones. As for the other ingredients, I take a bit of the everything-but-the-kitchen-sink approach. There are a few things it must have: hard-boiled eggs, radish, green pepper, and carrots are good too, then whatever else I find in the fridge that catches my fancy on that particular day. I season with salt, fresh-ground pepper, and a variety of seed spices, though I try to use no more than three, so there aren't too many clashing flavors. My favorites are dill seed, mustard seed, and cumin seed, though I've been known to use celery or caraway seed when in the mood.

Similarly I have found that tips and techniques for tile making can be quite varied, idiosyncratic, and at times seemingly contradictory. However, there are three basic tenets that just about every tile maker should agree with.

Number one has to do with the clay itself. Making tiles that do not warp or crack is a much easier task if one uses a clay with a good amount of sand and/or grog. Ideally that would be around 15 to 30 percent grog. I use 10 percent fine and 20 percent medium grog in my terra-cotta tile body. The open pore structure that the grog provides enables the tiles to dry more evenly and, therefore, helps prevent warpage.

The second basic tenet has to do with memory. "Yes, Virginia, clay does have a memory." If you can keep the slabs and later the tiles flat and supported throughout the entire tile making and handling process, you have a much better chance of ending up with tiles that are flat.

The third tenet is: do not hurry the drying process.

With those out of the way, it's on to tile making.

The first thing I do is set my slab roller to ½ inch (1.3 cm) and roll out a slab that is big

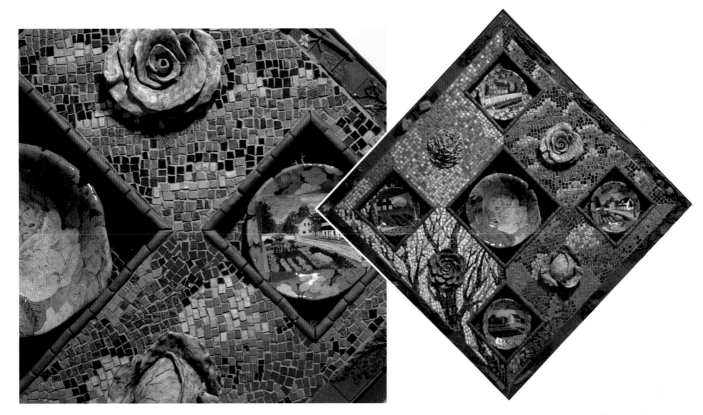

Shrine to the Seasonal Salad, 1993. 72¼ x 72¼ x 6½ inches (180.7 x 180.7 x 16.5 cm). Tile border and sculpted terra cotta relief; vitreous slip; cone 01.
Photo by artist.

enough for my tile template. Sometimes that entails adding a little more clay to a couple of areas and running the slab through a second time. I hate having to lose a tile or two out of the set because an edge is missing one teenie piece. Besides, if I make sure each slab gives me a complete cut from my template, it's much easier to keep track of how many tiles I've made each day.

When I go to move the slab from the slab roller to my work space, I slide it with the canvas onto a board, keeping the slab as flat as possible. Don't pick up the slab by the ends of the canvas and let it sag as you move it. That may be an OK idea for slab-building work, but a definite bad idea when you're tile making.

So now I basically build a sandwich made up of (starting from the bottom) a sheet of drywall, the canvas, the slab, two sheets of newspaper, and another sheet of drywall. I flip this sandwich over and peel off the canvas. I remove the canvas texture and smooth out any other surface imperfections. Next, I cut off the excess around the edges, making a big square slab.

This slab is too soft for cutting the tiles, so I set it aside to firm up in stacks: the drywall helps draw out moisture evenly from above and below, and the weight helps keep them flat. Too much weight restricts shrinkage, so don't put more than three of the slabs in a stack.

To prepare the slab for these stacks, I lay two more sheets of newspaper on top of it to keep the next sheet of drywall above from sticking. Depending on my schedule and the general weather and studio atmospheric conditions, I leave the stacks uncovered if I know I can get back to them within six to eight hours. At this point the slabs should be about ready to cut. If I don't have time to cut them just then, I cover them gently with plastic until I do have the time. (That timing is based on living in Cleveland near a fairly humid Lake Erie. If you live in an arid area or in the middle of a rain forest, you will need to adjust your timing accordingly.)

When I'm ready to cut, I remove the slab from its stack, being sure to use my whole forearm to support the drywall board. The moisture will

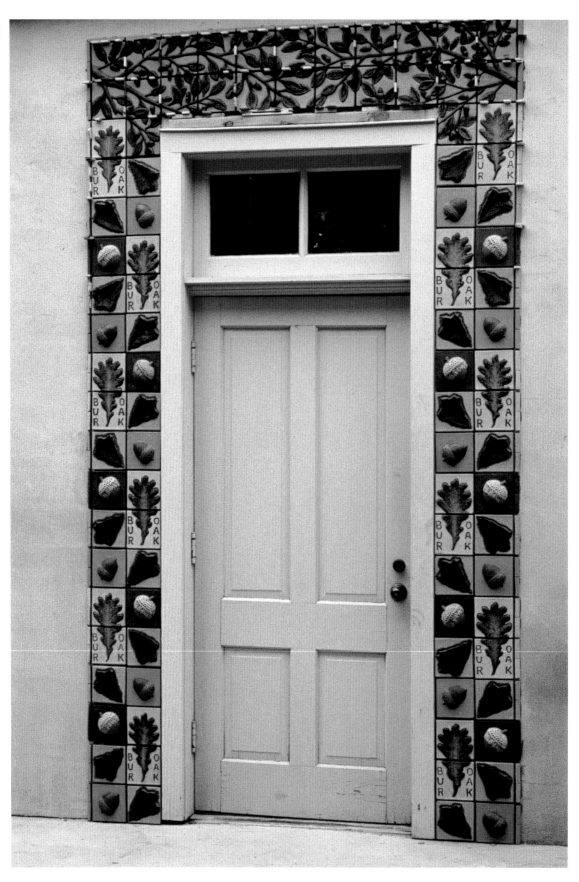

The Oaks of Texas
[Southwest School of Arts & Crafts, San Antonio, Texas], 1995. 11 x 6 feet x ½ inch (9.9 x 5.4 m x 1.3 cm). Relief hand-sculpted tiles and press-molded forms attached to handmade terra cotta tiles; wetware vitreous slip; cone 01.
Photo by Dennis Smith.

ANGELICA POZO

have temporarily weakened the plaster board, and if I don't support the board from underneath, it could give way on me.

If the tiles have been cut when the slab is at the right firmness, the tiles should easily separate from each other. I am still very careful, though, to avoid bending them at this stage. After spreading them out, I run my finger along the edges of each tile to soften and round off that sharp cut edge.

Now it's time to flip them over and texture the backs. This improves their adhesion during installation; the texture helps create suction, which mechanically keeps the tiles on the wall

while the adhesive or cement hardens. We're talking basic laws of physics here.

If I were making thin tiles I would just run a toothed metal rib along the backs. But since I'm working with those nice chunky ½-inch tiles, I like to actually gouge out grooves with a ribbon trimming tool. These grooves help make these thick tiles a little lighter and facilitate their drying. Plus they provide excellent suction with thin-set cement. My tile setter tells me he has never seen tiles stick on a wall as well as these do.

When I'm done texturing, I turn the tiles right side up. Then I lay the newspaper back on

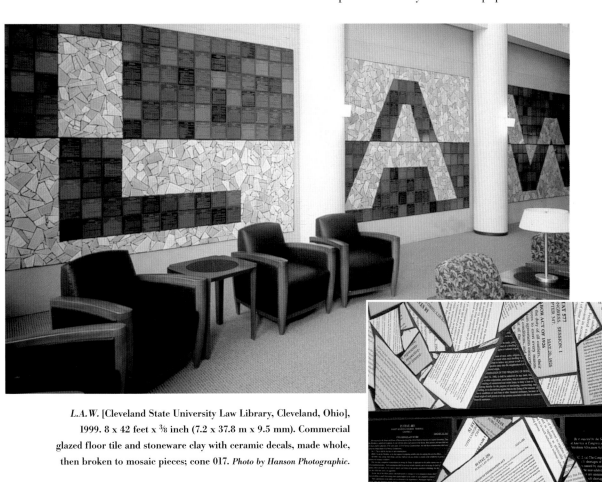

L.A.W. [Cleveland State University Law Library, Cleveland, Ohio], 1999. 8 x 42 feet x ⅜ inch (7.2 x 37.8 m x 9.5 mm). Commercial glazed floor tile and stoneware clay with ceramic decals, made whole, then broken to mosaic pieces; cone 017. *Photo by Hanson Photographic.*

them and put them back into the stacks for another overnight stint, covering the whole group with a sheet of plastic.

The next day when the tiles are rigid, I take the individual tiles off the drywall and stack them two high, face to face on my ware cart. This is where they'll finish the drying process. I cover and seal the entire ware cart in a big plastic sheet to create a sort of rolling dampbox. Every day I flip each tile stack over. This helps to prevent the tiles from curling up along the edges; the first day they lie facedown, and when they lie faceup the next day, they are weighted down by the other tile. As they get drier, I loosen the plastic until they are dry and ready to stack in the kiln for the bisque.

With the tiles on the ware cart, the drywall sheets are now available to start the process all over again with another batch of tiles. I let the drywall dry out for a day, though, before rolling slabs onto them again.

When stacking for the bisque, I set the tiles upright on their edges. I lean them off the sides of the kiln, continuing in toward the center in cantilevered sets of two or three. This system is not only a great kiln space saver, it's actually a much more successful way to bisque flat tiles than to stack them on top of one another. They can move and shrink unrestricted, and there is room around them for moisture to escape. However, if, as I'll show you next, I have worked up some thick relief on the tiles, then I would set them on the shelves individually on their backs as if for a glaze firing.

So now Part II: making those flat tiles bumpy. Just like the potato salad analogy a while back, there are also a multitude of approaches for doing relief work on tile. Here's how I go about doing a relief image for a tile mural.

First I draw on paper the image that I want to translate into relief, making sure it will fit within my 6-inch (15.2 cm) tile format.

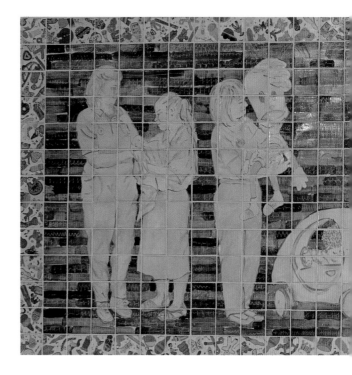

Then I trace the drawing onto a heavyweight sheet of clear plastic using a fine-point permanent marker. I assemble the nine leather-hard tiles tight up against each other. After laying the drawing on plastic over the tiles, I begin tracing the drawing again, this time using a blunt-tipped stylus tool that leaves an impression in the clay. Before pulling off the plastic completely, I check that enough of the lines have transferred for me to see what I'm working with.

Now is the time to start realizing the relief. I study the image and evaluate the depth range. Some parts will be built up using an additive technique, while other areas will be carved out of the surface using a subtractive technique. I start working with the parts of the image which are farthest and which will therefore be in the shallowest relief. I continue by building up to the closest and thickest parts.

To do this, I mist the surface of the tiles, and begin using my fingers to spread layers of moist clay across the various forms within the image. I work the clay across the tiles as if they were one whole slab. I'll worry about separating

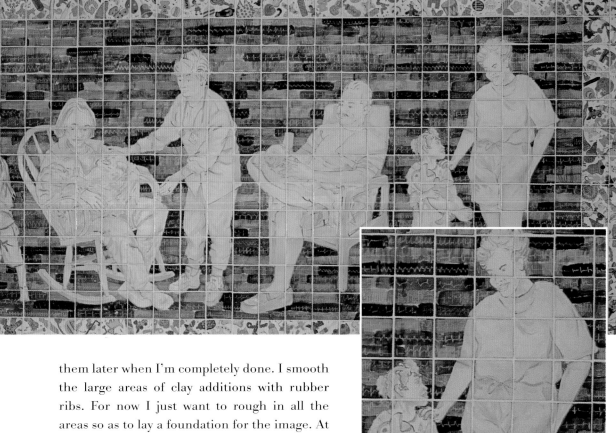

The Rhythm of the Rainbow
[Rainbow Babies &
Children's Hospital,
University Hospitals
of Cleveland, Ohio],
9½ x 22½ feet x ½
inch (8.6 x 20.1 m x
1.3 cm). Handmade
terra cotta tile;
majolica decoration;
glaze cone 04.
*Photo by Hanson
Photographic.*

them later when I'm completely done. I smooth the large areas of clay additions with rubber ribs. For now I just want to rough in all the areas so as to lay a foundation for the image. At this point the piece usually looks a bit amorphous. But as the process continues, the image is brought slowly into focus.

Next I begin to develop a bit more clarity by using wooden modeling tools to define the forms I have roughed in. In some areas I find the need to add more clay to further modulate the surface and forms. As the clay firms up and I start needing to develop sharper detail, I switch to metal ribbon carving tools.

The image is now basically all there and pretty clear. I go over it again, making sure that the layers of depth are clearly differentiated. What should be forward feels close, and what should be behind has a sense of being away from me. I ask myself, "Has the illusion been successfully executed?" I may see the need to still add a bit more clay here and there, or to carve other areas deeper. Now, I could end up obsessing over this part indefinitely, so I have to finally tell myself "I'm done." The image is

sharp and clear. I can clarify still further with color.

Before that, though, I must cut through the relief along the tile lines so that I may separate them. I lay a clear, flexible ruler over what I can see of the tile edges and begin to cut through with a thin, sharp knife.

At this point some of you may wonder, "Why didn't she just work on a whole slab and then cut it apart?" Well, I'm glad you asked that question. I prefer to work this way because then I know I'm working with even, square

ANGELICA POZO

tiles. It would be hard to try to accomplish that by making my initial tile cut through all that texture. I couldn't lay a ruler flat and square enough to get accurate cuts.

And now you may be thinking, "Why bother with square tiles at all in this case? Why not just cut around the forms in convenient little chunks?" Thanks. I'm glad you asked that question too.

This is the system I use because it easily translates to a larger, public art-sized format. In the first place, keeping track of the placement of irregular little chunks of tile would drive me and my tile setter crazy at the time of installation. With square tiles, I can grid out and number the image and mark the tiles to correspond. I can box them up in the order that they will be installed. That is a consideration when you're installing at a site that is still under construction or being used, and you don't have a bunch of space to spread out into.

Being organized keeps my tile setter very happy. I don't waste his time, and I don't give him extra headaches. Keeping him happy with the job makes him leap at the opportunity to work with me again, and he continues to charge me reasonable installation rates. He enjoys working on my projects because they offer him an interesting and challenging change of pace from his usual jobs.

Oh, by the way, the reason I use a tile setter is that, as I mentioned earlier, there are other parts of the project that I personally find more interesting and challenging. I'd rather spend my energies there, and leave the tile setting to someone with the skill and experience to make sure that the installation is sound and that we're using the right products for the particular situation; and besides, he makes my grout lines disappear.

Often novice tile mural makers are afraid of cutting up their image with the grout lines. The secret is that if the tiles are even, and the

grout lines are straight and evenly spaced, and you've selected the proper grout color for your piece, the grout lines disappear. The mind ignores the grout lines and sees the image first. But if there is a row of tiles that is off somewhere, the eye moves to that imperfection and begins noticing the grout lines before it sees the image. It's all in creating the proper illusion. So I think it's money well spent to pay my tile setter to impose his sense of geometry to the installation, because with it the illusion becomes a reality.

OK now...where was I? Oh yes. After cutting the tiles apart, I spread them and smooth the inner edges. On some of the thicker pieces, I carve out the back so that all the areas are about the same thickness, and drying will be more even.

Now I'm ready to start adding color. I start by laying in the flat color areas with my vitreous wetware slips. I model the color a little bit with these but leave the major color modulation and detailing for when I overlay with layers of translucent underglazes. I do all this painting while the clay is damp and leather-hard.

There, I'm done painting. I now go back and pick out some more detail by using a sgraffito tool to outline some of the forms against each other. This is the part I like about working with wetware slips—being able to work back into clay. It just makes the decorated surface feel more integrated with the clay form.

To let this piece dry, I cover it with plastic and gently loosen it bit by bit. I check daily for condensation. If I'm having condensation problems, I spread layers of paper towels between the tiles and plastic to keep the moisture from smearing the image and to keep the drying process more even.

So there you have it. My tips on tile and potato salad making. Enjoy!

ANGELICA POZO

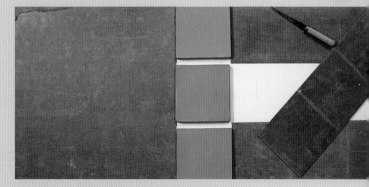

HANDS ON

*A*ngelica uses a tile template of her own design to plan and execute the production of multipart tile installations. She then demonstrates how she carves and builds a relief tile design with vitreous slip, and then adds underglaze painting.

THE BASIC TILE

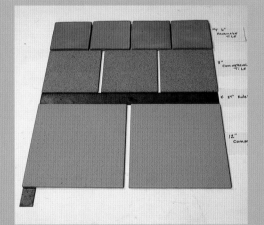

1. Sizing tile to include the grout line. My handmade 6-inch (15.2 cm) and commercial 8- and 12-inch (20.3- and 30.5-cm) tiles size up to a 24-inch (61 cm) ruler. Something to be aware of, however, when using commercial tile is the sizing. The actual size varies from one line of tile and/or manufacturer to the other, but is almost always sized smaller to compensate for the grout. And it is important that I have enough space between the tiles to be able to force the grout into. Though I initially may have adhered the tiles in place

with tile cement or adhesive, it is the grout that protects the installation and keeps the tiles in place. Generally, the thicker the tile, the more space you will need. Quarry tile thickness, about ½ inch (1.3 cm) thick, needs about a ¼- to ⅜-inch (6 to 9.5 mm) gap, while thinner tiles can get away with a smaller one.

2. Artist's E-Z tile template alongside a sampling of the fired results. This sizing system enables me to easily and accurately estimate how much tile is needed to fill a given space, so I carry the commercial sizing system over to my handmade tile. I find a 6-inch-square (15.2 cm) size is the

easiest for me to work with, both in terms of fabrication, as well as estimating tiles needed per square footage. That means that I cut my wet tile so that it will shrink to a quarry-tile thickness.

Making my tile template was simple. I figured out what size my wet tile needed to be to give me my desired finished tile. I multiplied that by three. Then I cut two pieces of ¼-inch (1.3 cm) fiberboard to those dimensions, keeping one whole, and cutting the other into one-third strips.

3. Using the tile template. Part one (the larger part) of the tile template is used to check that the slab is the right size.

4. Moving the slab onto a board. To slide the slab off the slab roller, I pull the canvas onto a board, being careful not to bend the slab.

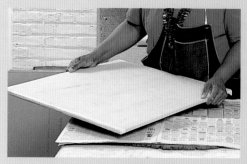

5. Topping off the slab-flipping "sandwich." For boards at this stage, I like to use ½-inch (1.3 cm) drywall cut down to 24 x 24-inch (61 x 61 cm) pieces, taping the exposed plaster edges with masking tape. The drywall helps pull out some of the moisture from the slab, allowing the slab to firm up evenly.

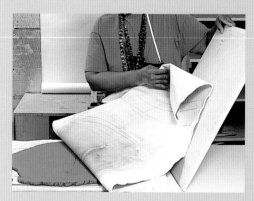

6. Peeling the canvas from the flipped sandwich

ANGELICA POZO

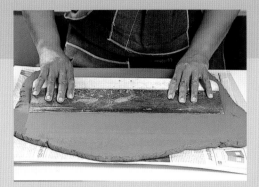

7. Removing the canvas texture by passing the drywall taping tool over the surface of the slab

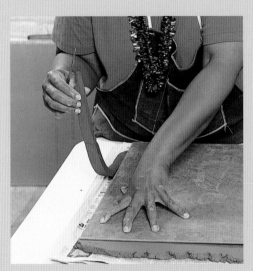

8. Trimming off the excess of the slab by using part one of the tile template as a guide

9. Preparing for firming up overnight. I cover the slab with two more sheets of newspaper before putting it in a stack of no more than three high. This half sandwich is what is stacked three high, topping with more newspaper and a single sheet of drywall.

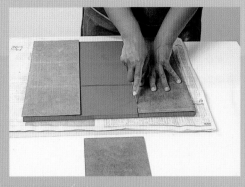

10. Cutting the tile using the three-sectioned part of the tile template. I take the three sections of my tile template, making sure to square up the edges of the templates to the slab. Then I remove the center strip to expose the inner edges of the two outer strips. These serve as my cut line guides. When I've gotten the first two parallel cuts done, I turn the slab 90° and lay the templates perpendicular to the last set of cuts. I repeat the process so that I have nine square tiles.

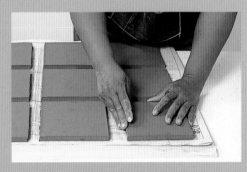

11. Using a finger to smooth the sharp cut edges of the tiles after spreading them out

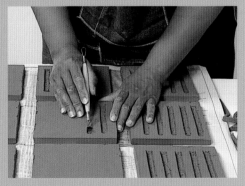

12. Using the ribbon trimming tool. The tiles have been carefully flipped so they are facedown; now the backs are textured by gouging out grooves.

ANGELICA POZO

13. Right side up, the tiles are covered with newspaper and set back into their stacks to firm up under plastic for one more night.

14. The next day, the tiles are placed in individual stacks, two tiles high and face to face, to dry slowly on a plastic-shrouded warecart. Each day these individual stacks of two are flipped, to prevent the tiles from curling up on their edges as they dry.

15. Tiles waiting to be taken out of the bisque kiln. Note how they are stacked on their ends.

16. Planning relief work by first tracing the drawing onto heavyweight clear plastic with a fine-point permanent marker. In this instance I'm working on an 18 x 18-inch (45.7 x 45.7 cm) image drawn on the diagonal.

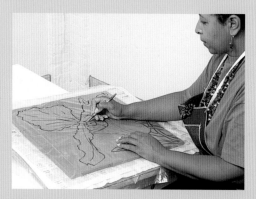

17. Transferring the design onto the tiles by retracing the drawing, now using a stylus tool.

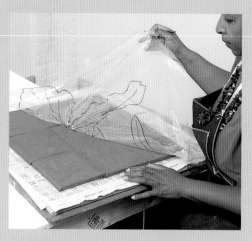

18. Peeling off the plastic overlay

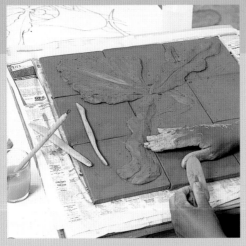

19. Spreading layers of moist clay over the various forms of the image

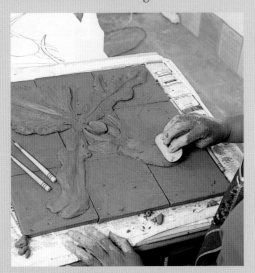

20. Using a rubber rib to smooth out the larger areas

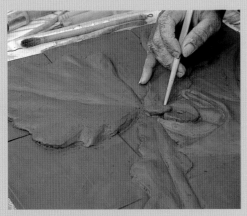

21. Sharpening up the image by using a wooden modeling tool

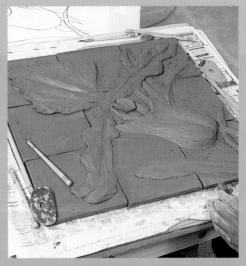

22. Fussing over the last bit of detail after going over it with ribbon carving tools

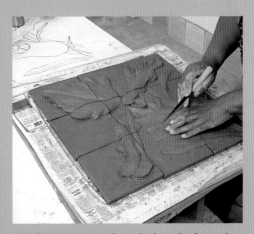

23. Cutting apart the relief work along the tile lines

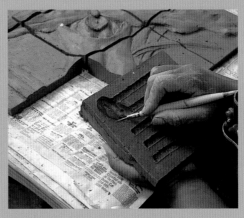

24. Hollowing out the back of extra-thick areas of relief

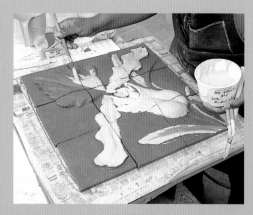

25. Laying in the flat areas of color with wetware vitreous slips

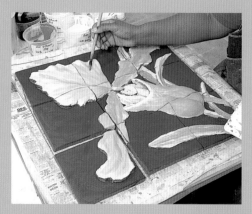

26. Modulating the color by first intermixing the vitreous slips. Over these, washes of translucent underglazes are worked in, to articulate the forms and add detail.

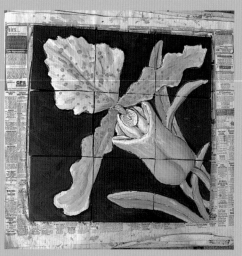

27. Finished piece, ready to begin the drying process

ANGELICA POZO, a studio artist living and working in Cleveland, OH, has been an instructor at several schools, including the School of Visual Arts at the Cleveland Institute of Art. Her lecture and workshop credits include Tile Heritage Conference, Erie Art Museum, Ohio Clay Workshop at the Dayton Art Institute, and Penland School of Crafts. She has lectured on such topics as "It Takes the Hide of an Armadillo...or, How Artists and Landscape Architects...Work Together," for the American Society of Landscape Architects Annual Meeting in Cleveland.

She has been awarded a number of grants, including an Ohio Arts Council Individual Artist Fellowship Award. Her work is featured in several permanent collections, such as the American Craft Museum, New York, NY, and the National Afro-American Museum and Cultural Center, Wilberforce, OH. Her site specific public art includes "Ohio Percent for Art Project," Ohio State University, Columbus, OH; and "L.A.W.," Cleveland-Marshall College of Law, Cleveland State University; and "Cleveland: Air Laboratory of the World," Rapid Transit Authority, Airport Station, Cleveland, OH. Among her group shows are "Uncommon Beauty in Common Objects," a traveling exhibit; "FLUX," Dublin Arts Council Gallery, Dublin, OH; "Couplets: Duality in Clay," The Clay Studio, Philadelphia, PA; "Latino Americano," Beachwood Center for the Arts, Beachwood, OH; and "First 20 Years: Then and Now," Baltimore Clayworks, Baltimore, MD.

GALLERY

*I*n this gallery I am able to offer you a small but tempting appetizer of the delectable variety of approaches undertaken by a smattering of the many talented artists working with tile these days. There is tile as sculptural object. This is evident in the monolithic drawing tablets of Dave Alban. They have a physical presence of their own, as palpable as the three-dimensional sculpture of Marlene Miller, both formed in an aggressive and visceral manner, totally acknowledging the tactility of the clay. Then there is tile as two-dimensional image, where clay often serves as a durable substitute for paper or canvas. In her pieces Joyce Kozloff actually combines images on paper with images on clay. We are hard pressed to see a big difference between the two surfaces. From a distance, Aurore Chabot's piece could almost be mistaken for a painting, as it projects a strong two-dimensional presence. And in between these two approaches is tile that comes up off the picture plane and into relief. The works of Gretchen Kramp, Carrie Anne Parks, and Donna Webb and Joseph Blue Sky here provide us with three very distinct expressions. I also wanted to include a few examples of mosaic. Carlos Alves and Isaiah Zagar both work in a piqué assiette *(broken shard mosaic)* style. Both artists like to incorporate dimensional clay objects, handmade as well as found, amongst their flat mosaic tile. Both artists have a penchant for excess, ending up with dazzling results uniquely their own. Cary Esser's work (see detail at right) is also mosaic. If you look closely, you can see that each segment is not a whole tile but rather several tiles of varying sizes cut to fit and interlock snugly together.

CARY ESSER, *Untitled Triptych (detail)*, 2000. 29 x 70 x 3 inches (73.4 x 177.8 x 7.6 cm). Press-molded and incised earthen-ware; terra sigillattas; glaze cone 04 oxidation; tiles epoxied to wood panel. *Photo by E.G. Schempf.*

MARLENE MILLER, *Woman with Gash*, 2001. 18½ x 21 x 9½ inches (47 x 53.3 x 24.1 cm). Stoneware with sawdust and perlite; built from solid mass, cut open and hollowed out at leather-hard stage and faced with porcelain slip; stained; cone 6. *Photo by artist.*

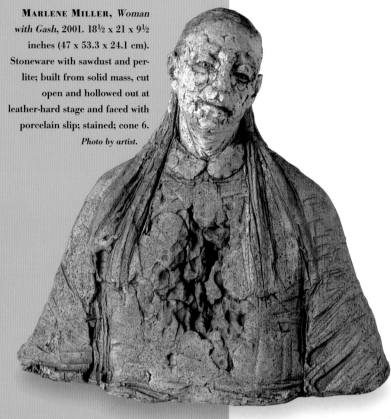

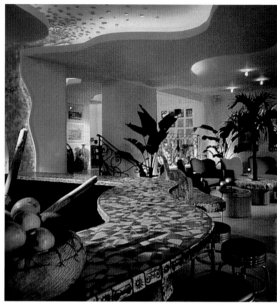

CARLOS ALVES, *Larios on the Beach*, 1993. 120 square feet (36 m²). Mosaic bartop and ceiling of handmade tile. *Photo by artist.*

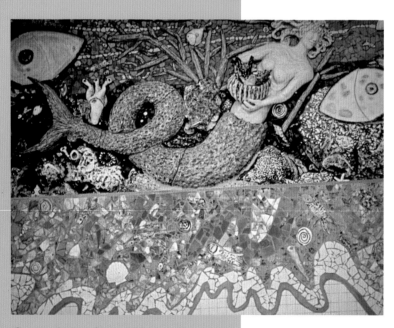

CARLOS ALVES, *Sirena*, 1993. 26 x 6 x 18 inches (66 x 15.2 x 45.7 cm). Handmade clay tile sculpture. *Photo by artist.*

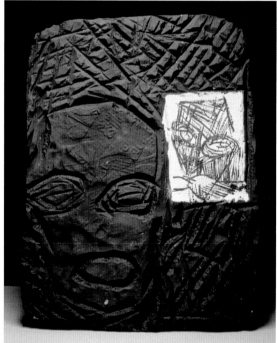

DAVID ALBAN, *Untitled.* 30 x 22 x 1 inches (76.2 x 55.9 x 2.5 cm). Slab-built earthenware; white vitreous slip; black slip; single fired cone 04. *Photo by Dan Meyers.*

ANGELICA POZO

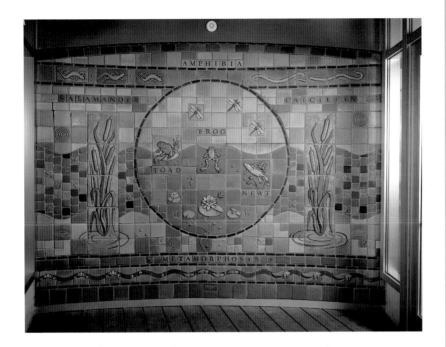

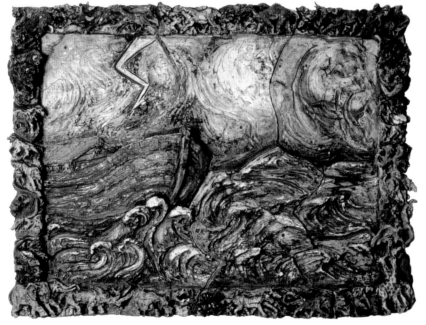

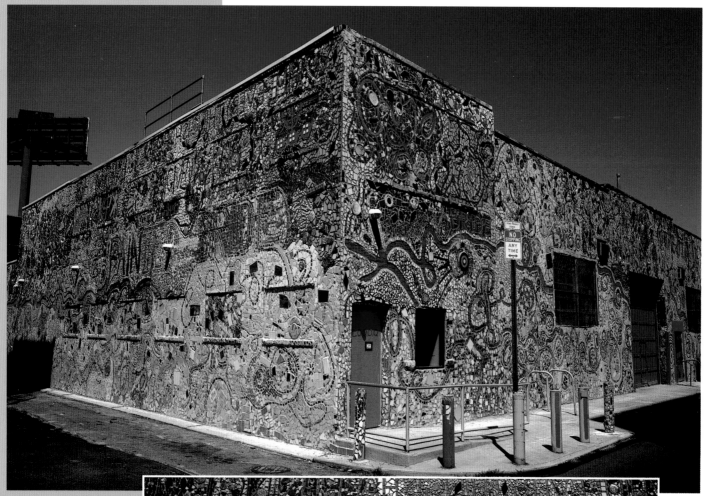

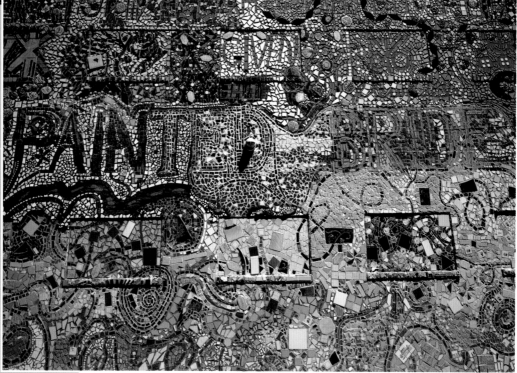

ISAIAH ZAGAR,
Painted Bride, 1991-
1999. Section of 6,000
square feet (1,800 m²)
of tile. Surface tiling
using the Zagar grout-
ing method.
Photo by artist.

ANGELICA POZO

JOYCE KOZLOFF, *Wearing Hats,* 1995. 3½ x 3½ feet (3.2 x 3.2 m). Hand-painted tiles; underglaze and glazed collage on paper; grouted on wood. *Photo courtesy of the collection of Dan and Diane Vapnok.*

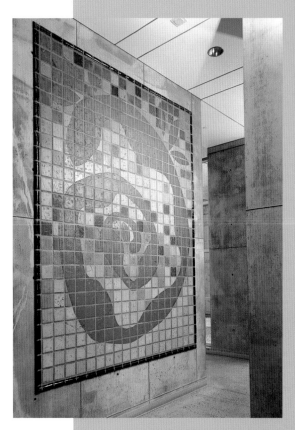

AURORE CHABOT, *Cellular Synchronicity* [one in a series of seven murals], 1997. 12½ x 10 feet x 12 inches (3.5 x 3 x .3 m). Handmade ceramic tile; reverse inlay made by fossils placed in a wooden mold, high-grog terra cotta pressed over their backs, compressed; sprayed glaze and terra sigillata in a design applied with large stencils; cone 3. *Photo by Balfour Walker.*

CARRIE ANNE PARKS, *Persona Non Grata,* 1998. 26 x 14½ x 6 inches (66 x 36.8 x 15.2 cm). Terra cotta; underglaze. *Photo by artist.*

ANGELICA POZO

MICHAEL SHERRILL

Michael Sherrill's rich, warm surfaces seem caught in a moment of stasis, yet the constructions themselves are active, tensed with life energy. He builds a language of beautiful sculptural objects that hold layer upon layer of texture, color, and, ultimately, nature's mystery.

Lovers' Leaves (detail), 2000. 11 x 16 x 7 inches (27.9 x 40.6 x 17.8 cm). Porcelain. *Photo by Tim Barnwell.*

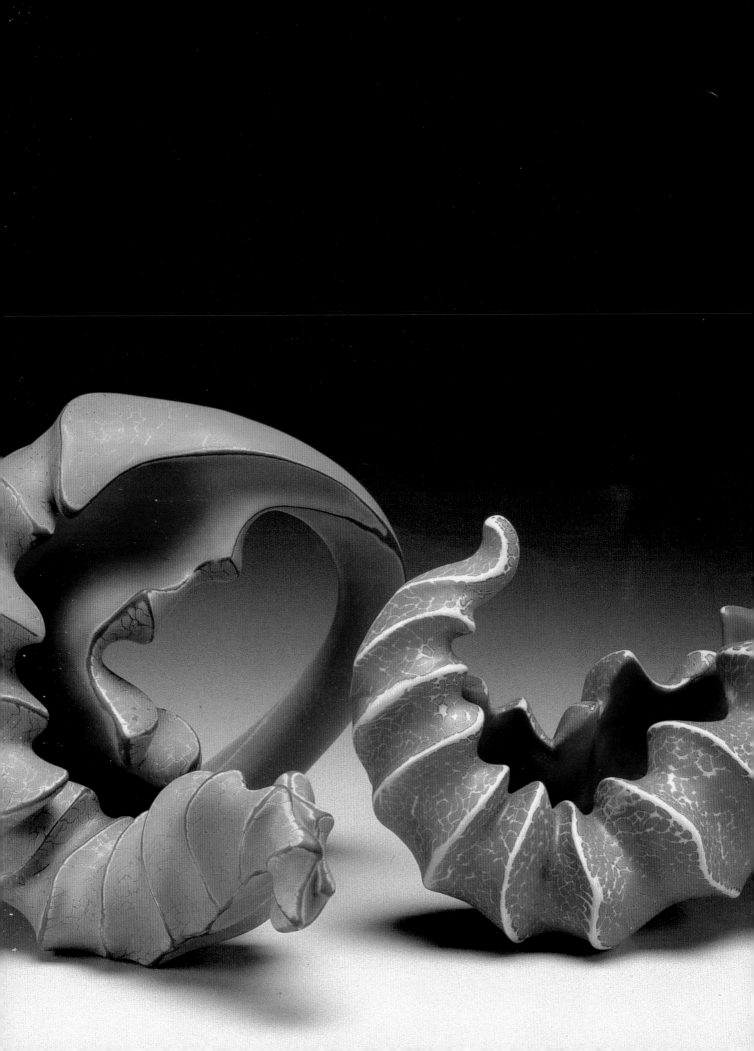

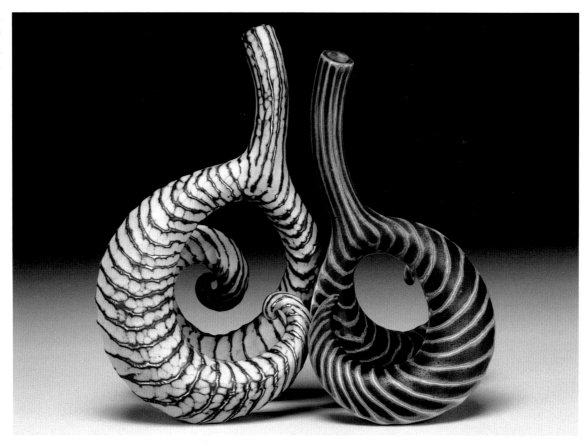

Locust Bottles,
2000. 11 x 4½ x 9
inches (27.9 x 11.4 x
22.9 cm). Porcelain.
Photo by Tim Barnwell.

A MAKER OF THINGS

I feel as if I have always been a "maker of things." Early in life I was frustrated by written language. That isn't unusual for a dyslexic. It didn't take long for me to find my way to the art room at school, and for it to become the place that would open the door to a different language—one that has become my way of communicating. I have always been surrounded by what I would call a culture of making. My father was an iconoclastic inventor whose workshop offered endless exploration in various materials. My grandfather connected me to a history of people who made things, out of necessity, to suit their needs. I had a brother who was an artist and he mesmerized me by seeming to make something out of nothing before my very eyes. All of this opportunity for exploration was grounded in a sense of safety that my mother and grandmother gave me. Making objects became my language, and in high school, clay became the vehicle by which I could write.

A visual language can often describe or express something that is otherwise hard to do with words. In writing about the religious iconography of the Middle Ages, Paul Johnson addresses this very concept. He explains that paintings and other images were the vehicle by which Holy Scripture (and the story of the Church) could be communicated to the average person who hadn't the ability to read or write Latin, which was the official language of the church. If these objects had simply been beautiful things, they would stand to become the focus of worship, or idols of sorts, and I think that would have been unfortunate. But they were more than that. They were a means of connecting to something. I strive for that same transcendent quality in my work. I don't know if I always find it, but I am inspired to try.

MICHAEL SHERRILL

I like to refer to other artists' work in a variety of media as a way to describe the aesthetic qualities that I'm drawn to myself. My friend Randy Shull creates wood surfaces that are rich with color and depth. Daniel Clayman, who works in glass and bronze, and glass artist William Morris both create surfaces that draw you into them. They each have a quality that I find valuable and a sensibility that I'm after, too: I want a marriage between the object and its surface.

My work prior to this present body was modernist-inspired. It was as simple as it could be, clean and strong. I think it was a reaction to the many years that I idolized Japanese and Korean pots. I was compelled to start looking for the heart of what made me an American potter. As a result, I worked through modernism in my own little way. The modernist mindset is a materials-based idea. I'm trying to bring this same sensibility into my current work, which is my reaction to the natural world around me.

In 1997, I built a new studio situated in a valley and surrounded by the great outdoors. I found myself bringing the outside in, surprised by the natural world that was literally at my feet. I started picking up poplar leaves and noticed that they were blighted, resulting in a gorgeous transition of color from green to banana yellow. I was inspired to keep looking outside, as if I had never noticed this natural world before. Often it's just a glimpse of something that catches my eye, but it's still that sense of object and surface being married that compels me. You don't see two separate things when you look at a leaf. You just see the leaf. This is how I want my current work to be seen: not as clay and glaze, but as an object that draws you into it, the same way that I am drawn into the objects that I discover. It's not an attempt to copy or strictly imitate; it's an attempt to talk to the viewer. Because my subject is from the natural world, it's not incredibly intimidating. It doesn't set itself apart from

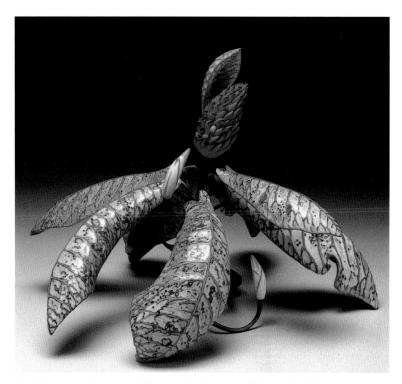

Seed (Mountain Magnolia), 2001. 14 x 18 x 18 inches (35.6 x 45.7 x 45.7 cm). Porcelain. *Photo by Tim Barnwell.*

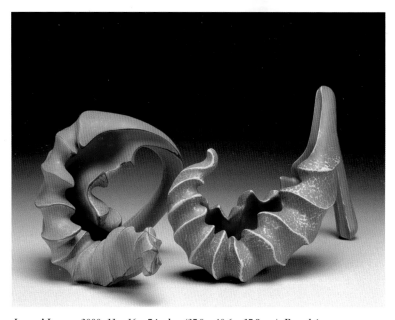

Lovers' Leaves, 2000. 11 x 16 x 7 inches (27.9 x 40.6 x 17.8 cm). Porcelain. *Photo by Tim Barnwell.*

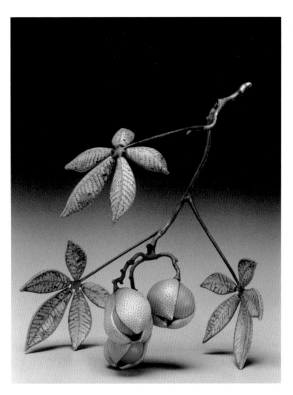

Love and Happiness,
2000. 21 x 18 x 18
inches (53.3 x 45.7 x
45.7 cm). Porcelain.
Photo by Tim Barnwell.

the viewer, leaving him to feel foolish for not understanding what he's looking at. I want these objects to speak about birth and life, sex and death, decay and loss. I don't think I would have come to this point if I hadn't really worked my way through the modernist mindset. I think I know what modernism is, visually: it's an attempt to make material things spiritual without religion.

The way I work with materials and tools is a natural extension of my lifelong exploration of visual language; they are all a means to expression. I've been using the extruder for almost 25 years. I see it as an extension of the wheel: a tool for finding other objects. At one time I was using it to pull long spouts for functional teapots. It occurred to me then that I could pull hollow forms and make them into bottles or countless other shapes. And so I did. I also

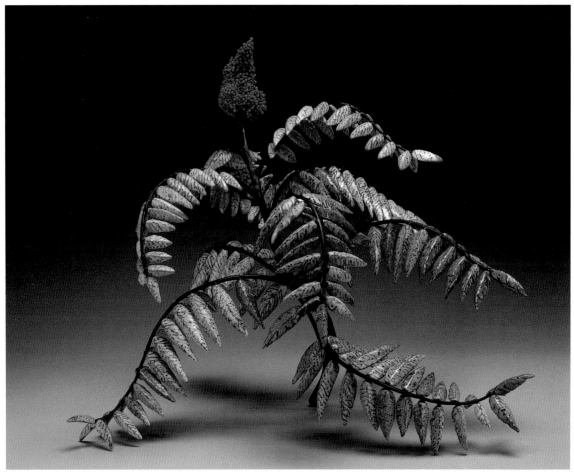

*Junk Plant Beauty
(Sumac).* 28 x 26 x
25 inches (71.1 x 66
x 63.5 cm). Glass,
ceramic, and forged
steel. *Photo by Tim
Barnwell.*

MICHAEL SHERRILL

wanted to experiment with new glazing techniques, so I began creating small shapes out of the extrusions, to be used as tests. These shapes were hollow and closed, and I stacked them on metal rods, much like beads on a toothpick—only bigger. One thing led to another, and I began to carve them to test the glazes. These tests were the birth of new sculptures created from objects threaded on metal. The extruder became a workstation for me. It holds my work while I stand and move around it, and it makes a difficult job easier. Because of the way I work, I use a fairly stiff grolleg porcelain, and the extruder serves as an extra pair of hands.

I started making my own dies as a result of what I found to be a faulty design. Most dies have a straight wall with a sharp edge. When I was extruding tubes and then pulling them into spouts, I found that the clay wanted to break at the edge of the die. I made a die with a slight curve at the top edge, and this design change caused the clay to push into the die, traveling around and through it with a smooth path. I also wanted to begin with extruded, round hollow tubes, instead of square or odd shapes, because it makes for a stronger form, with more integrity in the wall, not unlike a thrown pot. I can then reshape a round extrusion into whatever form I need.

For my dies, I use polyethylene or nylon sheets that are ½ inch (1.3 cm) thick (this is the same material used for some kitchen cutting boards). I have dies that make hollow tubes from 1½ to 4 inches (3.8 x 10.2 cm) in diameter. I take great care to make sure the dies and bridges are crafted with some precision, so that the thickness of the extrusion can be adjusted by changing the inside of the die. (The bridge is the part that connects the inside and outside of the die, creating the tube extrusion.) Over the years I've changed the bridge design to better mix the clay as it travels around the bridge and through the die, which results in a stronger extrusion. This is important when you want to

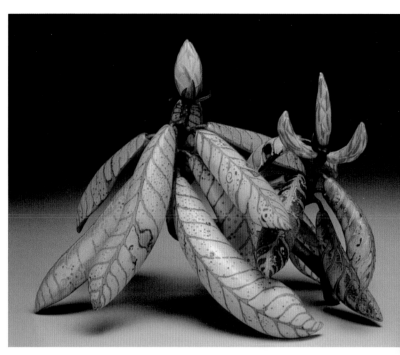

Yellowstone Rhododendron, 2001. 12 x 15 x 11 inches (30.5 x 38.1 x 27.9 cm). Porcelain. *Photo by Tim Barnwell.*

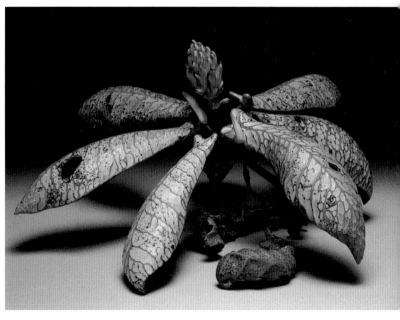

Mountain Magnolia, 2001. 11 x 21 x 21 inches (27.9 x 53.3 x 53.3 cm). Porcelain with steel armature. *Photo by Tim Barnwell.*

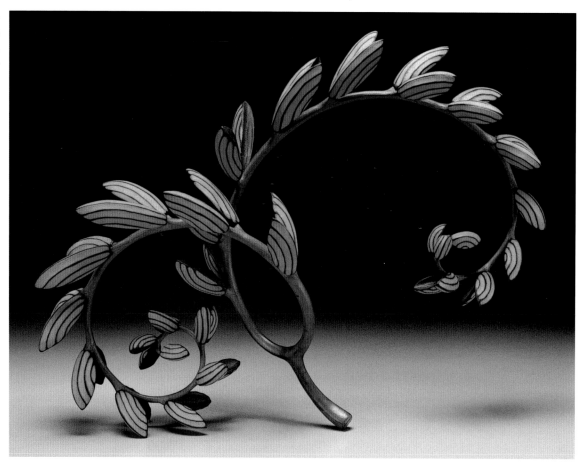

push out the walls of an extruded tube. They must have integrity.

Since I'm interested in the transition of one color to the next, I've had to figure out and formulate an engobe that would allow me to put down many coats of color. Glaze doesn't like to be applied in that way. Additional layers want to force previous layers to become unattached. This led me to try to calcine my slip, so that it would expand and contract as my bisque does (calcination uses heat to cause a chemical change in the slip). It's been a challenge to figure out how to make this work, and that is why I have looked to the ceramic industry and to industrial application to find things that will aid me in the coating and layering of material. I have experimented with a lot of different binders and suspenders, including some that behave like latex paint. These binders have a scientific application, but it requires one's

artistic sensibility to make the material produce the desired result. I think it beneficial to be open to what the industrial world has to offer us as artists. Many scientists appreciate that artists are willing to think outside of the box. This is where art meets science.

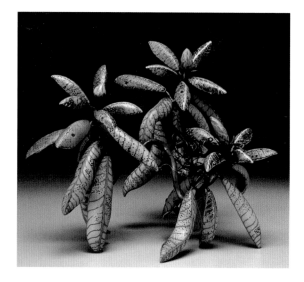

MICHAEL SHERRILL

I apply many layers of glaze, but must abrade them to work through and find the desired color transitions. This is a lengthy process, requiring up to four firings. My final firing is a cone 6 or cone 7 oxidation. Once the glaze is on, I can move on to the next stage in the process.

Carving has become an important component in my work because the peaks and valleys created by the carving serve to expose the glaze and create the color transitions. Porcelain is a great material for carving because it clearly shows the cut path, and I need the carved texture in the clay to enhance my glazing process. I like to catch the clay when it is leather-hard, just before the surface starts to go chalky. I get the pieces ready for carving and keep them in a big bucket lined with foam rubber; this inexpensive material is a good way to store the pieces as I work with them. The foam acts like a humidor in the bucket, letting the clay dry evenly, and it won't mar the clay's surface. It's also very useful when I need to turn over a piece of clay that I'm carving.

Carving has also become a real pleasure in my current work—a nice surprise. I use wood cutting tools, called palm gouges, as well as tools that I forge myself into a desired path or shape. I've made a series of knives with different arcs that I also use to create pattern. If you haven't already figured it out, I like tools and I like making them. For me, making tools is a part of the process that I really enjoy. I can make a tool that suits my need and allows me to produce the work I want. This has led me to designing tools for other potters, too. It gives me pleasure to know that they enjoy them.

Clay is the most malleable, quick, and responsive material to work with. When it's fired, it becomes strong, durable, and long lasting. Clay allows me to be a plastic thinker. In many ways, metal does too. They both allow themselves to be adjusted or rethought during the process. For me, the great thing about being a maker of

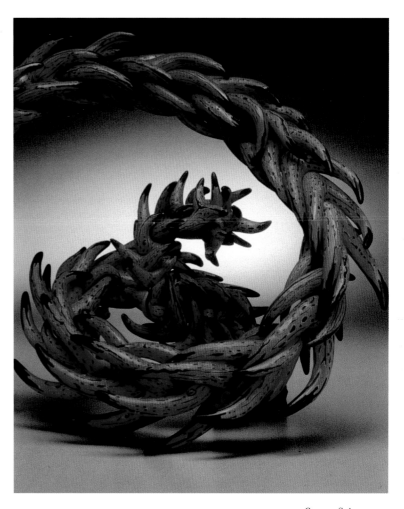

stuff is that I can have an idea and pursue it through to a tangible result. In our culture, people want immediacy and a quick response. As makers, what we do requires that we invest our time and make a commitment to knowing our materials. As I work, I find that while my parameter has widened, I still love clay and am glad to speak its language.

Corona Spinarum, 2000. 17 x 19 x 19 inches (43.2 x 48.3 x 48.3 cm). Porcelain. *Photo by Tim Barnwell.*

HANDS ON

*I*n these two photo series, Michael demonstrates the techniques necessary to create the two-pronged vessel and leaf forms that are components for his ceramic sculpture. For the pronged vessel, he forms, carves, hand builds, then joins a pair of extruded porcelain forms. The extruded leaf form is supported by air, then foam, as Michael builds, then radically alters it, to its final shape.

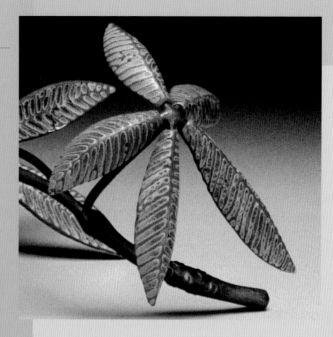

TWO-PRONGED VESSEL

1. Extruding a hollow clay tube

2. Wetting clay, tapering the end, and pulling the tube into a point

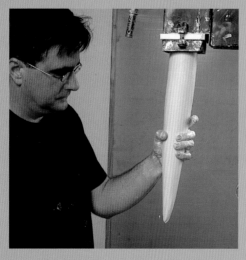

3. Relieving some of the air pressure by poking a small hole in one end of the closed, extruded clay tube

4. Supporting the clay tube with one hand so I can shape it with the other without over-thinning it

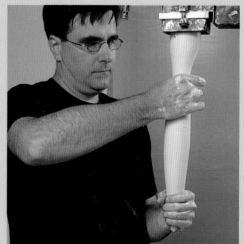

5. Cutting tube of clay off the extruder

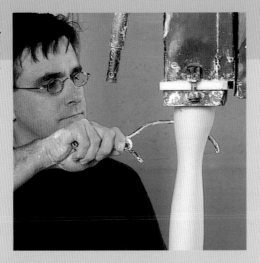

8. Completing the arc. It's important to work fast at this point to make use of the wet clay's plasticity.

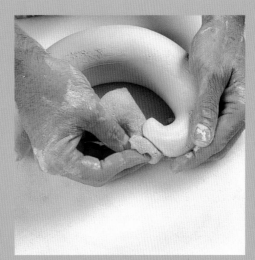

6. With wet hands, pulling the end of the tube again to close it. The air inside it helps bend the form.

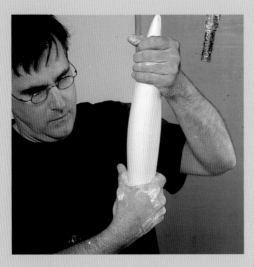

9. After making a hole in one end to relieve the pressure again, gently curve one end upwards, then close off the end, and smooth with a wet sponge.

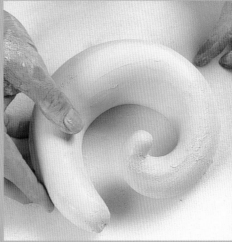

7. Forming the clay into an arc on a piece of foam rubber. To relax the clay and establish the curves, rub the insides and outsides of the arc with a soft rubber rib.

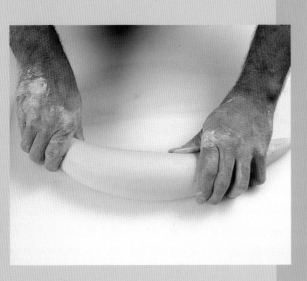

10. One of two completed prongs

MICHAEL SHERRILL

11. Completed forms air-drying, with ends wrapped in plastic

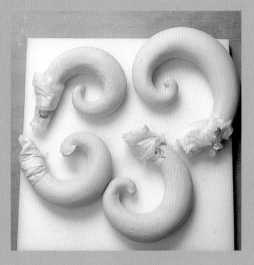

12 Sketching lines in pencil to set the flow for the carving

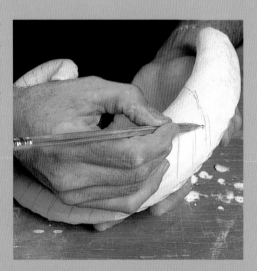

13. Carving the leather-hard porcelain form, which has the consistency of soft butter

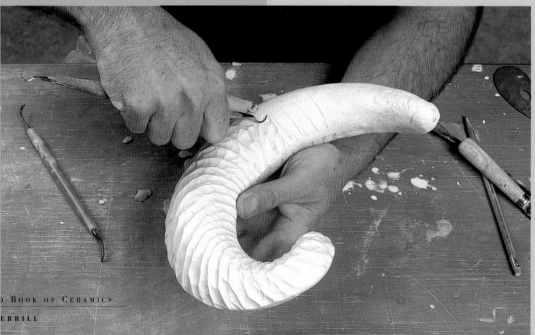

14. Making an overlap joint by thinning the edges

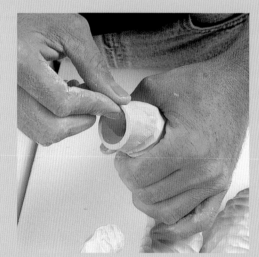

15. Thinning achieves a gradual transition (rather than a ledge) where the two pieces attach. The form is supported by foam rubber.

MICHAEL SHERRILL

16. Brushing slurry on the edges

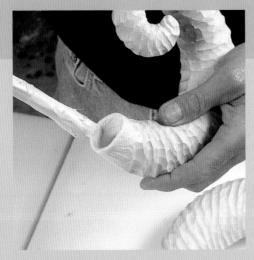

17. Adding a thin coil inside the ends to create a flange

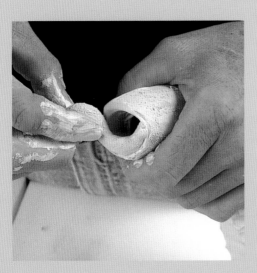

18. Thinning the edges of a narrow extruded tube

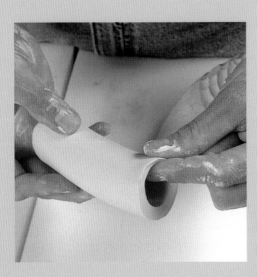

19. Attaching tube to carved piece to make a bottle neck

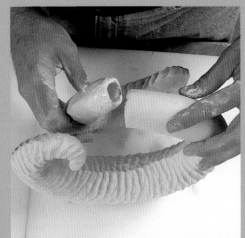

20. Pushing PVA ball on a dowel inside the tube to smooth the joint

21. Attaching the two carved pieces

MICHAEL SHERRILL

22. Using a pointed tool, pressing into the joined tube to ream out the opening

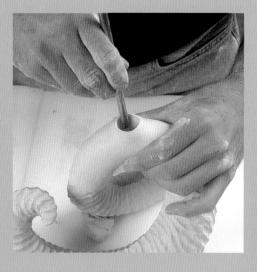

25. Attaching the neck

23. The joined tube

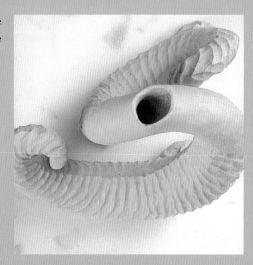

26. Using a hacksaw blade...

24. Placing PVA ball and dowel, first inside the second cut tube, then into the hole, to smooth the joins

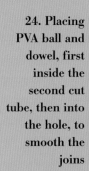

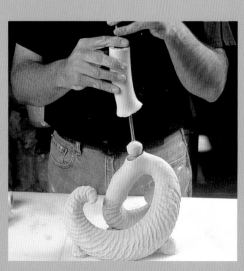

27. ...to smooth joined area

MICHAEL SHERRILL

LEAF FORM

28. Changing die to larger size

30. Another handy tool–a ball of PVA on a dowel

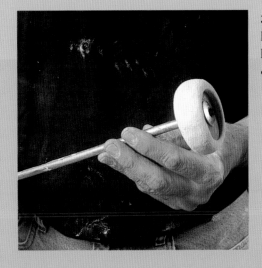

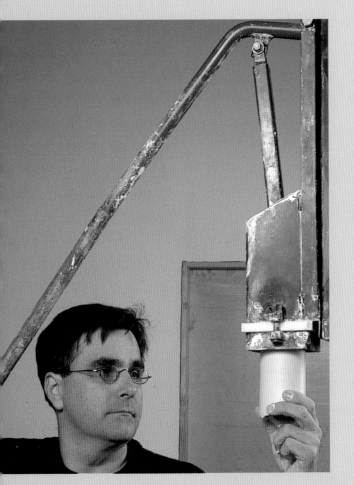

29. Extruding the tube. Work with clay at 8.2 on a 10-point clay deflection scale of stiffness. The weight of the clay pulls against itself, so I need a clay stiffer than that for throwing, in order for it to hold the extruded form well.

31. Pushing out the tube from the inside while the clay is still attached to the extruder

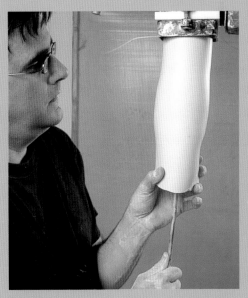

32. Tapering the end and closing it off

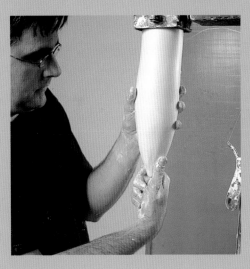

MICHAEL SHERRILL

33. Smoothing the tapered ends of the form cut from the extruder

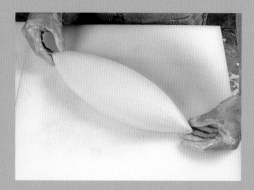

36. Brushing on slip along vertical axis

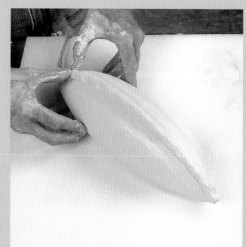

34. Inserting surgical tube into small opening in one end of form

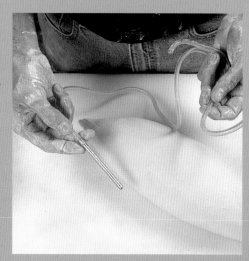

37. Adding a long coil of sof clay to the vert cal axis to create a central "stem" for the leaf "ribs"

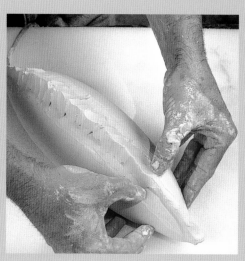

35. Closing off the end of the tube to maintain air pressure

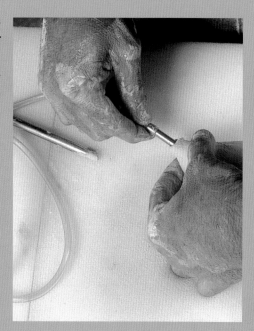

38. Smoothing edges of the co with fingers

MICHAEL SHERRILL

39. Smoothing edges of the coil with scraper

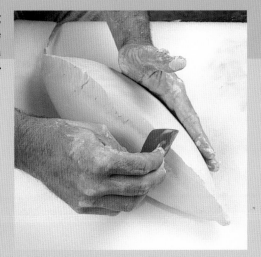

40. Adding thin diagonal coils of soft clay to create leaf ribs

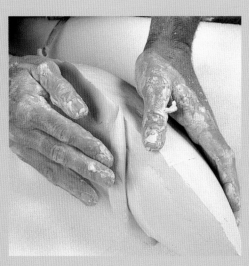

41. Smoothing the coils into leaf ribs

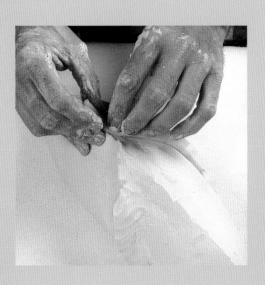

42. All the ribs are in place

43. Smoothing ribs with a sponge

44. Smoothing other sides of form where ribs attach

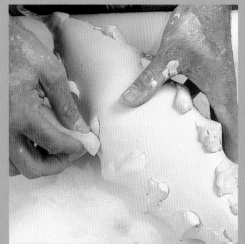

45. Removing clamp and slowly sucking air out of the form while also...

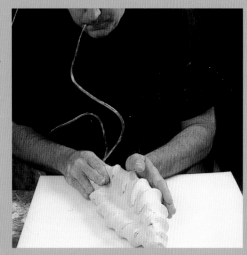

48. Continuing to control the shape with air pressure and the foam support

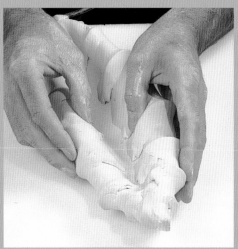

46. ...shaping and bending it

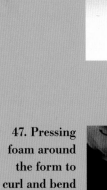

49. Completed leaf form

47. Pressing foam around the form to curl and bend it, while continuing to pump it out by mouth

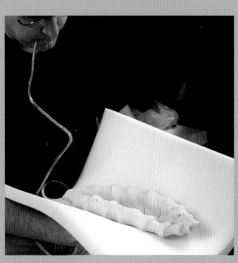

50. Leaf form and bisque-fired leaf form

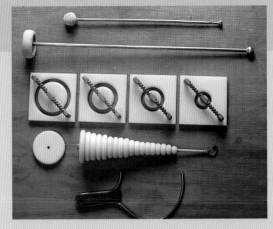

An assortment of dies designed and fabricated by the artist

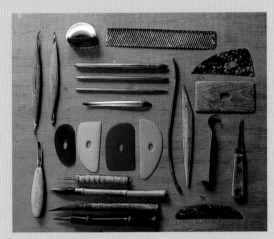

Michael made most of the tools shown here.

MICHAEL SHERRILL is a studio artist, living and working in Hendersonville, NC. His teaching credentials include 92nd Street YWCA, Pratt University, Arrowmont School of Crafts, and Penland School of Crafts. Among his solo exhibitions are "Selected Works at Gumps," San Francisco, CA; "New Works," Blue Spiral Gallery, Asheville, NC; as well as a show at the Mint Museum, Charlotte, NC. Selected group shows include "Color and Fire: Defining Moments in Studio Ceramics, 1950-2000," Los Angeles County Museum of Art, Los Angeles, CA; "Masterworks from the Collection," Mint Museum of Craft and Design, Charlotte, NC; "The White House Collection of American Crafts," The National Museum of American Art, Washington, DC, a traveling exhibit; and "The Penland Connection: Contemporary Works in Clay," The Society of Arts and Crafts, Boston, MA.

His work is featured in such public collections as the Smithsonian Institution, Renwick Gallery, Washington, DC; The American Craft Museum, New York, NY; NCNB Building, Charlotte, NC; and The White House Collection of American Crafts. Numerous private collectors own his work, too. His ceramic art appears in several books, including *Teapots Transformed: Exploration of an Object* (Guild Publishing, 2000) and *The White House Collection of American Crafts* (Harry N. Abrams, 1995), as well as such publications as *House Beautiful* and *American Craft* magazine.

GALLERY

What ties all these people to me is not that they use an extruder, or that their work looks like mine, but that I feel like their work embodies an honesty of expression that I admire, and I desire that quality for my own work. To me, Red Weldon Sandlin is the poster child for the postmodern. Her work is such an honest expression of who and what she is—ingenious, inventive, and at the same time, something right out of our childhood. I love Dan Anderson's work because it's rooted in a potting tradition, but it says so much more. I like the fact that his work has pulled both object and surface together to be one and the same. These objects give me a sense of place and time. It is difficult to express in words why I respond to Doug Jeck's work in the way that I do. I know that it stirs up a great sense of wonder and mystery. These are qualities that I seek in my work, and I greatly admire Doug's ability to make a piece that vibrates with expression. What I find engaging about John Byrd's work is his ability to take materials that are rural— even common—and make something artistically engaging with them. He appropriates these objects in a way that is not judgmental, building a bridge between the "low" and the "high." It's "truck stop mentality meets high art." The King of Subtext. Whether he's making a teapot or a sculptural object, Paul Dresang is like a big engine striking on different cylinders at the same time. Our humanity, our sexuality, our childhood and pubescence, our old age—all are part of his objects. His work has the potential to stimulate us in all these different parts of our lives, through a simple object. Paul accomplishes what many of us desire to do. Mark Shapiro's work speaks to me of the joy of making wonderful pots. My favorite piece of clay is the one he made that I drink out of almost every day. There is an honesty and a deliberateness that makes all of Mark's work hit the mark. The ease and grace in his work give the viewer and user something beyond the material.

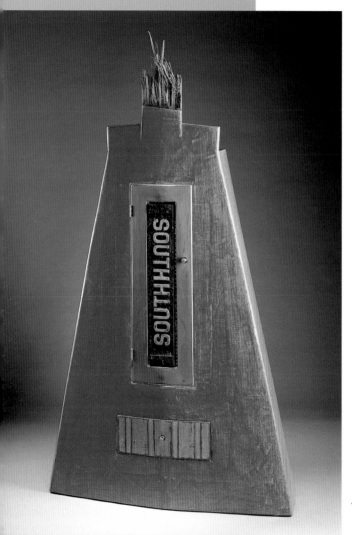

RANDY SHULL, *South South,* 1999. 88 x 51 x 18 inches (3.3 x 1.9 x .7 m). Carved and painted wood. *Photo by John Warner.* Collection of Brooklyn Museum, Brooklyn, New York.

MICHAEL SHERRILL

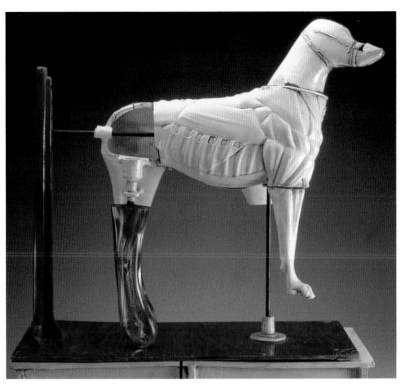

JOHN BYRD, *Untitled,*
2001. 27 x 25 x 10 inches
(68.6 x 63.5 x 25.4 cm).
Modeled, slab-built, and
thrown porcelain parts;
mixed media; cone 3. *Photo
by artist.*

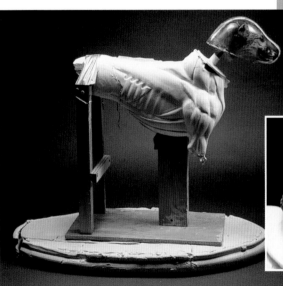

JOHN BYRD, *Monument for the Space
Race,* 2000. 30 x 30 x15 inches (76.2 x
76.2 x 38.1 cm). Modeled, slab-built, and
thrown clay parts; porcelain slip; mixed
media; cone 3. *Photo by artist.*

DOUG JECK,
Study in Antique White,
2000. 54 x 60 inches
(137.2 x 152.4 cm).
Clay, hair, fabric,
wood, plaster. *Photo by
Noel Allum. Courtesy of
Garth Clark Gallery.*

DAN ANDERSON, *True Round Barn Teas Set,* 1998. 8 x 16 x 10 inches (20.3 x 40.6 x 25.4 cm). Stoneware; soda fired; sandblasted.

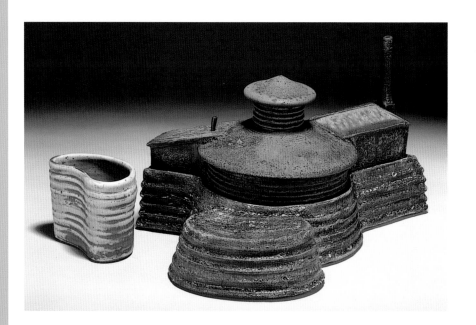

DOUG JECK, *Idiot Savant,* 2002. 14 x 7 inches (35.6 x 17.8 cm). Clay, hair, paint, metal. *Photo by R. Kardong. Courtesy of Garth Clark Gallery.*

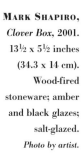

MARK SHAPIRO, *Clover Box,* 2001. 13½ x 5½ inches (34.3 x 14 cm). Wood-fired stoneware; amber and black glazes; salt-glazed. *Photo by artist.*

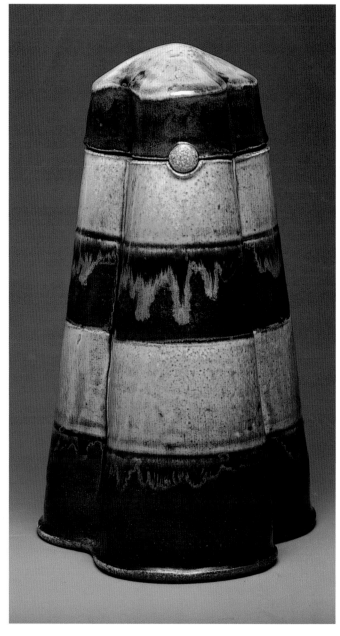

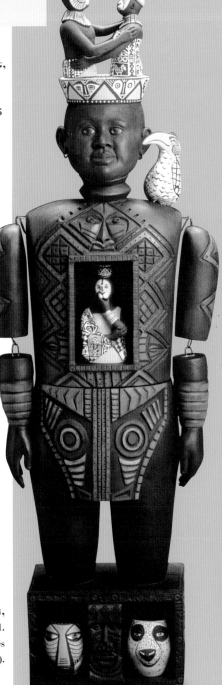

PAUL DRESANG, *Untitled (Bag Form),* 1998. Approx. 20 inches (50.8 cm) long. Porcelain; residual salt fired; underglazes; cone 9; multi-fired cone 04; lustre fired.

PAUL DRESANG, *Backpack with Water Pistols,* 2000. 16 x 16 x 5 inches (40.6 x 40.6 x 12.7 cm). Porcelain; residual salt fired; underglazes; cone 9; multifired cone 04; lustre fired.

RED WELDON SANDLIN, *The Teachings of Dick & Jane,* 2001. Each figure 13 x 5 x 5 inches (33 x 12.7 x 12.7 cm). Clay, wood, and acrylic.

RED WELDON SANDLIN, *Pride Rock Royal-Tea,* 2001. 39 x 11½ x 9 inches (97.5 x 29.2 x 22.9 cm).

MICHAEL SHERRILL

TOM SPLETH

At once fluidly geometric yet cooly impossible, Tom Spleth's slip-cast porcelain vessels seem to sway in a gentle underwater current. They curve and cleave to space itself, nearly springing free of the limits of gravity. And as the design's realization begins to transcend what is possible or even likely to occur in nature, each form embodies both quiet grace and profound strength.

Only You, 2001. Height: 6 inches (15.2 cm).
Slip-cast porcelain; cone 6. *Photo by Evan Bracken.*

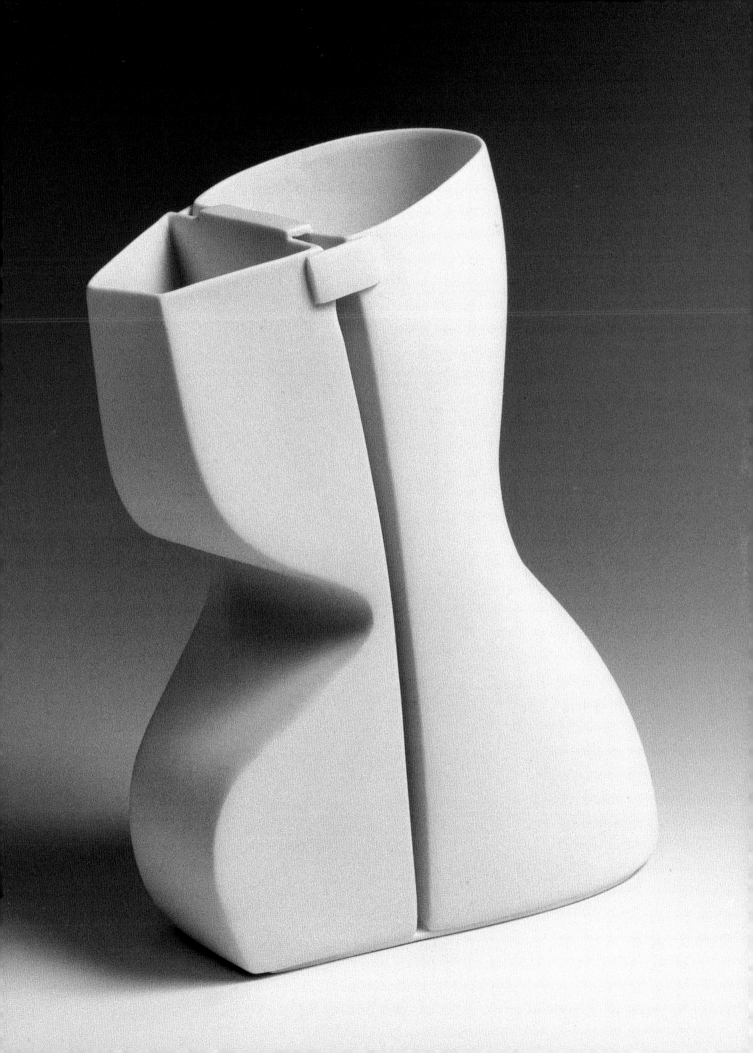

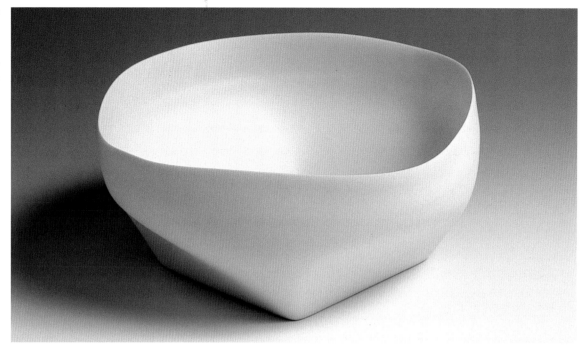

Bowl with Triangular Foot, 2001. Diameter: 8 inches (20.3 cm). Slip-cast porcelain; cone 6. *Photo by Evan Bracken.*

SLIP CASTING,
OR ROMANCING THE PLASTER

Ceramics as we know it is one thing; making molds and casting is something else altogether. In the context of hand-made pottery and other kinds of ceramics, the work I do in mold making is not of the brotherhood. The slip caster makes form with plaster, and the acts of wedging, centering, throwing, extruding, distorting, cutting, fitting, and attaching clays are unneeded. Slip casting side-steps the plasticity and sensuality of clay. Evidence of the hand is obscured. Casting with plaster molds is a way to make ceramics without participating in any of the universally accepted modalities of the craft.

Plaster is characterless. It has no grit, grain, or texture. A block of plaster is homogenous, smooth, soft, weak, and colorless. It is utterly passive. You might even say that it is dead. (I always feel that, when working with plaster, I am in the role of an undertaker, dressed in a lab coat, quietly adjusting something that is

lifeless, heavy, and cold to the touch.) Cast plaster dissolves in standing water and degrades in normal humidity. It is, therefore, ephemeral even if it appears to be inert. Electrically, plaster is an insulator, which is apt—it tends to block the flow. For example, it powerfully flocculates slip.

Its color is significant. A few weeks with plaster and the studio begins to disappear as all detail erodes and contrast pales under the pervading dust. One notices that one leaves footprints on the macadam when one walks to the car to leave. Like Dracula's complexion, the color hints at a close association with the dead. It haunts you. It is the Moby Dick of materials.

Clay has personality. It responds. One may develop a relationship with clay—there is a give and take. You can get to know it. It is diverse. It can betray and let you down. It can come through gorgeous. It can be a friend. You can love it. You can grow old with it. Plaster, on the

other hand, is never an object of infatuation that is the central *cause célèbre* of craft. Puritanical and reticent, plaster turns away from such romantic notions. It is closer in character to plastic, an industrially manufactured soulless substance. In addition to the passive and unremarkable personality of plaster, even its shallow tradition is suspect since plaster has been the means for the production of mountains of dreary industrial pottery. Plaster is like the unmodulated carrier wave in certain radio transmissions—it has virtually nothing to say until it is transformed. It is a physical manifestation of the ether—the whatever-it-is that lies between the electrons and protons of atoms. Plaster is nothingness made solid.

There are, however, certain advantages to be had when making form with plaster. Since plaster has nothing to contribute, one can be assured that every detail and nuance, each posture or pose, each comment made or characteristic implied by the form comes solely from the insight, skill, and will of the maker. It refuses to assist in any way. Its lack of dimensional change through drying or warping makes it suitable for the precise development of form. It dependably records ideas that can be revisited for appraisal or modification anytime. It is silky and soft enough to be carved with simple scrapers and rasps. It can be worked quickly and then sanded under running water with very fine waterproof sandpaper to produce smooth unblemished surfaces. These surfaces react beautifully with light and have a sense of being nearly immaterial.

Plaster objects are not limited in the same way clay objects are. To work with clay is to have a relationship with water. There is a constant inquiry—how much or how little to add while forming, whether the clay is too dry to bend or too wet to hold its shape, or whether it is drying properly once the form is made. The potter's primary challenge is verticality—to get the clay form up off the table or wheel head. Bowls and platters need to open with graceful aplomb

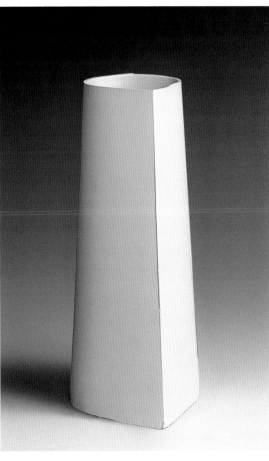

The Emotional Life of Plain Geometry, 2002. Slip-cast porcelain. *Photo by Even Bracken.*

without opening beyond the point where the clay collapses under its own weight. For better or for worse, carving plaster enables the potter/sculptor to make forms not attainable any other way. For example, transitions between, say, a round and square cross section on a plaster form have a more precise geometry with ultra flat surfaces and surfaces with spare, strong compound curves. In contrast, the thrown form, altered and squared, is always a little flaccid and floppy, with unavoidable superfluous bulges.

When I plan to use plaster to make form, I think about form only as the briefest of verbal descriptions. An image, with insignificant detail, unimpeded by gravity, floats in the indeterminate space created by my mind's eye. The piece, then, is free of references to function, tradition, or other expectations one might apply to ceramics. Plaster, being the passive but receptive material that it is, simply waits

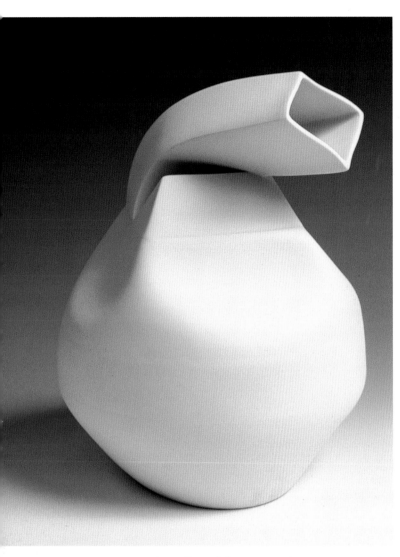

Vase in the
Form of an
Architectural
Cherry, 2001.
Height: 8 inches
(20.3 cm). Slip-
cast porcelain;
cone 6.
Photo by Evan
Bracken.

Next, I make a mold. At this place in the process, plaster is no longer the focus of attention as the bearer of ideas about form and surface, but, rather, it changes to become an anonymous recorder, the perfect material to accomplish the task ahead. Mold making is a craft filled with carefulness and strategy. It leads to an ability to conceive of complex sequential activity, to see how one thing done can only follow another done before. The mold describes the object it surrounds, and making a mold is a way that I become intimately acquainted with the form. The discipline of mold making leads to an ability to turn and tumble objects in the mind. True to plaster's nature, the mold is a physical manifestation not of what is, but of what isn't: the completed mold harbors a void within that is the sole reason for its existence.

Many times, the molds are the best part of the process. They have the frank honesty of a tool, which is what the mold is—a tool for making ceramic form. They are complete in their pristine plaster whiteness—so matte, so beautiful in the light. The parts of a mold fit together perfectly—a metaphor for an intimacy unobtainable in even our most intimate relationships. I have come to understand that the molds I make, the benches and devices I build that enable me to handle the molds, the organization and lighting of my studio environment, are all how I most clearly express myself as an artist and as a personality. I notice every step along the way and appraise the value and meaning of every touch. The final object—the dressy, completed, obtainable thing that is the result of all my activity—is only a reflection of the dynamic, engaging activity that has taken place in process. It is perhaps most true for the craftsman that the journey is all, that the destination counts for less.

At last, finally, clay and ceramics enter the picture. Plaster becomes supportive when the mold is dry, and the act of slip casting produces

silently as I modify its mass in response to the delicate preconceived notion that resides somewhere within my imagination. Sometime during the day, an object made of plaster appears on the table top, surrounded by chips and shavings, buckets, scrapers, and chisels, arriving as if it is a guest recently delivered to the studio from an airport, dazed by its recent change in environment and climate. It is never a perfect replica of the original image held in my imagination, but rather an approximation, only 90, 80, 50 percent true to the original impulse. But, the plaster object on the table, with its physicality, makes a strong claim on reality, and the former image within, whatever its attributes may have been, fades away like a dream forgotten.

a clay object. The molds support clay when clay is at its wettest and weakest, and enable clay to assume form not otherwise possible. Although the transition to clay is seemingly a secondary step taken late in the game, it is not an insignificant afterthought, because the ceramic version of the plaster form assumes the ancient and revered dynamics of clay and fire. It is as if the form is reborn to a new life. It can become thin-walled and hollow when cast and susceptible to warping and cracking as it dries. When fired, it can be translucent, permanent, and dressed up by glaze. All the elusive, figurative metaphors of ceramics become fitting and appropriate. For example, when the form was plaster—solid, cool, and massive—it simply had a top and bottom. But, after the slip cast conversion, those same places become the lip and foot of a delicate ceramic vessel. The plaster reality recedes in the presence of ceramics with its glorious trappings of deep tradition, breathtaking texture and surface, comfortable celebration of use, and its close association with people, flowers, and food. Ceramics is always invited enthusiastically into the house. Plaster remains outside, alone, asleep in the toolshed, forgotten.

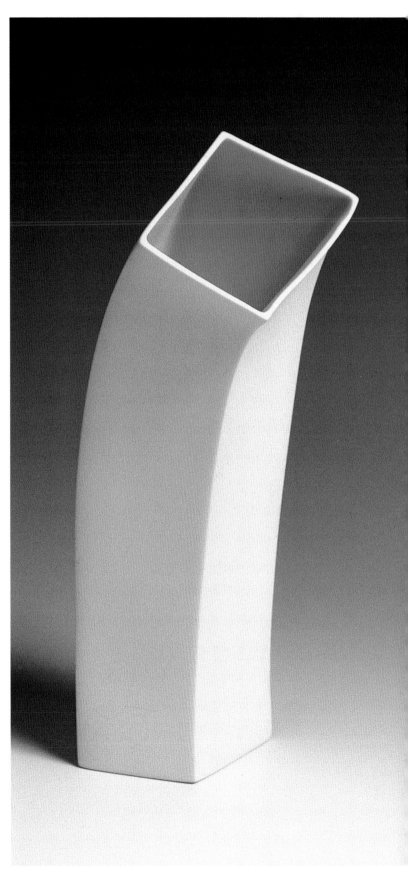

Bud Vase,
2001. Height: 6 inches
(15.2 cm). Slip-cast
porcelain; cone 6. *Photo*
by Evan Bracken.

TOM SPLETH

HANDS ON

*T*om shares his method for creating plaster molds for slip casting. He first mixes, then trowels the plaster into rough approximations of the previsualized forms. Once the forms are refined with sculpture tools, he creates the molds themselves. Finally, Tom demonstrates how he casts, releases, then joins the pieces of a porcelain vessel.

CREATING FORMS

Bowl with Squa *Foot,* 2001. Diameter: 8 inche (20.3 cm). Slip-cast porcelain; cone 6. *Photo by Evan Bracken.*

1. Mixing plaster. I use clean pails and cold, drinkable water. Weigh the plaster and water in separate buckets. For #1 casting plaster, use the ratio of 100 parts plaster to 65 parts water.

2. Sprinkling plaster into the water. I let it rest for 4 to 5 minutes. It will rest in the water like a small underwater mountain. It is getting used to being with the water. This phase is important.

3. I mix vigorously at first, to break up all lumps, then more slowly, being careful to avoid cavitation, which introduces air bubbles. After 3 or 4 minutes (depending on its freshness), I have plaster. It will inexorably set in the next few minutes in several stages. At first, I may pour it; then, when it no longer pours, I may trowel it. Both of these additive processes come to an end when the plaster masses will no longer stick to one another. Once this point is reached, the process becomes subtractive and the plaster may be carved away.

TOM SPLETH

4. Simple arrangement of boards and clamps, called a coddle, set up to make a poured cube

5. Pouring into a coddle

6. Trowel work (or "forming"), on the other hand, begins with pouring the plaster onto a board.

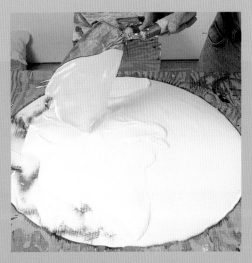

7. Too soon to trowel

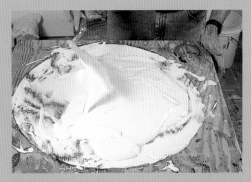

8. Troweling a form into existence. The opportunity to make form this way passes quickly—I have maybe two minutes' working time.

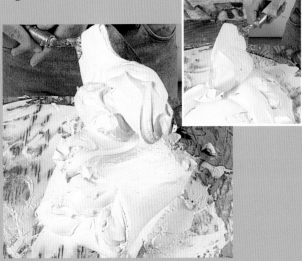

9. This is kinetic, active work, with no time to pause and reflect. Corrections can be made next time.

TOM SPLETH

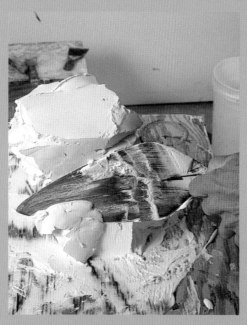

10. Subtractive phase begins. Even though the plaster is still soft enough to pick up with a trowel, if the plaster is picked up it will not adhere to the mass already troweled up. Now the plaster is modified by cutting the form with the trowel. As the plaster sets, cutting will go from quite easy to quite impossible.

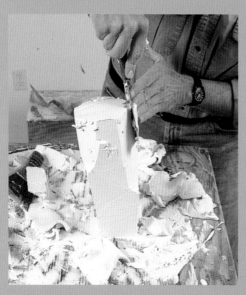

11. Carving with trowel. The plaster is getting more resistant. Once it gets warm and sets, the plaster will pop off the table easily. Before then, if I try to remove it, it will break off clumsily, leaving part of the form on the tabletop.

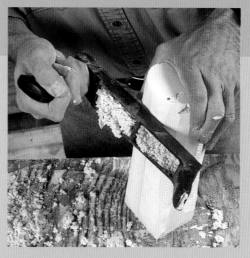

12. Carving with a Surform rasp to realize a fairly precise form

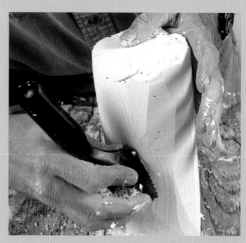

13. Diagonally crossed strokes eliminate waves and irregularities.

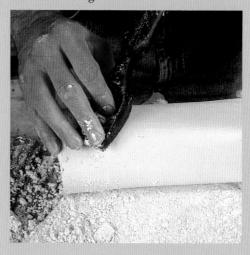

14. A towel now pads and supports the plaster form.

TOM SPLETH

15. Fine waterproof sandpaper used on the form under running water yields smooth, blemish-free surface.

16. The pour supported by the wooden setup has hardened long ago.

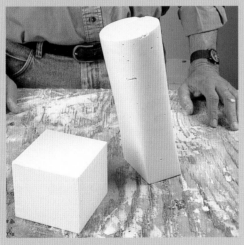

17. Two models made from plaster. Before making a mold, the model will be submerged in water until air pockets in the plaster fill with water and the fizzing stops.

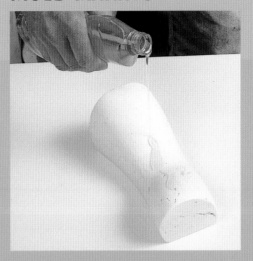

18. After pouring on Murphy's Oil Soap, the form is wiped off with soft, clean paper towels (I've found that Bounty towels don't leave fibers). After it dries, the process is repeated once or twice; this produces a surface so smooth and unblemished that the mold will come off clean.

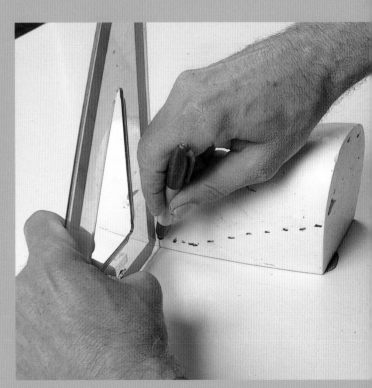

19. Using a square to determine the tangent where the mold will separate without undercuts. The model is marked all around with a pen where the square touches it.

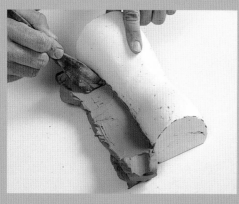

20. Building the clay to the dotted line. This is only one way to realize the mold setup.

21. Another mold setup method. This one-edged cylinder is first leveled with a lump of clay so the edge is level with the tabletop. The mold will be made using ¾-inch (1.9 cm) pink Styrofoam insulation board.

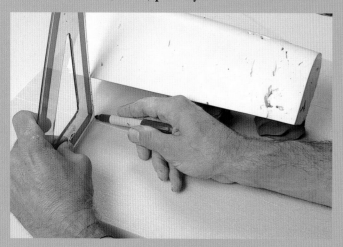

22. Using a square to mark the foam

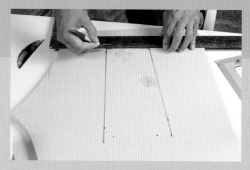

23. Marking a cutout in the foam to fit model exactly

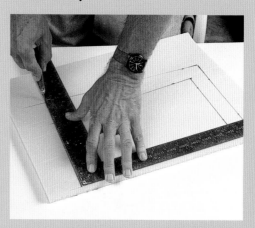

24. Cutting the foam with a sharp utility or craft knife. Excess pieces are snapped off, then a square exterior shape is cut to fit the inside of the clamped wooden setup.

25. Elevating and supporting the form with carefully measured blocks of foam

TOM SPLETH

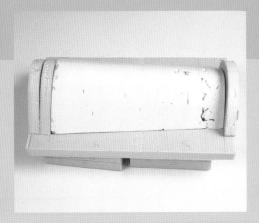

26. Adding additional foam parts in order to establish a trimming reservoir in the mold. This places the mold release along the edge of the bottom of the form (not across the bottom), which eases later cleanup.

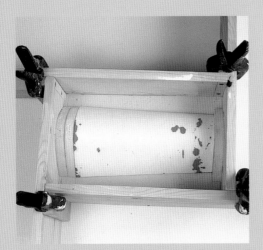

27. Wooden setup with clamps in place. Note that fine clay fills imperfections in the model. Scrape away any excess clay, then give the forms a once-over with a soapy paper towel. The clay will fall out if it doesn't stay wet.

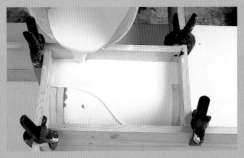

28. Carefully pouring plaster across the form from one corner. I jiggle the table to insure that bubbles are not next to the model and that the plaster flows into all the detail. Plaster is thixotropic, which means that when you add energy to it, it flows more easily. Jiggling the table makes the plaster more fluid, and the resulting mold will have greater veracity.

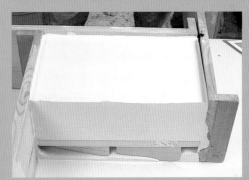

29. Removing the first half of the mold after the plaster sets

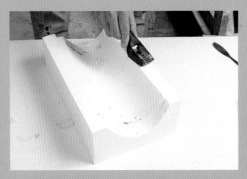

30. Scraping burrs off the edges with a Surform tool. I wait for the piece to be warm before turning it over and pulling off the other half.

There's an aspect of this work that's quite repetitive and labor-intensive. I used to resent this process. As I've grown older, I've come to consider it a great honor and privilege to do this.

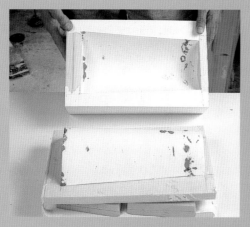

31. Removing the model. I clean up with an absolute minimum of scraping, shaving, and sanding.

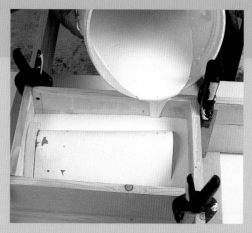

34. Pouring plaster into the mold. Pour the new plaster carefully from one corner. Jiggle the table.

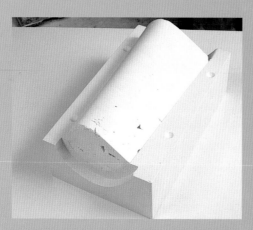

32. To replace the model in the first half, several spoon keys are gouged into the area surrounding the model, to aid in matching up the two mold halves later.

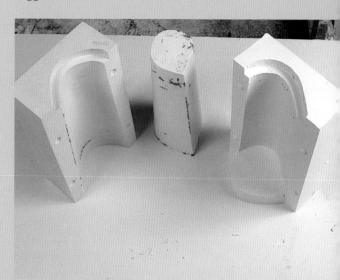

35. The completed mold with the model

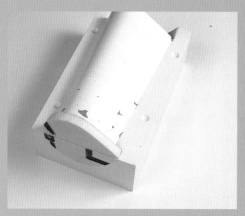

33. The foam that creates the trimming reservoir has been replaced.

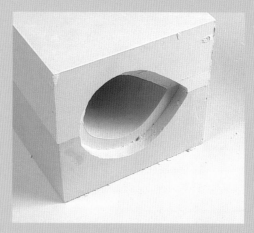

36. The completed mold, showing the trimming reservoir, ready for casting

SLIP CASTING

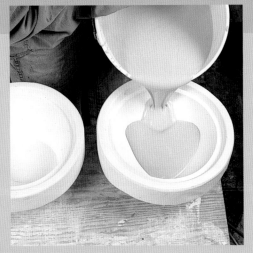

37. Open-mold casting

40. Closed-mold casting. Mold parts are banded together before pouring in the slip. This large form has a complex series of S-curves, so I pour slowly so no air pockets form. (I use a porcelain casting slip of my own devising. It fires translucent and has a smooth finish, but I'm always refining it. Slip making is a whole process in itself: everything important takes place invisibly under the surface.)

38. Once the slip thickens, it's poured out.

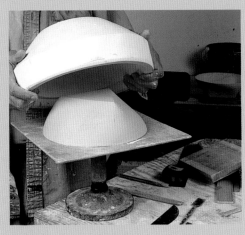

39. The cast piece releases from its plaster mold.

41. Pouring out the slip. The slip has thickened on the side of the mold. I time this period carefully. This particular mold required a tapered wooden plug in a hole opposite the pour-in hole. The plug is removed at the right time to let the slip out. The complexity of the form within required this accommodation; otherwise, the mold would not empty. Each form requires its own engineering strategy.

TOM SPLETH

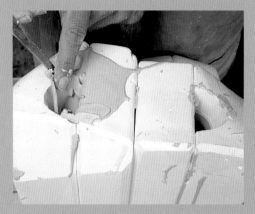

42. Trimming away the extra slip from the reservoir. The scrap is tossed back into the slip bucket. I wait patiently while the slip-cast form continues to dry within the mold, perhaps half an hour.

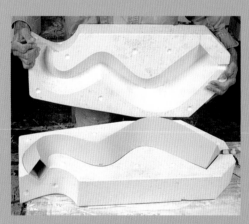

43. Opening the mold. Voila! Porcelain object.

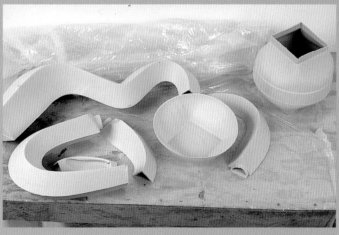

44. Several molds produce a variety of forms...

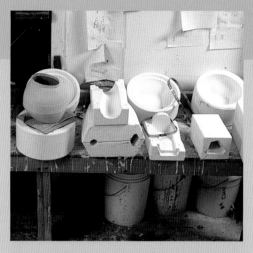

45. ...which can easily be cut, trimmed, and fitted with a craft knife.

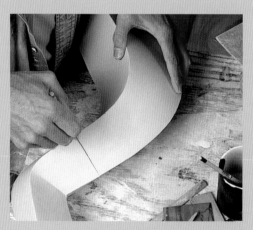

46. Cutting with a craft knife

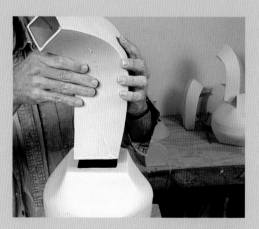

47. Bonding the cast parts. I brush on the same casting slip before joining them; scoring or abrading the adjoining surfaces is not necessary.

TOM SPLETH

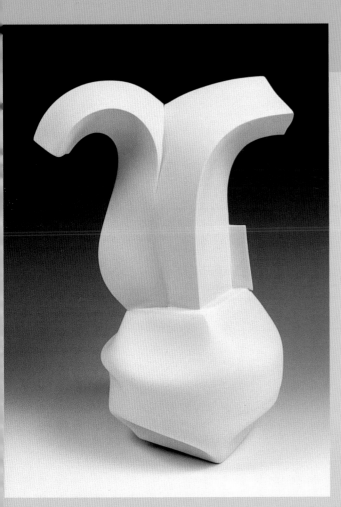

Vase Form with Two Options, 2001. Height: 13 inches (33 cm). Slip-cast porcelain; cone 6. *Photo by Evan Bracken.*

TOM SPLETH is a self-employed artist, who paints and creates slip-cast ceramic art. He was an assistant professor at the New York State College of Ceramics at Alfred University from 1978-1984 and has taught and lectured at several institutions, such as the University of Minnesota, Rhode Island School of Design, and Penland School of Craft. His painting exhibitions include Tryon Center for Visual Art, Charlotte, NC; Hickory Museum, Hickory, NC; East Carolina University, Greenville, NC; and Penland Gallery, Penland, NC. He has exhibited his ceramic work at Blue Spiral Gallery, Asheville, NC; South Eastern Center for Contemporary Art, Winston-Salem, NC; International Museum of Art, Alfred University, Alfred, NY; John Michael Kohler Arts Center, Sheboygan, WI; and Greenwich House Pottery, New York, NY. Among the grants and commissions he has been awarded are an Architectural Tile Commission, Governors Square, Raleigh, NC; Art in Public Places Project, Arts Festival of Atlanta, Atlanta, GA; and National Endowment for the Arts Fellowship. He has been a panelist at the National Conference on the Education of Ceramic Art, and on the Visual Arts Panel, New York State Council of the Arts.

GALLERY

Steve Heinemann and Anne Kraus each use casting to make form that contributes something essential to their work. I've admired the depth of their commitment to the vision that informs their work from the first moments I became aware of it, many years ago. Additionally, each uses casting for its ability to make objects of a particular kind, rather than for casting's propensity for mass production. (I would think that casting, if it weren't so per-fectly suitable for their final products, would make life more difficult for them, rather than easier.) Steve's investigation into form and sur-face transcends his methods; he is able to make things which have a mysterious presence and which never bring process to mind. It is as if his work issued forth from an ancient site or from an intelligence that is ruminating upon the nature of existence itself. Anne found the casting process nearly 20 years ago and, from the first moments of her involvement, she pro-duced ware that was uniquely beholden to areas of the ceramic tradition rarely recognized by contemporary potters. European ceramics (French, Italian, and British) bring a Western sensibility to her work that is perfectly suited to her subject matter. She is an artist who has found a format exquisitely and pre-cisely tailored to her needs, and it has enabled her to produce work of delicate subtlety and heartbreaking poignancy. Other artists I have selected use plaster and casting to make objects outside of the realm of clay. Susie Ganch is a metalsmith of uncommon intelligence who fearlessly incorporates any material that will further her ideas. As is so important to me about each of the artists I have chosen, the process in Susie's work is never her foremost consideration. The red

ANNE KRAUS,
Pilgrim Bottle, 1996.
13½ x 8½ inches
(34.3 x 21.6 cm).
Whiteware. *Photo courtesy of Garth Clark Gallery.*

TOM SPLETH

hard-candy shoe is the only cast object that I have seen her make but, without the mold, this very successful work is inconceivable. Deborah Horrell has a long history with casting processes in clay and with marvelous industrial processes that she has bent to her own devices. In a way, however, all of that has been dropped in the interest of work that provides us with a razor-sharp presentation of a focused personal vision. Her late work in pâté de verre *(a process that utilizes molds, colorful, finely ground glass, and kilns)* is a poetic discussion of still life and the painter Morandi, brought into the 21st century. In my mind her work is related to Steve Heineman's, as both artists contend with how things exist in consciousness and in the world.

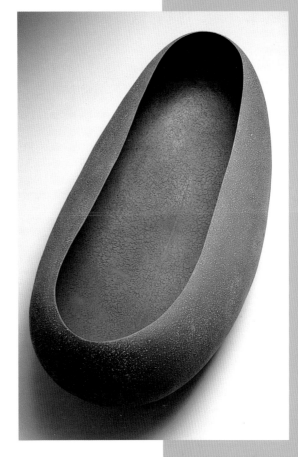

STEVE HEINEMANN, *Untitled*, 2001. 10 x 28 x 14 inches (25.4 x 71.2 x 35.6 cm). Slip-cast earthenware; multiple firings. *Photo by artist.*

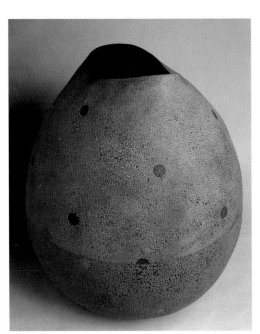

STEVE HEINEMANN, *Untitled*, 2001. 25 x 21½ x 21 inches (74 x 53.3 x 52.6 cm). Slip-cast earthenware; multiple firings. *Photo by artist.*

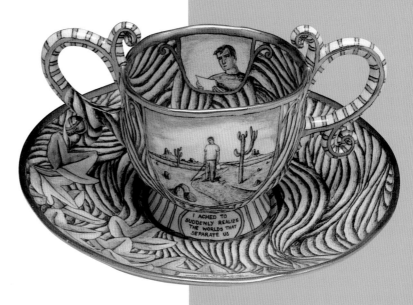

ANNE KRAUS, *The Loving Cup*, 1989. 4 x 7½ inches (10.2 x 19 cm). Whiteware. *Photo by Noel Allum.*

STEVE
HEINEMANN,
Untitled, 2001.
26 x 7 x 27 inches
(66 x 17.8 x 67.3
cm). Slip-cast;
multiple firings.
Photo by artist.

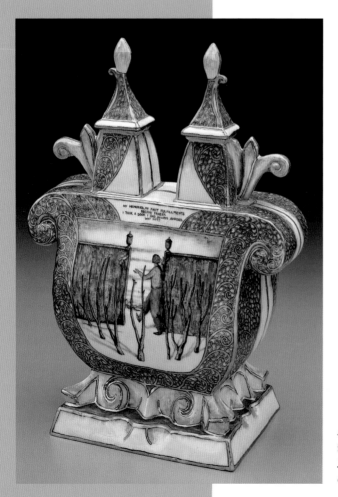

ANNE KRAUS, *Lilac Vase,* 1988. 12 1/2 x 9
inches (31.8 x 22.9 cm). Whiteware. Photo by
John White; courtesy of Garth Clark Gallery.
Collection of Gretchen Adkins.

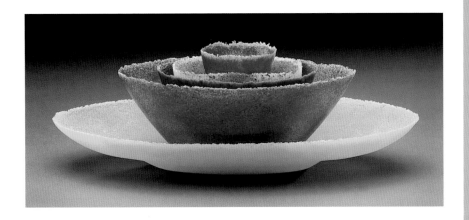

DEBORAH HORRELL, *Unfolding II.* 5¼ x 16 x 5 inches (13.3 x 40.6 x 12.7 cm). *Pâté de verre*; 01 glass frit, plaster, silica mold, glass mixture packed on inside mold; fired to 1420°F (771°C); cold-worked with diamond pads. *Photo by Paul Foster.*

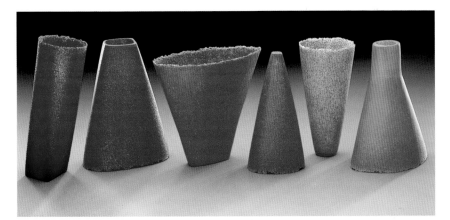

DEBORAH HORRELL, *Red Geometry.* 9 x 28½ x 6 inches (22.9 x 72.4 x 15.2 cm). *Pâté de verre*; plaster, 01 glass frit packed into silica mold; fired to 1420°F (771°C); cold-worked with dia- mond pads. *Photo by Paul Foster.*

SUSIE GANCH, *Decadence*, 2001. Women's size 6. Sugar, sterling silver. *Photo by John Littleton.*

LINDA ARBUCKLE

Linda Arbuckle masterfully marries form and surface with majolica vessels that speak intimately, often interpreting nature on a human scale through the functional object. The experience of the natural world is transformed by her vigorous palette and free brushwork, creating lively conversation with a foot, a lip, or a belly.

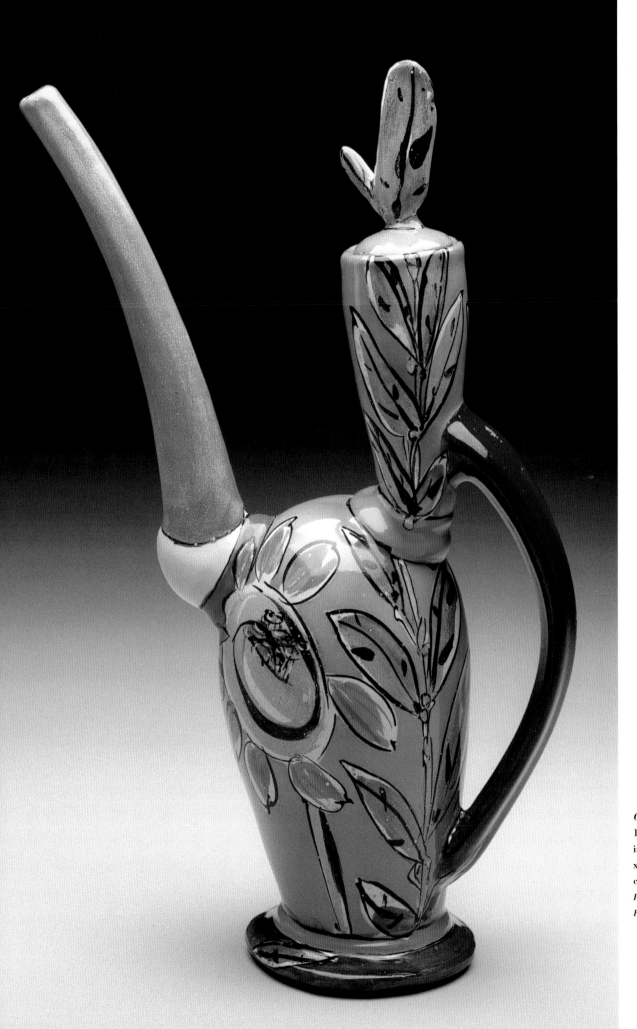

Green Balance,
1999. 12 x 4½ x 13
inches (30.5 x 11.4
x 33 cm). Terra
cotta; majolica.
*Photo by University of
Florida.*

Leaves, 1999.
4 x 2½ x 3
inches (10.2 x
6.4 x 7.6 cm).
Terra cotta;
majolica.
Photo by artist.

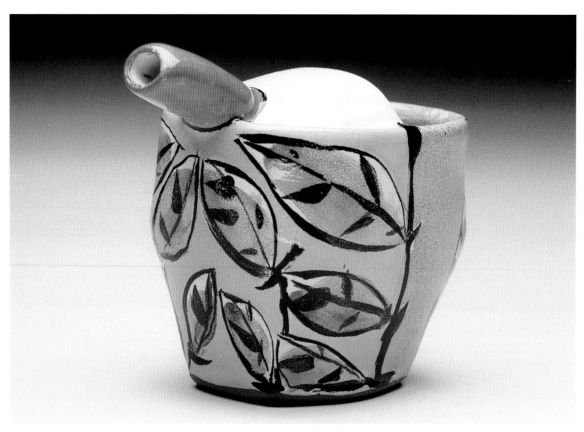

SHAMELESSLY DECORATIVE

"Technique in art is like technique in lovemaking: heartfelt ineptitude has its charms,
and so has heartless skill, but what we all want is passionate virtuosity."

ROBERT ARNESON

Bob Arneson's thoughts speak to the heart of the skill issue in art practice: technical virtuosity is best in the service of impassioned, personal thought. In making pottery with surface decoration, there are many manual skills to be honed, and yet there is still the vital work of personal expression. Today's world has many mass-produced pottery objects that are technically well-made...but devoid of heart. Our mission as artists in functional pottery is to make that piece that not only holds coffee, but speaks to the user so that a relationship is forged. I want to make that cup that someone will go to the bottom of the dish drainer to get, that favorite cup that someone cares about because it speaks to them.

Many artists invest the form with the primary message, using surface texture and color to support that intent without an additional surface vocabulary. For some, this vision is the grail. Many wonderful historic and contemporary works resonate through the primary message in the form. This is one kind of substantial design challenge.

The addition of surface information, however, can shift the role of the form from the primary site of content to a passive role as a blank canvas, or to an equal collaborator with surface to produce a dynamic interplay that delivers the content.

Forms are often simplified (yet not genericized) to allow the artist the greatest flexibil-

LINDA ARBUCKLE

ity in surface. A plain, rectangular dish, for example, allows more surface treatment options than a dish that has the shape of a fish. The artist must deal with the shape of the fish (even if it is to deliberately contrast surface with that form), which is more specific and has more constraints than a simpler rectangle. I find the most complex challenge is in making surface respond to form, or in making particular forms for specific surfaces.

An appreciation for painterly qualities, such as line quality and direction, color, use of negative space, and other conventions of painting and drawing, contributes to successful surfaces in my majolica work, yet I'm not actually making paintings that would stand apart from the pottery. A portion of the surface content is its placement on the functional object, the integration with the three-dimensional form, and the location of the object (by function, by scale) in a domestic setting, rather than isolated on a pedestal. I'm most interested in the problems of relating form and surface. To me, there is a risk that a surface truly composed as a painting—that could stand alone without the pot—would overwhelm the form rather than collaborate with it, and the viewer would see the surface as separate from the form. It's an interesting power struggle, and many days I'm striving for balance.

Since childhood I've had an attraction for color and decoration used to personalize my domestic life. Growing up in Parma, Ohio (a suburb of Cleveland), from Eastern-European roots in an ethnic neighborhood, I was influenced by the decoration and color of things like the Polish textiles and Ukranian Easter eggs I saw, with their reds, blues, greens, and yellows. From beginnings in high school home economics class, I became an active seamstress. I loved putting personal selections of color and pattern together into a functional object that I could pull into my life. Gardening is another one of those domestic pursuits with color and texture. As an avid gardener, I pay attention to what's blooming, and to the seasonal changes in color and density around me.

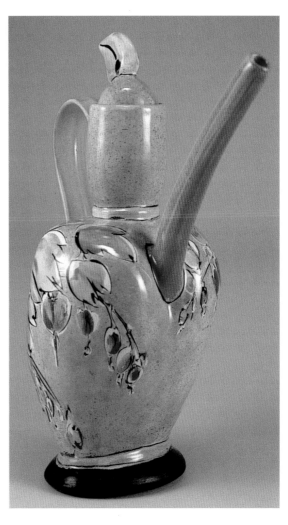

To the Heart, 2001. 11 x 6 x 8 inches (27.9 x 15.2 x 20.3 cm). Terra cotta; majolica. *Photo by artist.*

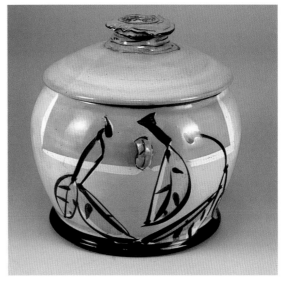

Fall with Blue Sky, 2001. 6½ x 8 inches (16.5 x 20.3 cm). Terra cotta; majolica. *Photo by artist.*

LINDA ARBUCKLE

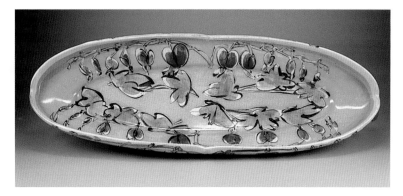

Bleeding Hearts, 2001. 24 x 8 x 3 inches (61 x 20.3 x 7.6 cm). Terra cotta; majolica. *Photo by University of Florida.*

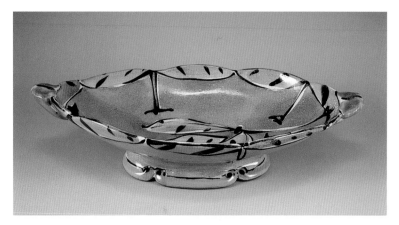

Winter, 2001. 13½ x 6½ x 3 inches (34.3 x 16.5 x 7.6 cm). Terra cotta; majolica. *Photo by University of Florida.*

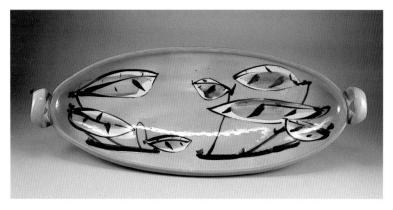

Blue with Fall Leaves, 2001. 21 x 8 x 4 inches (53.3 x 20.3 x 10.2 cm). Terra cotta; majolica. *Photo by artist.*

The color in my work has been guided by my desire to make bright, cheerful, friendly pots. When I began doing majolica, bright, stable, food-safe reds were not available. Now we have "inclusion" stains that encapsulate oxides for these colors in zirconium to make them more stable and reduce toxicity. The availability of brighter reds and oranges has been wonderful, and has helped me work with a livelier palette with more contrast.

My palette has broadened over the years. Lately I've been amusing myself with a kind of midlife crisis, thinking about seasons of the year and seasons of life, especially fall and winter. These somber subjects have had their effect on my color choices. Fall is sometimes about going down in a blaze of color, winter a more restful time, more restrained, and softer.

In school, I had two years of strong foundation that included design, painting, and drawing. I was impatient with design classes, perhaps because they were exercises in inexpensive materials (like chipboard and tempera paint) that were destined for the dumpster as soon as they were graded. I was impatient to make real, useful objects, and didn't yet have any design problems of my own to solve. Now, I am so thankful for those design classes, and find I return to basic design texts to give me new ideas on solving my artistic problems. Now design is interesting, and as a teacher I am at times visited by a student as impatient as I was.

Going to school in Cleveland has produced a lot of people who do surface work—such as Eddie Dominguez, Deirdre Daw, George Bowes, and Gregg Pitts. The city itself seemed to foster a determined individualism, colored by an ethnic love of ornament. Because avant-garde art didn't rule there, you could do whatever you wanted. We were encouraged to be very expressive in personal ways, often larded with the blue-collar practicality of work with a function, whether graphic design, hand-blown glass, jewelry, or pottery. There was a grand diversity in

LINDA ARBUCKLE

what was being made there, and I never felt functional work was any less art than those isolated objects of contemplation meant for life on a pedestal.

Graduate school helped me dig deeper, to discover who I was, what was worth making, and helped me hone my critical abilities to address in a formal, analytical sense work that was very unlike my own studio practice. Learning to look beyond one's own taste is a valuable lesson that opens up the (art) world to you. With these tools, I was better able to understand my own work, and better able to talk with other people about theirs.

There's something else inside those of us who like to decorate, something about using surface. We have a need to customize the surface, and to personalize it. It's a different sort of challenge.

Not all art that a person likes shows up directly in his or her studio work, but I do have favorites that have inspired me. I've been influenced by the edginess of Egon Schiele's line quality and compositions, and by Gustav Klimt's seductive decorative qualities. Japanese art uses negative space in a poetic way and turns the familiar into something fresh. The Minoans were good at making cheerful decorated pottery with very active, mobile surfaces. Islamic art has a sensuous character, with a supple line quality and a more-is-more aesthetic through the use of geometric/floral arabesque and calligraphic inclusions—an appreciation of diversity and change in the infinite.

From the start, I wanted to make work that spoke to me. When this happens, there's a rightness about all the parts; nothing needs to be added, and I wouldn't take anything away. The process of arriving at this resolution is one of making marks and adding two-dimensional objects that put things out of balance, and responding to what's there and working to resolve the movement or complete the action.

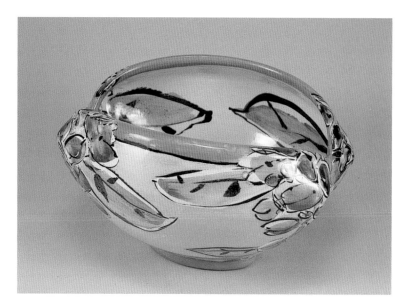

Persephone, 2001. 7 x 6 x 4 inches (17.8 x 15.2 x 10.2 cm). Terra cotta; majolica. *Photo by University of Florida.*

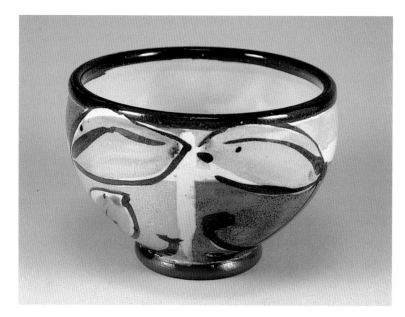

Fall, 2001. 3½ x 5 inches (8.9 x 12.7 cm). Terra cotta; majolica. *Photo by artist.*

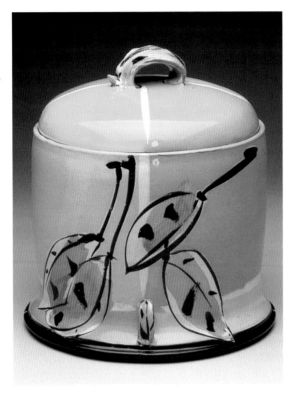

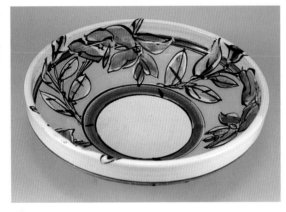

In other words, painting myself into a corner, then trying to make that work out. Decorating is like dance; it's a work in motion that builds over time.

There's only one way to grow while making art: take risks and allow yourself to make a lot of bad work, then look at it. I consider what is working well, what missed the mark or confused the reading, what needs to be adjusted on the next one. Working in series is a very useful approach because it allows me to keep a level playing field while seeing the effect of changing some of the elements. A series also allows me to exhaust my superficial ideas and get to the less apparent problems and solutions. I'm confident of my inclination to keep myself interested by repeatedly investigating new subtleties of a problem.

By solving this problem of form and surface five times or 50 times or 500 times, I get more information each time about that problem and understand new things. It's a slow, incremental understanding that is partially intuitive and involves the eye and the hand in addition to the brain.

It's important to talk to other people about your work and really entertain criticism, but in the end the artist is in charge of making the decisions about the work. I don't know how to explain to someone else what I'm seeing because the recognition comes before the words, yet the challenge of doing the analysis after I've made the piece really makes me grow. Teaching forces me to put words to my intuitions, and I learn a great deal from talking with students about work.

Furniture maker Wendell Castle says, "If you're in love with an idea, you're no judge of its beauty or value." Well, there's blind love, and there's being willing to examine something. I have to be passionate about my creative idea, but open to the pursuit of it—not fixated on one manifestation. Someone described artists in their working habits as either hunters or farm-

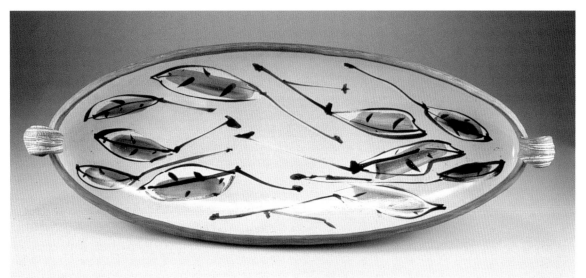

Separating, 1999. 20½ x 7½ x 4½ inches (52.1 x 19.1 x 11.4 cm). Terra cotta; majolica. *Photo by artist.*

ers. Hunters strategize about where that idea or solution might be, what it might look like, what its habits are, and stalk/research until they spring upon the fully formed beast. Farmers, on the other hand, begin with the small manifestation or seed and tend it so that it grows incrementally into its full form, gradually, over time. Both strategies take much hard work. I find I'm a farmer, more comfortable with slow, cumulative progress.

Learning to decorate means ruining some of the forms you are trying to enhance. Taking risks and failing has been helpful in the long run, as it teaches me that these disappointments are just things in need of adjustment and continued effort. As a teacher, I've seen that some students are really talented, but unwilling to leave the comfort zone of their skill. Some of my most inspiring teachers were pluggers who worked constantly, were willing to adjust ideas that didn't work out the first time, and evolved as artists over time. That growth from determination, learning, and persistence was more reassuring to me than the work of someone who appeared a mercurial talent.

Studying to be an artist is learning about learning. Many resources exist for learning about design principles, use of color, and investigating art that's already been made. The synthesis

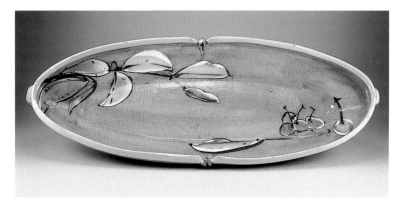

of this kind of study and personal vision is a lifetime pursuit. I find surface decoration on pottery to be a rich intellectual challenge that is continuously reinvented for me in my studio.

Majolica offers a special kind of accessibility and warmth from the hand of the maker to the eye of the beholder. It's a material for those willing to be seduced by beauty, line, and color, and willing to pass that along.

Fallen Fruit (platter), 2001. 23 x 9 x 3½ inches (58.4 x 22.9 x 8.9 cm). Terra cotta; majolica. *Photo by artist.*

HANDS ON

*L*inda prepares for majolica paint-ing by first showing how to achieve the best glaze consistency for dipping. She plans the design care-fully in relation to its form, applies special glazes and wax resist to peripheral areas, then goes on to illus-trate the fine points of ceramic oxide paints, as well as her techniques for confident brush control.

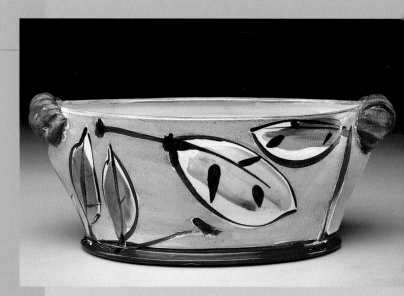

Oval: Green with Envy, 2001. 12 x 4½ x 4¾ (31 x 11.4 x 12 cm) Terra cotta; majolica. *Photo by Evan Bracken.*

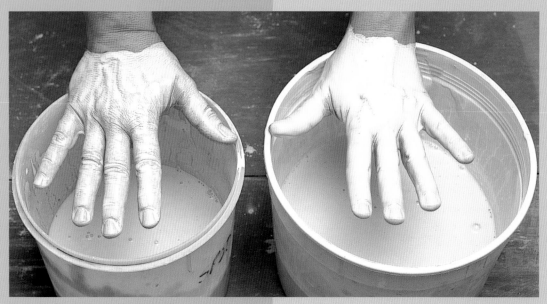

1. Compare the thinner coating of the same batch of glaze deflocculated (on the left) with the thicker, more opaque coating of the flocculated portion on the right. When you stir a deflocculated glaze that seems to be the appropriate consistency for dipping, it will run off your hand, and the tone of your skin will show through the glaze. When you stir a flocculated glaze of dipping consis-tency and lift your hand out, the glaze covers your hand in an even layer and remains opaque even after the excess has run off.

If newly made, or sitting for more than six weeks, the glaze should be sieved through a fine screen (100- or 120-mesh), then adjusted for thickness, flocculated, and readjusted to the consistency of half-and-half cream. It's easier to get an even coating of glaze if the liquid glaze is floc-culated. The prepared glaze should be adjusted to give you about a postcard's thickness of glaze coating on your work.

LINDA ARBUCKLE

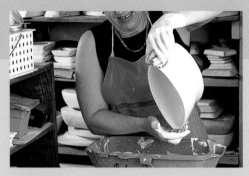

2. Dipping an oval form in a long, rectangular bucket. Dip barely damp pots into the glaze for perhaps a count of three. The time depends on your clay body, bisque temperature and time, thickness of the glaze, and thickness of the piece.

The handles and bottom of the piece shown here are finished with terra sigillata, colored with crocus martis when bone dry, then bisque fired. A patina of titanium dioxide and flux was applied and wiped off the handles, then the handles and bottom were waxed before the form was dipped in glaze.

3. Sketchbook pages. Because I like the thrill of the chase and responding to what I have in front of me as the surface develops, I rarely make a complete drawing of the surface decoration of a pot. However, I feel it is very important to make basic design decisions about what you want to accomplish visually before you begin. What is the general feeling you want the work to have? How do you want to move someone's eye around the work? How can you compose active negative spaces? What part of the "geography" of the form do you want to reference: the long axis, the

verticality, the fullness of a curve, the buoyancy of the form, the place where the spout joins the body, or the forward thrust of a pouring vessel?

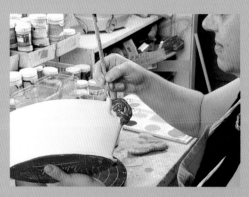

4. Touching up glaze. A soft brush can be used to pat extra glaze on thin or bare spots.

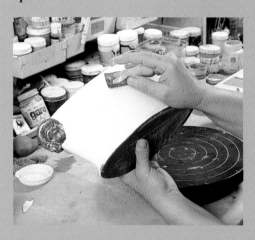

5. Sanding down a raised drip of glaze before decorating. Once the glaze is dry, you may use your fingers or fine sandpaper (320- or 400-grit wet-and-dry sandpaper works well) to remove any large lumps or bumps of glaze.

The dust from sanding must be removed so it doesn't wad up on your brush during decoration. If you have access to a spray booth, this would be a good place to blow off that dust without getting it into your environment. The glaze does not contain toxic materials, but is a dust and silica hazard if inhaled. Other ways to remove dust would be to gently use a very soft brush over a bowl of water to catch the dust, or gently pat with a barely damp sponge.

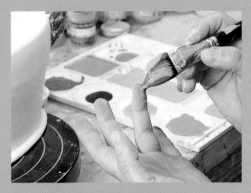

6. Loading the tip of a brush with another color. Majolica decoration is done with ceramic oxides or commercially prepared ceramic coloring stains. Decorating colors for majolica must be mixed with a flux, such as Gerstley borate or frit, to help the materials melt into the glaze surface. Commercial products are now available for those who do not wish to mix decorating colors; several manufacturers have developed products ready right out of the jar for decorating on majolica. Some of the single-application underglazes (e.g., One-Strokes, Velvets) will work as majolica decorating colors, but it's wise to test first, as some are too refractory (resistant to heat) and do not melt sufficiently for use on top of majolica.

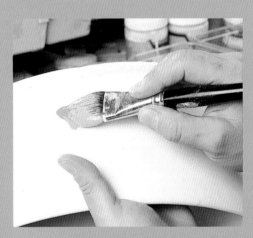

7. Begin a stroke using the tip of the brush. In majolica, brushwork will show thick or thin areas that telegraph the movement and speed of the brush, but the color will be the same throughout. If you want to see color variation, you may want

to try loading your brush with more than one color by dipping the brush in a major color, then applying a small amount of a complementary (contrasting) or analogous (related) color to the edge or tip of the brush. These colors will blend with the stroke of the brush. The longer you use the loaded brush, the more blended the colors will become. With complementary colors, this will result in duller, more neutral colors (e.g., red and green will go toward brown). With analogous colors, it will result in an intermediate color (e.g., blue and green will go toward blue-green). Turning the brush with each stroke will give you a fresh side of color and allow several brush strokes before you need to wash out your brush and reload.

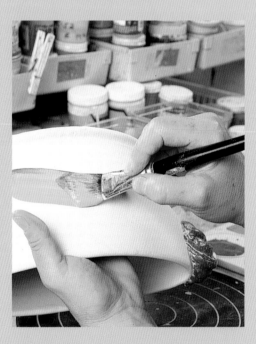

8. Laying in areas of color for the foreground motifs. Press down on the brush as the stroke progresses to widen the stroke and use the body of the brush. Experiment with beginning a stroke with the tip of the brush, then pressing down to use more of the belly of the brush as you proceed through the stroke, then lifting up to finish the stroke with the tip of the brush. Practice making confident marks; remember to breathe while you work!

LINDA ARBUCKLE

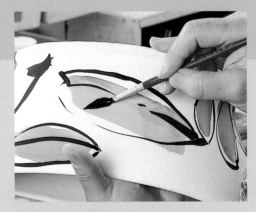

9. Change to a liner, Japanese, or small dagger liner brush to do the black line work that develops the motif shape.

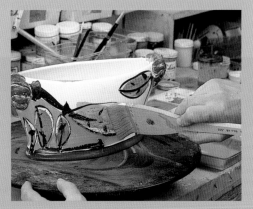

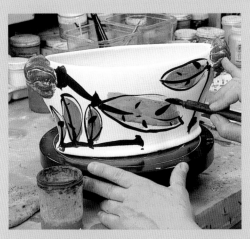

10. Using a brush dedicated to liquid wax resist. Resist will protect the motifs from the later background application.

12. Once all the motifs and the bottom stripe are wax-resisted, apply slightly thinned color with a broad, soft brush. Complete one area before moving on to the next. Because brush directions tend to show in majolica decoration, painting around the motifs would leave evident directional marks. You can either develop these directional marks into a texture (e.g., vertical stripes), or use a broad, soft brush across wax-resisted motifs to crosshatch the ground color and make it look smooth. Make sure you mix enough thinned color for the entire background. If you're not happy with the smoothness of the ground application, you can also go back and sponge color lightly onto the ground, which gives a textured rather than a brushy look. This will leave small blobs of color on top of the wax-resisted areas.

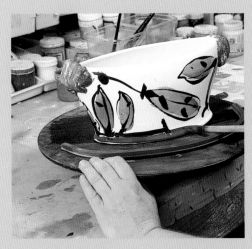

11. Using a flexible rule as a guide to band the bottom of the form

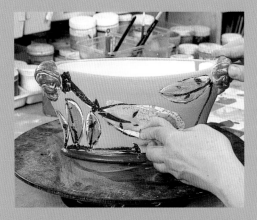

13. Picking up spots of background color left on top of the wax resist with a small, damp sponge. If left on the wax, the color would be evident in the fired work.

LINDA ARBUCKLE

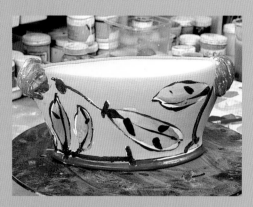

14. The unfired, decorated oval form. Firing usually takes about 12 hours. The kiln is turned up slowly until the wax is burned off [around 600° F (316° C]. After that it is still turned up gradually to red heat, at which point it can proceed a bit faster. In very small test kilns, you may not need to turn the kiln all the way to high for a 12-hour firing cycle. I always use visual cones in front of the peephole. Kiln sitters vary. Computer kilns are a wonderful tool, but it's the effect of time and temperature that determines when things are adequately melted.

15. A sampling of useful brushes. Brushes with soft bristles that have some spring when wet are good for majolica decoration. This includes many Japanese brushes, watercolor brushes, and hake brushes.

ABOUT THE ARTIST

LINDA ARBUCKLE lives in Micanopy, FL, and teaches at the University of Florida, in Gainesville. For many summers she has taught workshops and lectured at such institutions as Haystack Mountain School of Crafts, Penland School of Crafts, Mendocino Arts Center, Santa Fe Clay Co., Arizona Clay, Archie Bray Foundation, and the University of Wales Institute Cardiff, UK. In 2001 she was an invitational attendee at ICRC: Interpreting Ceramics, Research Collaboration, at the Victoria and Albert Museum, London, UK. That same year, she was a lecturer and participant in an international pottery demonstration in conjunction with the World Ceramics Exposition 2001, in Yoju, Korea.

Her awards include an NEA Visual Artists Fellowship Grant, and she has juried several shows. Her work is part of many collections, including the City of Orlando, Orlando, FL; NationsBank Corporate Headquarters, Charlotte, NC; Frederick R. Weisman Art Museum, University of Minnesota, Minneapolis, MN; and the Museum of Decorative Arts in the Arkansas Art Center, Little Rock, AR. Her work has appeared in numerous ceramic books and magazines, including *The Contemporary Potter* (Rockport Publishers, 2002), *500 Teapots* (Lark Books, 2002), and *Ceramics Monthly*. Recent exhibitions include the Vermont Clay Studio, Waterbury Center, VT; Kentucky Art and Craft Foundation, Louisville, KY; Santa Fe Clay, Santa Fe, NM; George R. Gardiner Museum of Ceramic Art, Toronto, Canada.

GALLERY

These majolica artists have all accepted the challenge of making functional pottery and using traditional materials with a personal investment. I find their works provocative and engaging. Stanley Mace Andersen was one of the first contemporary role models I had of a "real" potter, working as a studio artist in majolica. His work has a lively, active tone and durable, functional shapes that I use every day to bring cheer to my table. Bill Brouillard's large presentation majolica platters are only a portion of the ways he works in clay. I've always been intrigued that a successful high-fire potter would extend his range into figurative majolica work at heroic scale. Alan Caiger-Smith is a master of pottery form and surface. His brushwork dances on the forms, responding to the shape but making new choreography of its own. In addition to his inspiring visual work, Alan has written a number of important books and inspiring articles about majolica, brushwork and decoration, and luster-ware. Bruce Cochrane is another established high-fire potter who has taken a vacation in majolica with good result. His use of analogous color for visual blending on strong forms results in work of interest and quiet certainty. He effectively makes use of terra cotta by often playing off the red color of the clay with cool blues and greens on the fat majolica glaze. Andrea Gill was doing majolica in Kent, Ohio, when I was an undergraduate student, and I've been enjoying her work since. She often explores both poles of potential relationships between form and surface; surface may help describe the form, or surface may camouflage or contradict the form, making it difficult to tell what is really dimensional and what is painted. Steve Howell has been developing a colored majolica base glaze, with decorating colors laid on top of that base. There is a drama to his color that's echoed in many of his forms. His black majolica is a nice foil for the soft colors on top of it. Matthias Ostermann uses majolica materials in a unique way. He's developed a palette of deep, saturated, gem-like colors and uses a white, sgraffitoed line to define his images. While most people try to eliminate the powdery quality of the raw surface colors, Matthias has turned this into a virtue and blends the color in expressive

LIZ QUACKENBUSH,
Bumpy Creamer,
2001. 4 x 5½ x 3 inches (10.2 x 14 x 7.6 cm). Terra cotta; hand-built with applied bumps; majolica; gold lustre; cones 04, 017.
Photo by Dick Ackley.

LINDA ARBUCKLE

BILL BROUILLARD,
Dogma, 2000. 4 x 26 inches
(10.2 x 66 cm). Majolica.

WALTER OSTROM,
Jealous Potter, 2000.
11¾ x 4¾ inches (30
x 12 cm). Assembled,
wheel-thrown, and
press molded
elements; terra sig-
illata; majolica with
stain. *Photo by Ying-
Yueh Chuang.*

ways that are akin to work with pastel chalks.
Walter Ostrom's encyclopedic knowledge of
historic ceramics colors his work in subtle ways.
I enjoy the direct forms, the playful quality of
his surfaces. In addition to the contribution of
his own voice in low-fire work, he's been an
inspirational educator, particularly of low-fire
potters doing surface decoration. Liz
Quackenbush really embraces decoration and is
fearless in her use of luster. Her work is rich,
bold, and engaging. I'm charmed by her flower
bricks and the way the pot and the blooms
work with each other. Wynne Wilbur's forms
are often altered, with an elongated axis. On
this ground, she plays with how much of a
motif the viewer needs to see to make sense of
it, making negative space an equal player. Her
combination of terra sigillata surfaces with the
fat majolica glaze contrasts the qualities of both
of those materials.

**ALAN CAIGER-
SMITH,** *Large Jar.*
14 x 11 inches
(36 x 28 cm). Red
earthenware; tin
glaze; copper-silver
reduction lustre.

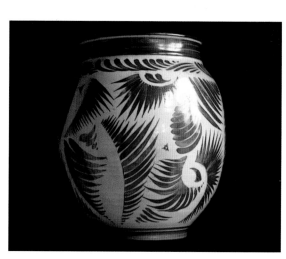

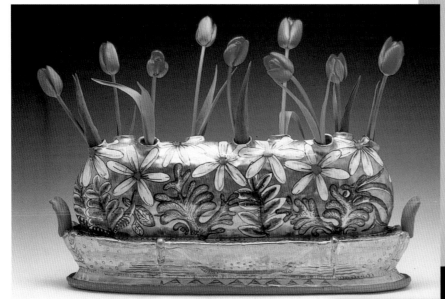

LIZ QUACKENBUSH,
Daisy Vase, 1999. 8 x 16 x
4 inches (20.3 x 40.6 x 10.2
cm). Hand-built; majolica;
terra sigillata; gold lustre;
cones 04, 017. *Photo by Dick
Ackley.*

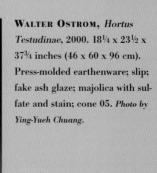

BRUCE
COCHRANE,
*Elevated Serving
Dish*, 1993.
Thrown and
reconstructed.
Photo by artist.

WALTER OSTROM, *Hortus
Testudinae*, 2000. 18¼ x 23½ x
37¾ inches (46 x 60 x 96 cm).
Press-molded earthenware; slip;
fake ash glaze; majolica with sul-
fate and stain; cone 05. *Photo by
Ying-Yueh Chuang.*

LINDA ARBUCKLE

MATTHIAS OSTERMANN, *Woman With Skirt,* 1999. 24 x 7½ inches (61 x 19.1 cm). Thrown and altered earthenware; majolica glaze; brush drawing; wax resist; wet-blended colors; bisque cone 06; glaze cone 05. *Photo by Jan Thijs. Courtesy of Prime Gallery, Toronto.*

ALAN CAIGER-SMITH, *Fin-Handled Jar.* 9¾ inches (25 cm) high. Red earthenware; tin glaze; in-glaze silver-cobalt reduction lustre.

ANDREA GILL, *Tuscan Figure,* 2001. 29 x 16 x 14 inches (73.7 x 40.6 x 35.6 cm). Slab-built using press molds; majolica and other low-fire glazes; bisque cone 05; glaze cone 06. *Photo by Brian Ogelsbee.*

STANLEY MACE ANDERSEN, *Teapot,* 2001. 9 x 8 x 4½ inches (22.9 x 20.3 x 11.4 cm). Wheel-thrown red earthenware, hand-built spout and pulled handle; majolica; cone 03. *Photo by Tom Mills.*

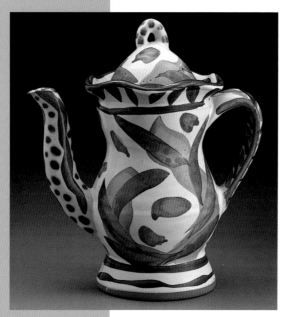

LINDA ARBUCKLE

STEVE HOWELL, *Teapot.* 14 x 17 x 6 inches (35.6 x 43.2 x 15.2 cm). Red earthenware; color-saturated majolica. *Photo by Randall Smith.*

DALE PEREIRA, *Platter,* 2001. 36 x 7 x 5 inches (91.4 x 17.8 x 12.7 cm). Majolica. *Photo by Vince Noguchi.*

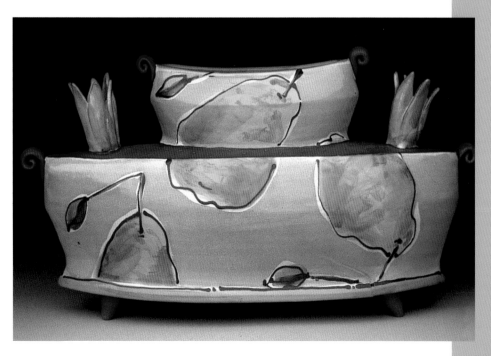

WYNNE WILBUR, *Tumbling Pears Flower Brick,* 2000. 8 x 16 x 5 inches (20.3 x 40.6 x 12.7 cm). Thrown and altered earthenware, slab and hand-built additions; terra sigillata; majolica; bisque cone 05; glaze cone 03. *Photo by artist.*

LINDA ARBUCKLE

NICK JOERLING

Nick Joerling's altered, wheel-thrown pots make singular presences. Each exuberant vessel stands as a statement of form, yet engages the viewer as if it were a magnetic personality. Complemented by subtle and witty brushwork, his energetic, fluid forms are joyfully confident interpretations of function.

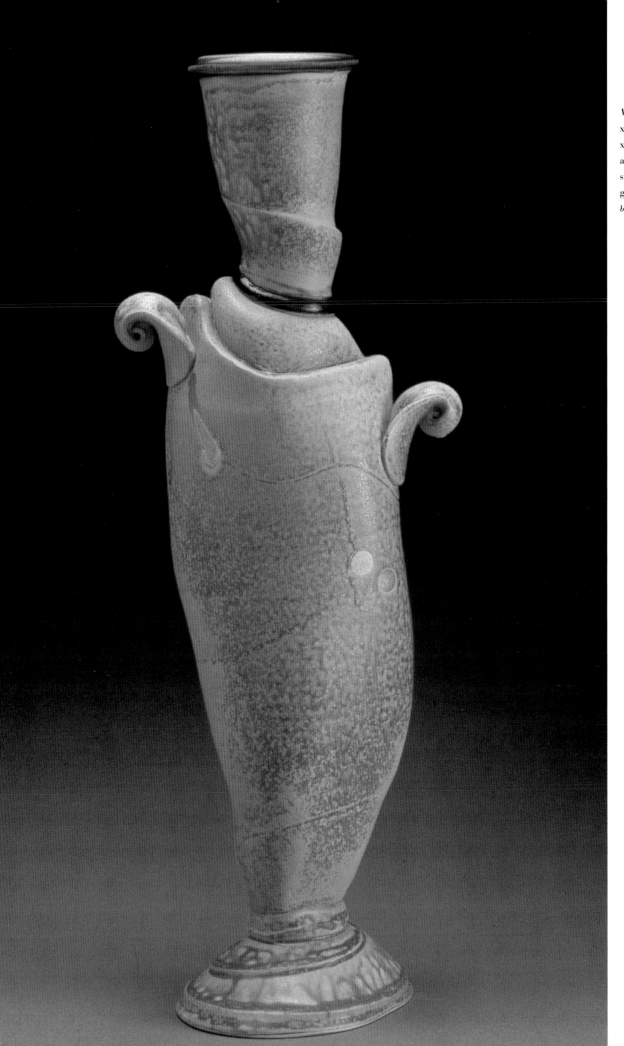

Vase, 2002. 22 x 4½ x 6 inches (56 x 11.4 x 15.2 cm). Thrown and altered stoneware; cone 10 gas reduction. *Photo by Tom Mills.*

THE ALTERED POT

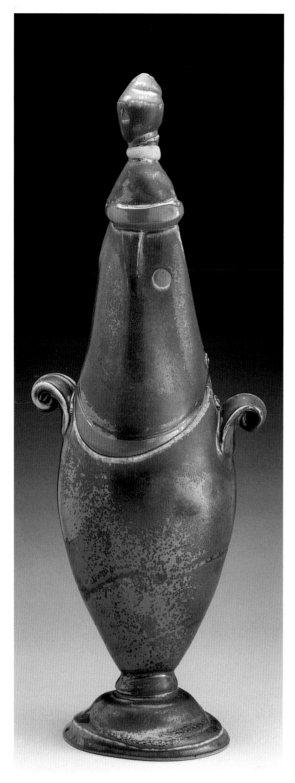

Jar, 2001. 15 x 4 x 5½ inches (38.1 x 10.2 x 14 cm). Thrown and altered stoneware; cone 10 gas reduction.
Photo by Tom Mills.

Everything I make comes from the wheel. I periodically question myself about this, especially when it comes to pots that are so changed that they leave little trace of being wheel thrown. But handbuilding these pots from inception—by coil or slab—would mean giving up the liveliness that can be put into the clay by throwing, and it's this lively quality that I'm drawn to. There's something about starting with the circle (maybe I'm being too romantic)—the potency that's in the circle—that gives altered pots coming from the wheel their particular flavor. Altering pots by cutting, stretching, and darting isn't a way to circumvent learning to throw. Making good round pots is a life's challenge, and you'd have to be either inexperienced or foolish to think otherwise. A good altered pot has to have buried inside it the skeleton of a well-made round pot. Why one would alter pots was explained nicely by Tom Spleth in a recent catalog essay: "As work departs from thrown forms that simply refer to pots and pottery, it gains the ability to describe forms in nature, suggest the vulnerability of the figure, and express the asymmetry found in human experience."

Initially I was after a very different pot than the trophy jar in progress on page 116. Starting with a closed form, I was going to square it, cut a lid into the top, and put it up on feet. But as I distorted the pot by throwing it out on the table (it distorts but doesn't collapse because of the air trapped inside), I noticed that the most interesting thing that was happening was in the part of the pot that had been touching the bat. Because that part of the clay had not been exposed to the air (these pots remain on the bat while drying), it remained wet and therefore plastic, while the rest of the pot dried to a point beyond being tacky to the touch. The wet section ballooned in an unanticipated way. How to show that off had me turning my original pot idea upside down.

With new work I typically do some very brief sketching, not sketching as rendering, but just

NICK JOERLING

doodling. That process sends me to the wheel, but after that there's a lot of information coming from the clay. I've always liked the definition of a handshake—giving and receiving at the same time—and to me it's an image that's appropriate for working in any material...it's about listening. I don't do as much drawing as I used to, but I always keep a sketchbook open in the studio. It describes an attitude: it's that sense of being in the studio with the metaphoric windows open so that chance can blow in.

After I've formed the basic shape, I sometimes use a board to articulate the form and lay out the area that will become the lid. The board is a Masonite product called Duran, which is also what my bats are made of. It's a smooth, blank surface with the seemingly contradictory quality of being slightly porous but water resistant. It doesn't leave any marks and it gives the clay back. I've cut where I've marked the lid but leave the parts to dry to a leather-hard stage together.

So much of working the way I do—making labor-intensive pots with lots of tablework—has to do with when I most enjoy touching clay. Many potters love the wet stage. I like clay leather-hard. The clay takes light so nicely then—it absorbs and softens it—and it's the point when the clay is most like our bodies. It accepts touch and slightly pushes back.

The disc that I've thrown on the wheel is stretched and domed to become the foot. I'd be nervous about the character of the clay in the foot being different from the body of the pot, except for the fact that what happens in the foot (the clay opening and stretching) also occurs in what has become the lid.

When I can handle the lid without distorting it, I add a coil to serve as a flange. I want to put the lid back on the pot body as soon as possible, but not before the newly formed flange has dried sufficiently, so that it won't adhere to the pot.

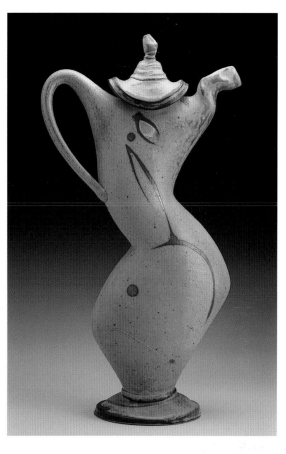

Teapot, 2001. 15.5 x 3.5 x 8 inches (39.4 x 8.9 x 20.3 cm). Thrown and altered stoneware; bisque cone 08; glaze cone 10. *Photo by Tom Mills.*

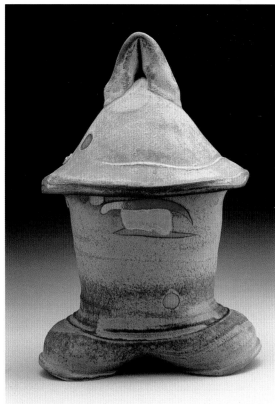

Hut Jar, 1999. 12 x 4 x 7 inches (30.5 x 10.2 x 17.8 cm). Thrown and altered stoneware; bisque cone 08; glaze cone 10. *Photo by Tom Mills.*

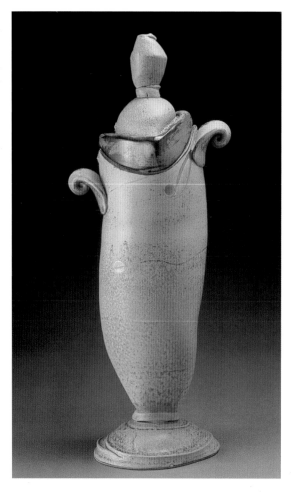

With smaller pots of this sort, I place the pot on the foot and then add handles. If I were making this pot on a larger scale, I'd worry that my working the clay might jeopardize the connection between body and foot, so I put the handles on first. This spot on the pot, this connection, is important. It is, of course, that precarious balance point, the still point, and it enlivens and activates everything that takes place above it.

There was an illustration I came across years ago, in a book I think either by Gombrich or Arnheim, that I found fascinating. It was a single line drawing of a Greek column, very plain, with a simple two-step base and corinth, and a plain column in between. What the author did was register eye movement as people looked at the drawing, and then dotted the places where the eye lingered. You had lots of dots around the corinth and the base, especially where there were corners, and very few dots through the column. The point was that our eyes love and search out the details, that we return again and again to sip at the particularities. Handles, connections, what we might do with edges—are

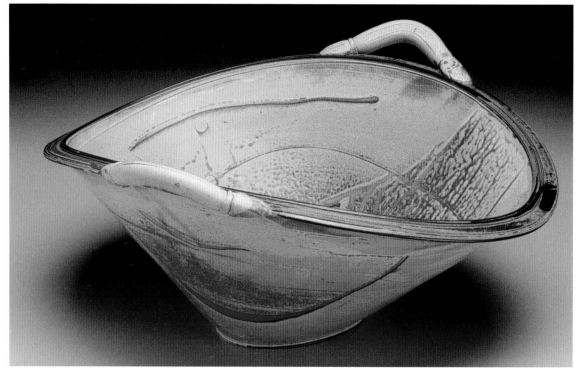

those lingering places we put into our pots.

So many times when I'm struggling with new work, I finally get the basic form to be acceptable (for the time being), I'm tired, I'm ready to quit, and I think to myself, okay, put the handles on and go home. And of course I bring the old handle to the new form and it's not right, and then off I go, trying to find additions that make sense.

When I'm assessing work like the two pots that appear in the Hands On section—pots with parts—I'm looking for a pot that has a sense of unity. That doesn't mean you give up mystery or contrast, but that things add up and make sense together. It's helpful for me to think in terms of a conversation among the parts. Sometimes when I look at the components of a pot (my own or others'), it can seem as if the parts are like individuals seated in a restaurant at separate tables, all engaged in private conversations. How do you get them to sit at the same table? But I also don't want the conversation to be predictable—to go from foot to pot body and think, "oh, of course"...from handle to knob, "oh, of course." That's a boring conversation. What I'm hoping for is the sense that the parts are talking about the same subject but are adding to it in slightly different ways.

The last thing I do in the making stage is to key the lid and add rubber bands to keep the lid pressed into the pot while it's drying. There can be some warpage in the foot, so I sand it against a flat surface when it's thoroughly dry.

Making pots is such a long process, from making the clay to firing the kiln. As a beginner I thought you had to like every part, but now I can see that you can pick your spots. You don't have to love every step, but you do have to bring your curiosity along to all the different stages. I like to put pots together and decorate and glaze.

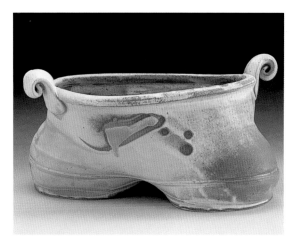

Serving Dish, 2000. 5 x 6 x 13 inches (12.7 x 15.2 x 33 cm). Thrown and altered stoneware; bisque cone 08; glaze cone 10. *Photo by Tom Mills.*

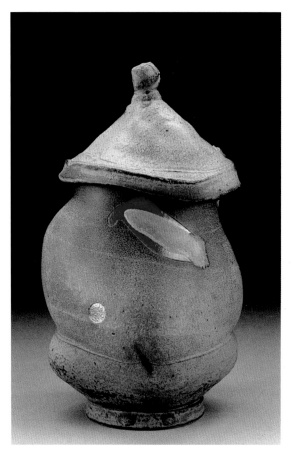

Jar, 1999. 7 x 3½ x 4 inches (17.8 x 8.9 x 10.2 cm). Thrown and altered stoneware; cone 10 gas reduction. *Photo by Tom Mills.*

When I was in graduate school, I was salt firing. After school, having the good fortune to rent a studio that came with a gas kiln, I was interested in using glazes in a manner that produced the same effect that had attracted me to salt firing—that varied, modulated, somewhat unpredictable surface. That interest led me to thinning the glazes, and, on the same pot, vary-

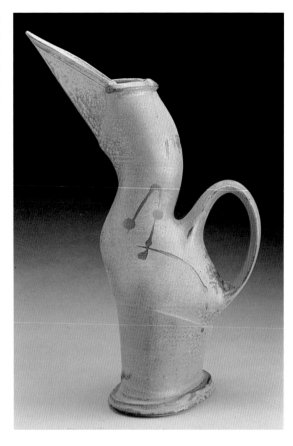

Pitcher, 2000. 14 x 4
½ x 6 inches (35.6 x
11.4 x 15.2 cm).
Thrown and altered
stoneware; cone 10
gas reduction. *Photo
by Tom Mills.*

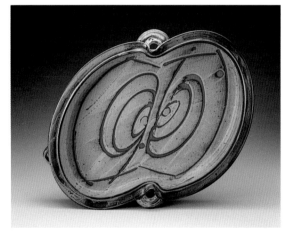

*Baking/Serving
Dish*, 2000. 2½ x 13
x 14 inches (6.4 x 33
x 35.6 cm). Thrown
and altered
stoneware; cone 10
gas reduction. *Photo
by Tom Mills.*

ing the thickness of application. Atmospheric glazing (wood and salt/soda) seems always to add interest to the form; but when you dip (or spray) the pot, you have to be conscious of getting glaze on it in a way that most complements the form. I know very little about glaze chemistry, but I like the activity of glazing. Varying the thickness of the glaze gives the pot surface movement. I want to show how the glaze travels across the pot, from that thin skin that so nicely reveals the clay, to the fat opulence of a thicker application.

I'm not someone who likes glaze testing, but I always do some experimentation, if not with new glaze tests, then with familiar glazes on new forms. A few years ago, wanting to be more emotionally involved in what was coming from the kiln, I began adding colors. Something I'm learning is that color has scale: some glazes please my eyes across a broad scale range while others are limited. I have a potter friend who says it's five years after he introduces a new glaze before he knows it. The specific number of years isn't important: the point is the value of staying with a glaze—or clay, or form, or method—over a period of time. It's one of the things the studio teaches—the understanding that things take time—which is so contrary to what we hear from our culture.

Decorating pots is when I am most at play. Some of that has to do with posture: I'm standing, moving about—decorating has my body in motion. I bisque the pots so I can be carefree in my handling. The kind of brush decorating I do serves a couple of purposes: it's a way to bring color to a pot, and it adds, or accentuates, movement. With some pots the brush marks are like those movement lines that appear in cartoons. There was a time that I made a very serious pot, and then tried to rescue it with loose, gestural brush marks, but over the years I think the forms have caught up to the animated quality I've always liked in my sketchbook drawing and brush decoration.

I like room around a brush stroke. I couldn't do that beautiful patterning that other potters do to save my life. A couple of my favorite reminders about decorating come from Matisse and Paul Klee. Matisse tells us that every mark that's added diminishes the one that preceded it. This is not a prescription—it's just noticing what marks do to one another. And Klee: a line is just a dot out for a walk. It makes sense that I decorate sparingly. Many of the pots have gotten complicated, and in order to keep a clarity of form, I have to brush decorate with restraint. Actually, I begin my decorating when I'm throwing, putting marks into the clay, and then I add more marks while putting the pot together, so that the brush decorating I do is simply reacting to and finishing off what's already occurred in the clay.

I glaze the pots first with a thin shino glaze, then decorate with the wax resist. I use a commercial wax that's kind to my brushes and cleans up quickly with hot water. I frequently add color to the interior area that's formed between brush strokes, and wax over that so there's a strong contrast between that color and the final glaze. A strong, assured brush stroke with clear definition is what I'm hoping for, and a crisp edge with some definition—what Mimbres decoration also embodies—is what's appealing.

One of the rewards of being in the studio over many years is the slow understanding of what the work is about. I like the lag time, first the working, and then the catching up to the work: it's like having the cart before the horse, and having the horse periodically nudge aside the tarpaulin and sniff what's inside. My pot's source is most often you and I, our bodies. It's where my cues come from: dance, people seated on a park bench, the cleaveage that forms on the inside of a bent elbow. But I want the pots to refer to the nuanced space between the clay and human forms; when the pots do this successfully, they are animated and

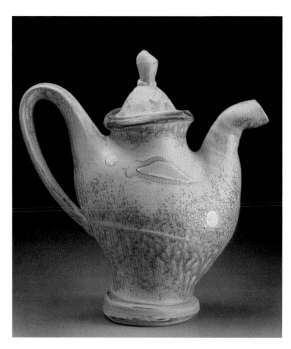

Teapot, 2001. 7 x 5 x 7 inches (17.8 x 12.7 x 17.8 cm). Thrown and altered stoneware; cone 10 gas reduction. *Photo by Tom Mills.*

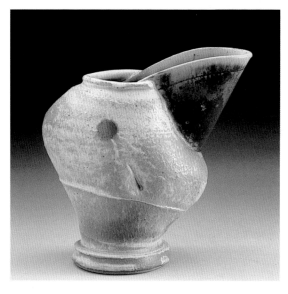

Small Pitcher, 2001. 4½ x 2½ x 3½ inches (11.4 x 6.4 x 8.9 cm). Thrown and altered stoneware; cone 10 gas reduction. *Photo by Tom Mills.*

enlivened. What I hope for are pots that have qualities of sensuality, compassion, humor, and risk.

When I ask myself what has me eager to be in the studio, part of the response is the sense of discovery. I love how elusive good form can be, how in my own studio satisfaction is so temporary—that what I'm after won't stay put.

HANDS ON

*N*ick reveals some of the methods he uses to make his thrown and altered vessels. For his shino-glazed, lidded trophy jar with handles, he first creates a separate foot "off the hump." The beak pitcher employs a different foot-construction technique, and also incorporates a lug-pulled handle.

TROPHY JAR

1. Removing the throwing marks after the sides have been pulled up

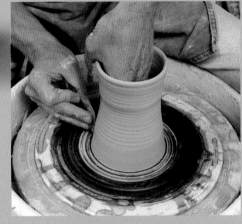

2. Collaring

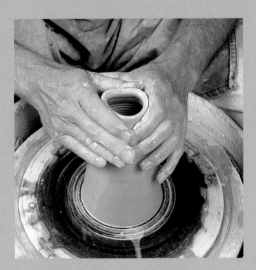

3. Closing up the form

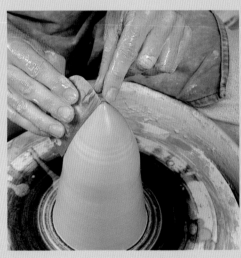

4. Smoothing out the closed form

5. Making lines on the form

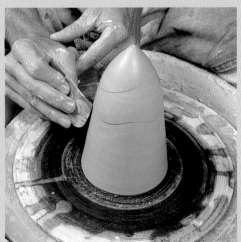

NICK JOERLING

6. Shaping the closed form

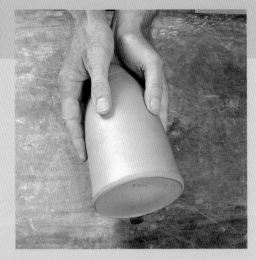

7. The shaping is done by tossing it against a flat surface when the clay is at a soft leather-hard stage.

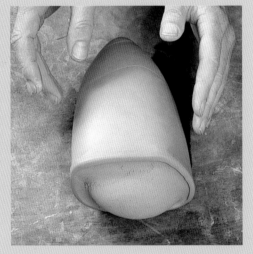

8. Shaping the bottom of the form

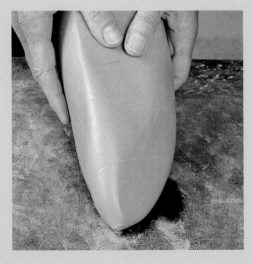

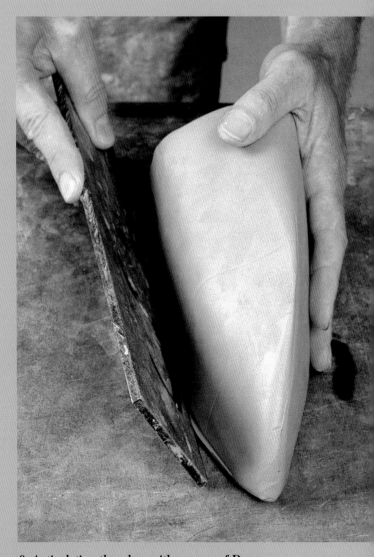

9. Articulating the edges with a scrap of Duran

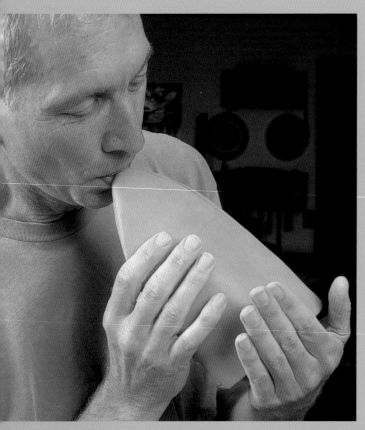

10. Blowing air into the form

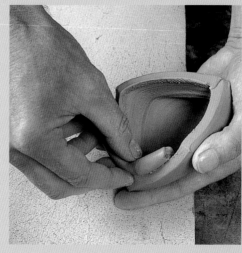

12. Cutting the lid

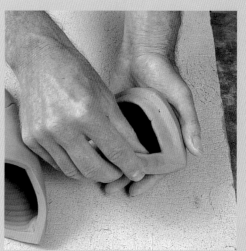

13. Creating the lid's flange. Scoring the inside of the lid, then adding a coil.

11. Marking the position where the lid will be cut

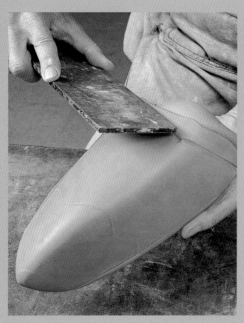

14. Pinching the flange

NICK JOERLING

15. Throwing the foot from a solid disc, thrown off the hump

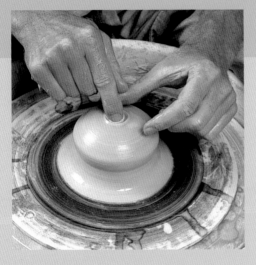

18. When the clay is plastic but not tacky, the thrown foot is stretched and domed.

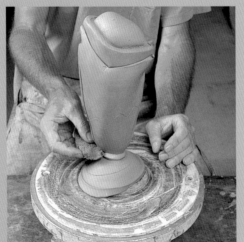

16. Shaping the foot with a rib

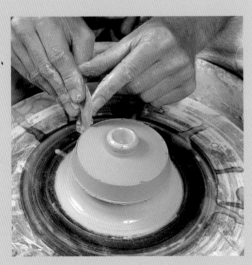

19. Forming a "lip" on the top of the foot with a piece of Duran

17. Making decorative lines on the foot

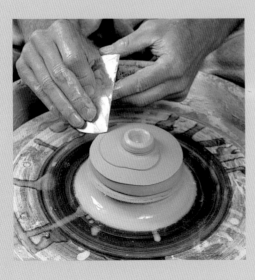

20. Scoring, attaching, and smoothing the connection between the pot-body and foot

NICK JOERLING

21. Rolling and shaping the handles and knob

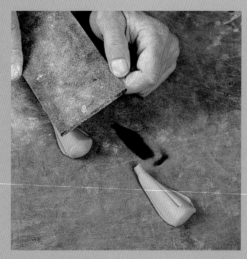

24. Rubber bands keep the lid pressed into the body while drying.

22. Attaching, then curling, the handles

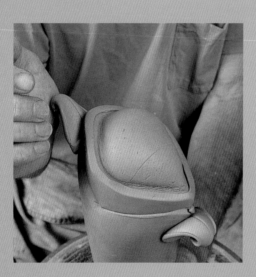

25. Dipping the bisqued jar into a bucket of shino glaze

23. Keying the lid to the body

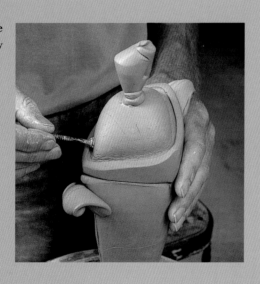

26. Wax-resist decoration

NICK JOERLING

27. Adding glaze color inside the wax marks.

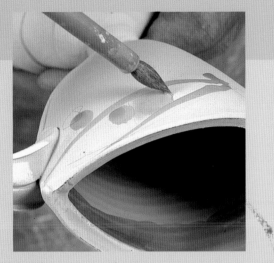

28. Waxing over the glaze color

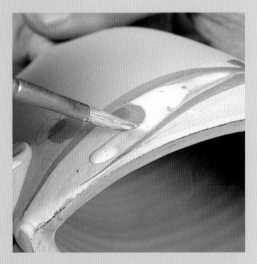

29. Dipping the jar into cover glaze

30. Centering and opening the pitcher's form

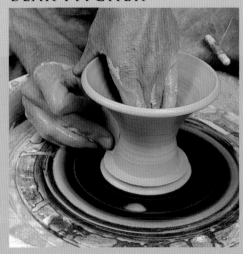

31. Refining the foot

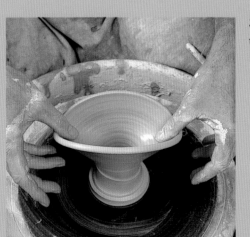

32. Distorting the lip

33. Pinching off to create a new shape

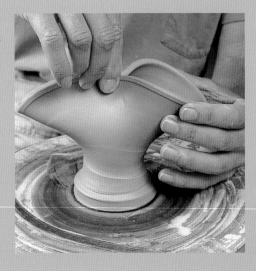

34. Trimming the pinched area

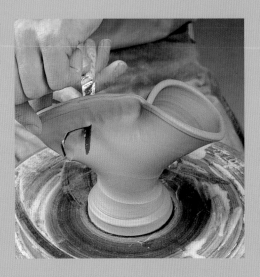

35. Shaping the pitcher; opening it up from the inside with a forming tool made by Jack Troy

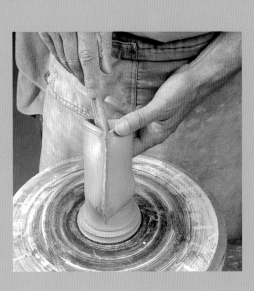

36. A coil added to the inside seam

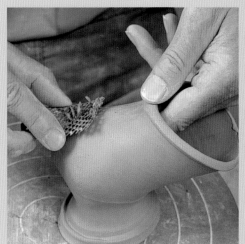

37. Cutting off the exterior seam

38. Using a Surform blade to remove clay

NICK JOERLING

39. Smoothing the seam

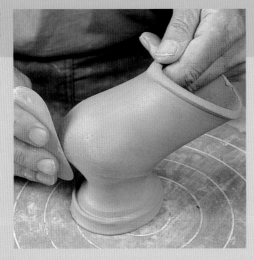

40. Scoring the bottom of the pitcher to ready it for the tapered slab bottom

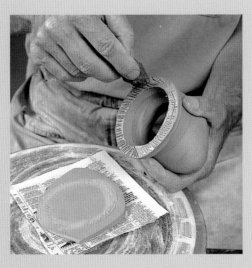

41. Trimming away excess clay before compressing the slab bottom to the pitcher body with a rib.

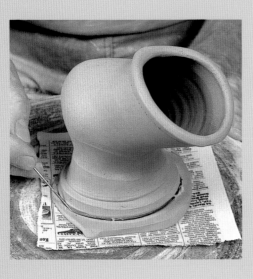

42. Using a template to cut the beak spout

43. Cutting the pitcher where the beak will fit

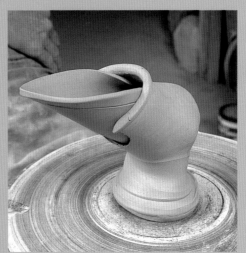

44. Determining the position and fit of the spout to the body

NICK JOERLING

45. Removing excess clay

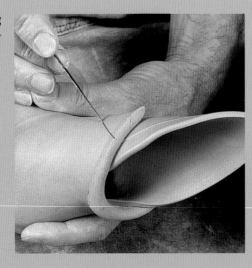

48. Flattening the end of one lug before scoring, adding slip, and attaching it

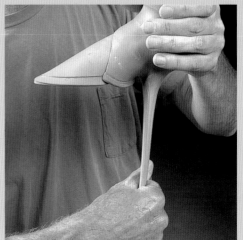

46. Scoring connecting areas and attaching the beak

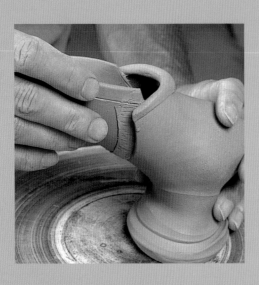

49. Pulling the handle

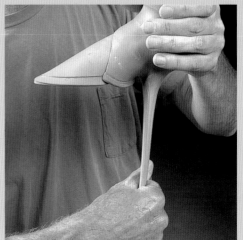

47. Cutting the handles off lug

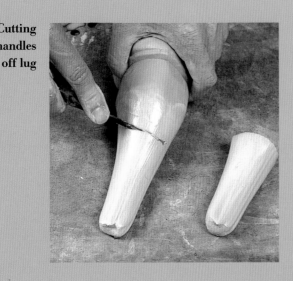

50. Attaching the handle

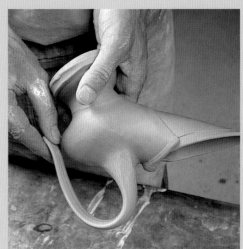

NICK JOERLING

51. Final shaping

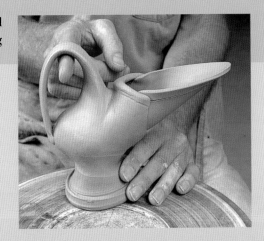

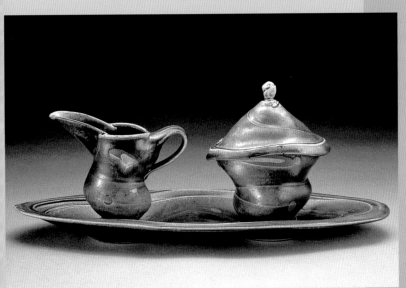

Cream/Sugar Tray, 2000. Sugar jar 5½ x 3 x 4 inches (14 x 7.6 x 10.2 cm). Cream pitcher 5 x 4 x 3 inches (12.7 x 10.2 x 7.6 cm). Thrown and altered stoneware; cone 10 gas reduction. *Photo by Tom Mills.*

ABOUT THE ARTIST

NICK JOERLING, a studio artist living and working in Penland, NC, frequently teaches and lectures at such places as Baltimore Clayworks, Arrowmont, John C. Campbell Folk School, Penland School of Crafts, Haystack Mountain School of Crafts, Greenwich House Pottery, and the American Craft Council Southeast Regional Conference. Recent group shows include "Pots Presented" (curator), Baltimore Clayworks, Baltimore, MD; "Taking Measure," American Ceramic Art in the New Millennium, NCECA, World Ceramics Exposition 2001 Korea, Yeoju, Korea; "Penland NCECA," Charlotte, NC: "25th Anniversary," Lill Street Gallery, Chicago, IL; "The Altered Forms of Nicholas Joerling and Leah Leitson," Belk Gallery, Western Carolina University, Cullowhee, NC; and "Smithsonian Craft Show," Smithsonian, Washington, D.C.

He is a member of the Southern Highlands Craft Guild, and a board member of Penland School of Crafts. His work is featured in a number of private collections, including Roger Corsaw Collection of Functional American Ceramics, Alfred University, Alfred, NY, and the Lancaster Museum of Art, Lancaster, PA. Several books, such as *Wheel-Thrown Ceramics* (Lark 1998) and *Functional Pottery* (Krause Publications, 2000) include examples of his ceramic art.

GALLERY

*I*n putting together this gallery section, I attempted to gather a variety of pots, all of a functional scale, all coming from the wheel, and then altered. Some of the potters are working comfortably within the boundaries of utility; others are pressing against those constraints. Often these two approaches are at work within the same potter. It was inspiring to see this work; it makes me want to go to the studio. There's some regret, too—so many good people who couldn't be included. So this is a sampling of pots, coming from potters working at a high skill level, in clear, individual voices, making pots with care and curiosity. The chance to share their work pleases me.

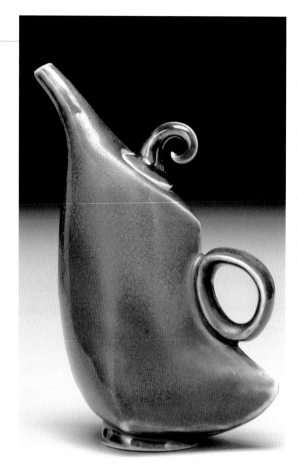

SUSAN FILLEY, *Feather Ring,* 2000. 5 x 4 x 2 inches (12.7 x 10.2 x 5 cm). Thrown and altered porcelain; copper glazes; fired in reduction, 2308 °F (1300 °C). *Photo by Tim Barnwell.*

SILVIE GRANATELLI, *A Swan Moon,* 2001. 20 x 8 x 10 inches (50.8 x 20.3 x 25.4 cm). *Photo by Tim Barnwell.*

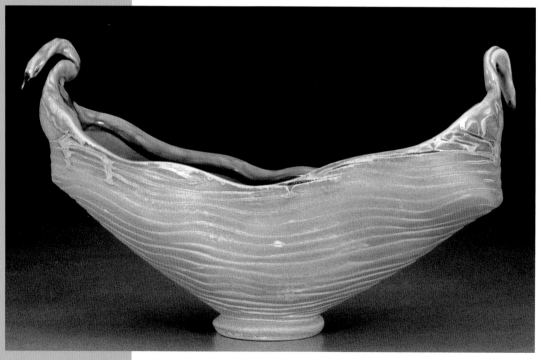

NICK JOERLING

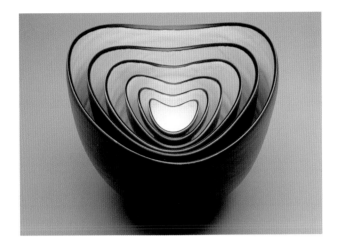

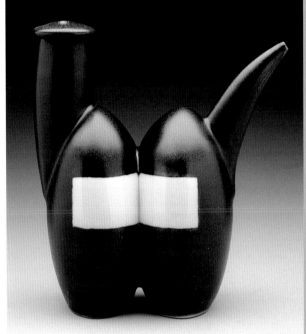

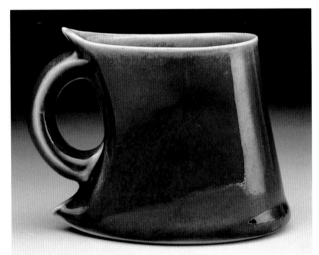

SUSAN FILLEY,
Simple Slide, 2000.
Thrown and altered
porcelain; layered
glazes; fired in
reduction 2308 °F
(1300 °C). *Photo by
Tim Barnwell.*

Top left: **PETER BEASECKER,** *Stacked
Bowls,* 2000. 9 x 10 inches (22.9 x 25.4
cm). Thrown and altered porcelain; cone
10. *Photo by Harrison Evans.*

Top right: **PETER BEASECKER,** *Ewer,*
2001. 8 x 7 x 4 inches (20.3 x 17.8 x 10.2
cm). Thrown and altered porcelain; cone
10. *Photo by Harrison Evans.*

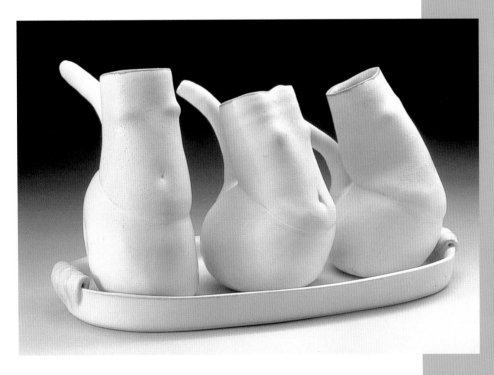

SILVIE GRANATELLI,
Lady Ewers, 2000. 7 x 8 x 4½
inches (17.8 x 20.3 x 12.7 cm).
Thrown and reformed porce-
lain; matte glaze; gas cone 10.
Photo by Tom Mills.

NICK JOERLING

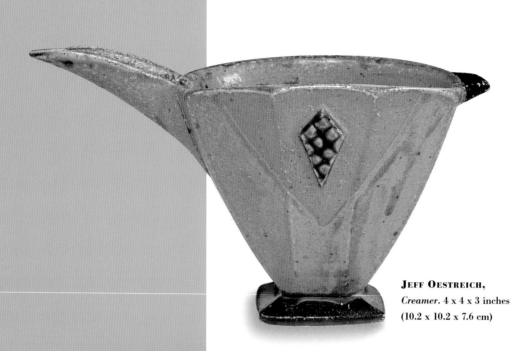

JEFF OESTREICH,
Creamer. 4 x 4 x 3 inches
(10.2 x 10.2 x 7.6 cm)

LINDA CHRISTIANSON,
Teapot.
5½ x 9 x 3½ inches
(14 x 22 .9 x 8.9
cm). Thrown and
altered stoneware;
slip, low-fire under-
glaze; woodfired,
slightly salted.
Photo by artist.

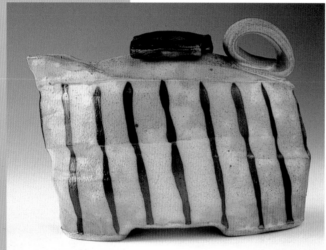

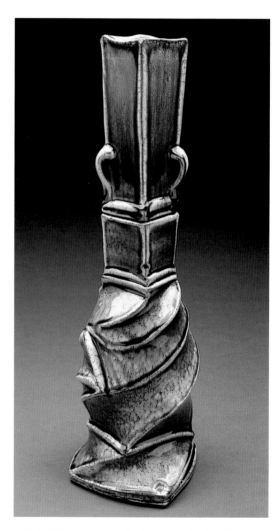

WOODY HUGHES,
Bottle, 2001. 12 x 5
x 10 inches (30.5 x
12.7 x 25.4 cm).
Thrown, altered,
and assembled terra
cotta; terra sigillata,
polychrome slips;
transparent glazes,
electric cone 04.
Photo by artist.

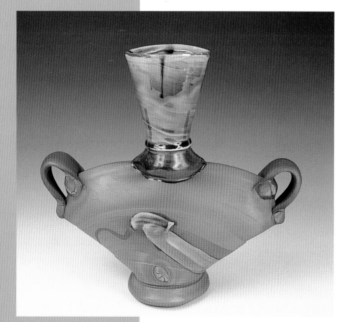

BRAD SCHWIEGER, *Bottle,* 2001. 21 x 6 x 6 inches
(53.3 x 15.2 x 15.2 cm). Thrown and altered stoneware;
multiple slips and glazes, soda cone 10. *Photo by artist.*

NICK JOERLING

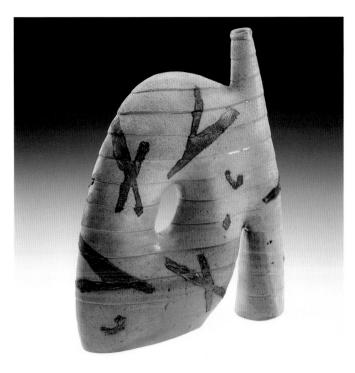

JAMES LAWTON, *A-Shaped Bottle with Chromosomes,* 1999. 12 x 8 x 1½ inches (30.5 x 20.3 x 3.8 cm). Thrown, darted, and altered stoneware; salt cone 10. *Photo by Tom Silva.*

MICHAEL SIMON, *Persian Jar/Black Dog,* 2000. 6 x 6 x 5 inches (15.2 x 15.2 x 12.7 cm). Thrown and paddled stoneware, thrown and cut lid, applied feet; wax resist pattern over white slip; salt glazed cone 9. *Photo by Walker Montgomery.*

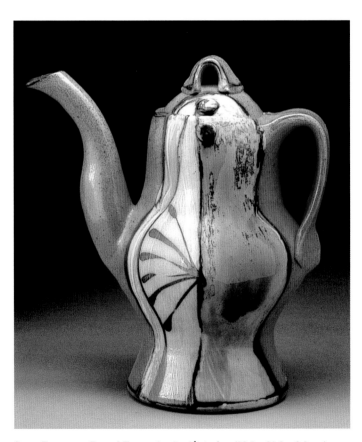

SUZE LINDSAY, *Darted Teapot.* 9 x 8 x 3½ inches (22.9 x 20.3 x 8.9 cm). Thrown and altered stoneware; salt cone 10. *Photo by Tom Mills.*

MICHAEL SIMON, *Three Legged Vase/Black Slot,* 2000. 11 x 5 inches (27.9 x 12.7 cm). Thrown and altered stoneware; faceted; wax resist pattern in black stain over kaolin wash; salt glazed cone 9. *Photo by Walker Montgomery.*

CYNTHIA BRINGLE

The large, totemic vessel forms made by Cynthia Bringle are imbued with a cool singularity. Each pot is made and marked by private inner motives, but the rhythm of her kickwheel becomes visually accessible at the surface as a simple, yet profound, offering.

Untitled, 2000.
21 x 9 inches
(52.1 x 22.9 cm).
Stoneware;
wood/salt fired.

THE LARGE (AND SMALL) OF TURNING AND BURNING

Throughout my years of making pottery, I have always enjoyed making larger vessels along with coffee mugs, bathroom sinks, and serving pieces. I've used a variety of forming methods—slab, coil, thrown, and combinations of all of these. But whether I'm throwing coffee mugs or large sculptural vessels, at the heart of the work it is form and design that are the truly important aspects of throwing. Learning and practice...reflecting and producing...these are the foundations of growing in clay.

When I was in undergraduate school we didn't have electric wheels. Through lots of practice, I found I could manage 50 pounds (22.7 kg) of clay on a kick wheel. I now mostly use a kick-wheel with a motor. I like the momentum, the motion of the heavy flywheel, which I find

makes forms that are quite fluid. People tell me that when I throw these large forms on the wheel I make it look easy, but for me, working large is always a challenge.

I have been throwing large pots for more than 30 years and, like throwing in general, learning the basics is not difficult if you're willing to practice and give yourself time to gain the skills. Working large is primarily a question of controlling the clay. When I teach, I have students throw small, then large, then small again. After working with more than 20 pounds (9.1 kg) of clay, 10 pounds (4.5 kg) feels easy. But practice is key: I can *tell* you that when I work with 20 or 30 pounds (13.6 kg) of clay and start to pull up the sides, I press in on the clay from the outside and the inside at the same time so that I can keep pulling up without the vessel

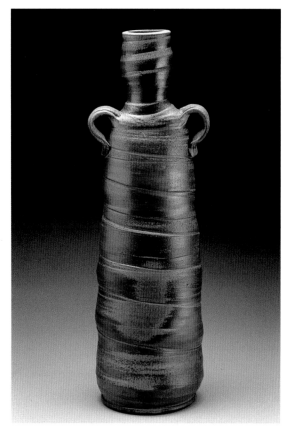

Untitled, 1999. 24 x 8 inches (61 x 20.3 cm). Stoneware; anagama fired.

Untitled, 2001. 25 x 8 inches (63.5 x 20.3 cm). Stoneware; wood/salt fired.

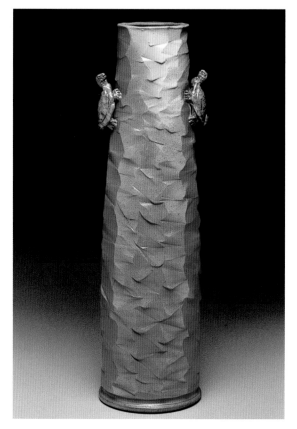

CYNTHIA BRINGLE

falling down. But until you try this over and over for yourself, my words won't mean much.

Working on large pieces requires physical strength plus, of course, technical expertise, but if aesthetics are not a part of it, what you wind up with is something that is not pleasing to the eye and that takes up a lot of space. It's not hard to make something that is big and ugly. I think it's essential for students in pottery to have a background in drawing, painting, and design, because it teaches you to look and evaluate. (I was enrolled in college as a painting student when I started to work with clay, and I just never stopped.) Also, it's important to learn to sit back and look at what you have made. We learn by studying our work, not just by producing it. My challenge is to keep looking at what I'm doing and to go forward. I'm always evaluating my work and asking, What is the next step? What if next time I swelled out the belly of the pot more, or finished the handles differently?

Of course, most of the work I do is not large. Production pottery means to me the work I produce to make a living, but I have the freedom to make many different kinds of pots. I consider all of my work to be one-of-a-kind. I could make a dozen vases of the same size, all alike, but that is not how I usually work. Each of my pieces has its own character. In some, the form will be altered: maybe fat, maybe thin, maybe carved.

When I make custom dinnerware, I'm considering who the person is I'm making the plates and bowls for, and designing a set for that individual. I can easily make a group of almost identical pieces, but because the hand has made them, no two are exactly alike. If I'm not making a custom order, a group of bowls or pitchers will each have their own individuality. No two mugs or candlesticks that I throw are alike from the standpoint of their design, and their surface alteration and decoration all have subtle differences of the hand. I see lots of

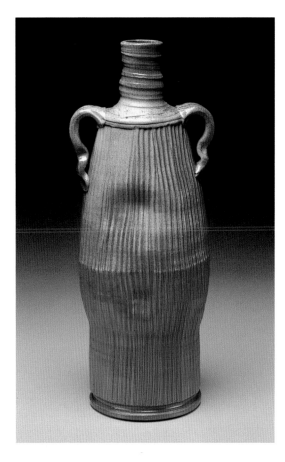

Untitled, 1999. 26 x 10 inches (66 x 25.4 cm). Stoneware; wood/salt fired.

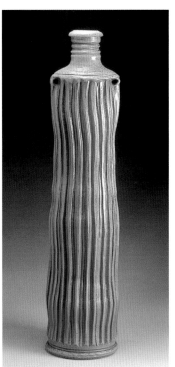

Untitled, 2001. 26 x 7 inches (66 x 17.8 cm). Stoneware; wood/salt fired.

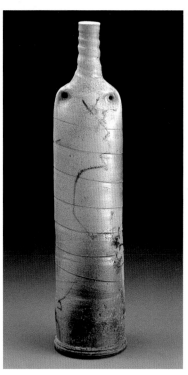

Untitled, 2001. 18 x 6 inches (45.7 x 15.2 cm). Stoneware; anagama fired.

CYNTHIA BRINGLE

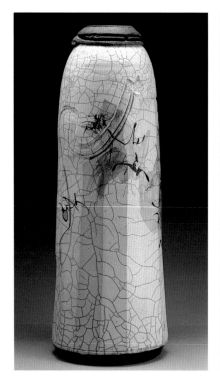

Untitled, 2001. 24 x 8 inches (61 x 20.3 cm). Stoneware; raku fired.

Untitled, 2001. 34½ x 9 inches (87.6 x 22.9cm). Stoneware; wood/salt fired.

mugs out there that look dead to me. There's nothing about them that says the hand made them.

Most of my pieces begin on the wheel, and then I alter them by incising, cutting, carving, stamping, and other surface techniques. Glazing is time-consuming, as I look at each piece and decide if I'm using brush decoration, one glaze or several. I try to approach clay forms as three-dimensional paintings. I like the brushwork—that's when I get to feel like a painter again. Like a lot of potters, I think the pots look best at the leather-hard stage. That's when I carve them. My carving has developed and changed over the years. I'm doing some of it in patterns now, using carving and faceting together. My objective is for the eye to follow the carving around the form.

Most of my firing is in gas or wood, and some are in raku. Each way of firing produces differ-

ent results; it's just like a painter working in watercolor or oil. The ware in the gas kiln is glazed. Most of the ware in the wood kiln has no glaze, but is lightly salted, relying on the ash and flame for surface.

I think an artist can "study the market" and then purposefully try to fill some sales niche, but that approach is not for me. I've been at this a long while. I feel fortunate to have found what I love doing, that I'm able to make a living selling my work and doing a few workshops. But I don't think you can make good work if you're not speaking from your heart and soul. One of the questions I often hear from visitors to my gallery is, How many people work here? Since my work goes from coffee mugs to architectural wall paintings, gas to wood firing to raku, they are astounded that it's one person's work. I work to pay attention; I look at what I've done, then go forward.

Clay continues to be exciting for me. Clay is why I do the work. It's so plastic, so immediately responsive to my touch, my whims—which of course aren't whims at all, but thoughtful responses developed out of years of practice and discipline. The hand works intimately with the clay on the wheel, pulling, pressing, squeezing. As in childhood, my fingers are often my first tools.

The photographs on the next five pages show a vessel made with thrown parts. Remember this is only one way. Clay has never-ending possibilities, so keep looking at what you're making and thinking about the next step. Size, of course, will be relative to your ability to handle the clay. And the way you choose to finish and fire should always be a part of the thinking process. But the key thing for me, and what I try to communicate about pottery is—whether you work small or large, on or off the wheel, carve, or stamp, or do fancy brush work—if you don't make what's in your soul, then what in the world are you doing this for?

CYNTHIA BRINGLE

HANDS ON

Cynthia shows how to make a large vessel made with thrown parts, then carves the form and incises patterns into the clay with simple carving tools.

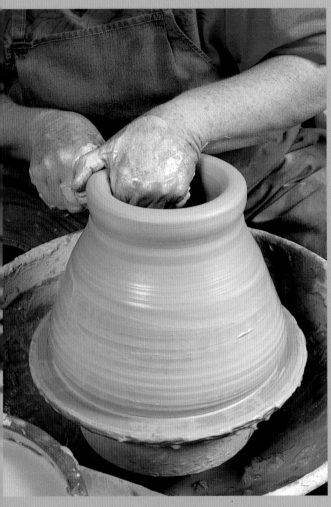

1. Opening up the 18-pound (8.2 kg) base, or bottom section, and starting to pull up the sides. It takes skill and some physical strength to be able to press in on the clay enough to raise it without having it fall down.

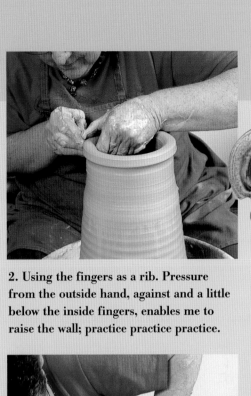

2. Using the fingers as a rib. Pressure from the outside hand, against and a little below the inside fingers, enables me to raise the wall; practice practice practice.

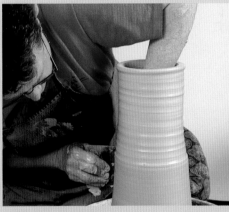

3. Continuing to raise the wall. I use a rib to compress the clay and to straighten the sides.

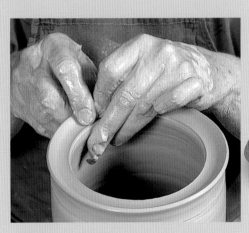

4. Making a groove by pressing the index finger down. This is where the second section will be attached.

CYNTHIA BRINGLE

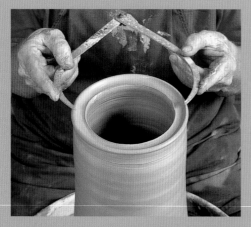

5. Measuring the rim of the base section, which has been left thick enough to support the next section. The plan is to carve the piece, so some excess is also needed for that.

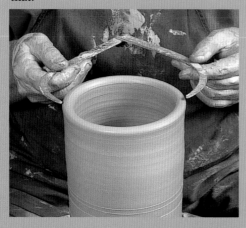

6. Measuring the second section, which was thrown from 7 pounds (3.2 kg) of clay. A sketch of the form I'm working toward helps in the planning process. This section will be turned over onto the first section, so I make sure it fits top to top.

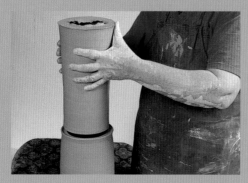

7. Attaching the two sections by joining the top of the second section to the wetted

top of the first one. I use thin slip for wetter sections and thick slip if I'm waiting until almost leather-hard to join. I let the sections set up for a while—from 15 minutes to several hours, depending on the conditions in the room. They need to be the same consistency.

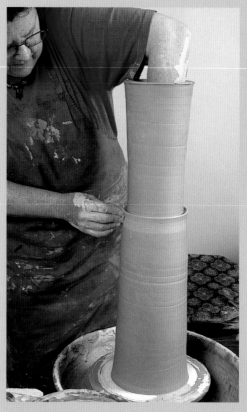

8. Throwing the two sections together on the wheel

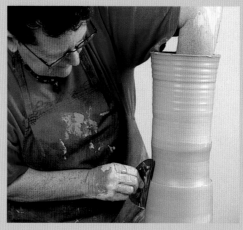

9. Using a rib to add pressure and straighten the wall of the top section

CYNTHIA BRINGLE

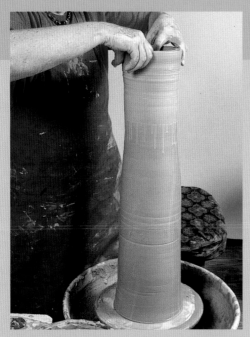

10. Pulling up the extra clay for additional height. What is now the top was previously the base of the second section. Both hands are working together on opposite sides of the pot. I'm squeezing in and pulling up at the same time. The more surface of my fingers that can touch the clay, the more control I have.

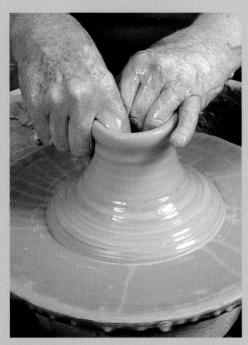

11. Pulling in a neck. The base was measured to fit the top of the pot.

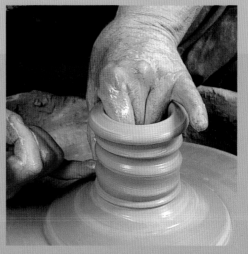

12. Using the little finger to add definition to the neck. The base is also made wider, to allow for variation in application.

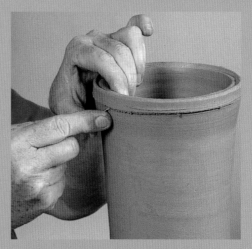

13. Trimming the top to fit the shape of the inside base of the neck

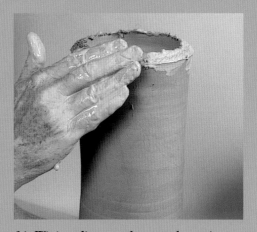

14. Wiping slip onto the scored top rim

CYNTHIA BRINGLE

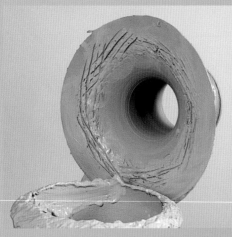

15. Scoring the underside of the neck before joining its base to the body

16. Trimming the excess of the neck. I let the body and neck set up for a few hours after joining them. This makes for a tighter weld, because the slip then has time to join with the pieces.

17. Using the thumb to create a decorative groove at the base of the neck

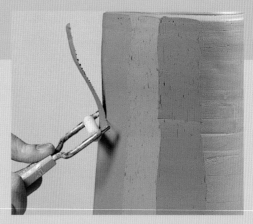

18. Using a cheese cutter to cut broad patterns in the clay

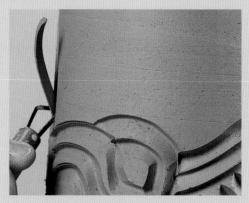

19. Using a clay trimmer to carve a design. The line will vary, depending on the tool you choose to use and the consistency of the clay. The pattern I carve is a design process that relates to the form of the piece. My decoration—be it with a brush or carving—is a result of 35 years of adding different surface treatments.

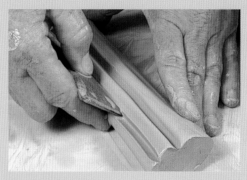

20. Processing groves into a pulled handle. It's important that I think about the handles as they will relate to the vessel. Will handles add something, or just be an unneeded appendage?

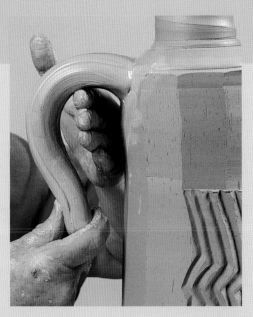

21. Attaching the handle. I score and slip the shoulder of the vessel first, and look at the size as it relates to the piece. If it doesn't look good now, I'll cut it off and start over, because it will not get any better. I have often put on three handles before I get the one I think is right.

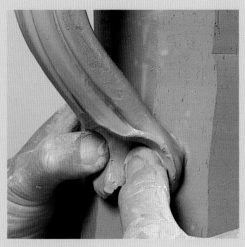

22. Attaching the end of the handle by using the thumbs to press it in. There are a variety of other ways to do this, too.

ABOUT THE ARTIST

CYNTHIA BRINGLE has lived and worked as a studio artist in Penland, NC since 1970. She has taught at Penland School of Crafts, as well as at Anderson Ranch, John C. Campbell Folk School, and from Florida to California, to Australia and Brazil. She is a Fellow of the American Craft Council, and a Life Member of the Southern Highland Craft Guild, the organization that honored her in 1999 with a retrospective entitled "Cynthia Bringle: A Fiery Influence."

Her work has been the subject of many one- and two-person shows, and her list of invitationals and juried shows includes "Ceramic National 2000," which toured the U.S.; "Birds, Beasts & Little Fishes," Santa Fe Clay; "Utilitarian Clay III," "Kutani International Invitational," Ishikawa, Japan; and "Fifth Annual Teapot Exhibition," Craft Alliance Gallery, St. Louis, MO. Among the permanent collections featuring her work are the Mint Museum of Craft and Design, Charlotte, NC; the High Museum of Art, Atlanta, GA; and the Craft and Folk Art Museum, Los Angeles, CA.

GALLERY

I have included work from Ben Owen, David Stuempfle, and Mark Hewitt because they all work in a traditional manner making nicely formed, large vessels, but each of them has his own unique method of surface decoration. In addition, Mary Roehm has pushed the realm of porcelain with the size of her pots; Peter Volkous was important to include because of the strong presence of his work; and Don Reitz works with the vessel format in a scale that transforms the pieces from vessel into sculpture.

BEN OWEN III, Combed Vase, 2001. 34 x 27 x 27 inches (86.4 x 68.6 x 68.6 cm). Thrown stoneware; made from four sections; combed with saw blade at leather-hard stage; wood fired (natural ash).
Photo by David Ramsey.

CYNTHIA BRINGLE

BEN OWEN III,
Genie Bottle, 2001.
38 x 20 x 20 inches
(96.5 x 50.8 x 50.8
cm). Thrown
stoneware; made in
four sections; oxi-
dation ; cone 06.
*Photo by David
Ramsey.*

MARK HEWITT,
Large Planter,
2000. 26 x 23 x 23
inches (66 x 58.4 x
58.4 cm). Thrown
and coiled
stoneware; ash
glaze drips; blue
glass runs; wood
fired; salt glaze;
cone 12. *Photo by
Jackson Smith.*

DON REITZ, *Teastack,* 2001. 50 x 24 inches (127 x 61 cm). Wheel-
thrown and hand-built; wood fired, oak ash; cone 12. *Photo by
Photographer's Image.*

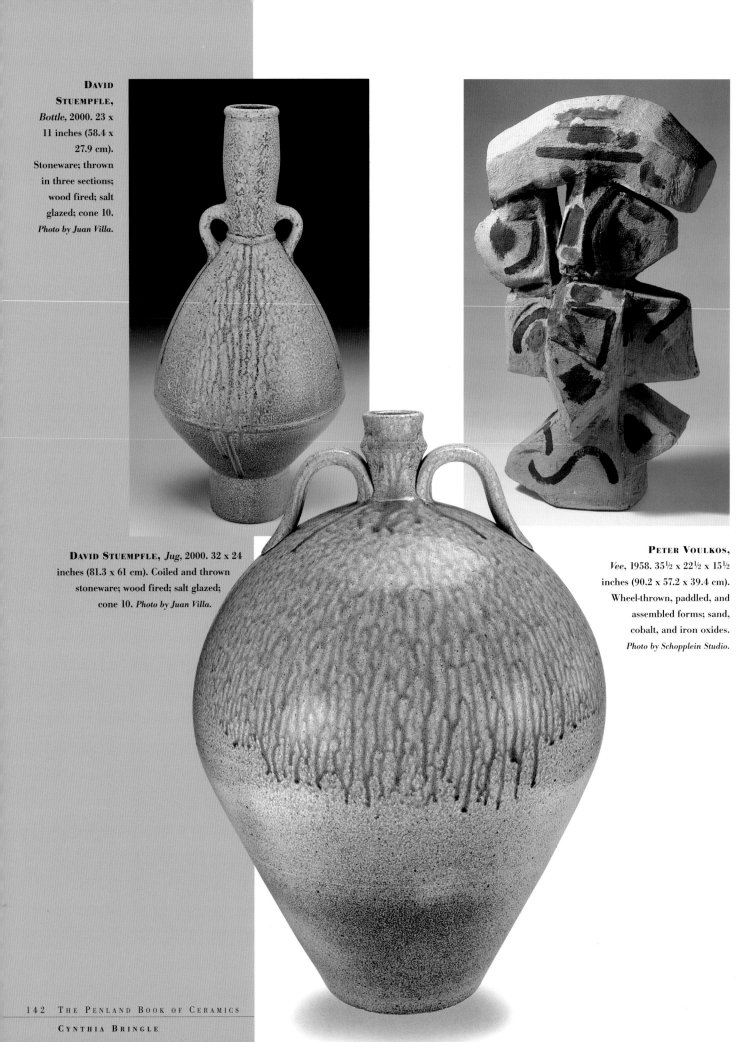

DAVID STUEMPFLE, *Bottle,* 2000. 23 x 11 inches (58.4 x 27.9 cm). Stoneware; thrown in three sections; wood fired; salt glazed; cone 10. *Photo by Juan Villa.*

DAVID STUEMPFLE, *Jug,* 2000. 32 x 24 inches (81.3 x 61 cm). Coiled and thrown stoneware; wood fired; salt glazed; cone 10. *Photo by Juan Villa.*

PETER VOULKOS, *Vee,* 1958. 35½ x 22½ x 15½ inches (90.2 x 57.2 x 39.4 cm). Wheel-thrown, paddled, and assembled forms; sand, cobalt, and iron oxides. *Photo by Schopplein Studio.*

CYNTHIA BRINGLE

PETER VOULKOS, *Isis,* 2001. 50½ x 26 inches (128.3 x 66 cm). Wheel-thrown, cut and manipulated sections; John Balistreri anagama, Ohio. *Photo by Schopplein Studio.*

MARY A. ROEHM, *Columns,* 1997. 8 feet x 8 inches (2.4 m x 20.3 cm); 9 feet by 10 inches (2.7 m x 25.4 cm). Porcelain; coil-thrown sections; natural ash glaze; cone 12. *Photo by STORM.*

MARK HEWITT, *Wigstand with Facial Tumor,* 2001. 24 x 15 inches (61 x 38.1 cm). Thrown and assembled stoneware; manganese slip; wood fired; salt glaze; cone 12. *Photo by Jackson Smith.*

MARY A. ROEHM, *Group of Three,* 2001. 4 to 5 feet (1.2-1.5 m) high; 7 inches (17.8 cm) wide. Stained porcelain; unglazed; cone 10. *Photo by STORM.*

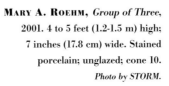

JOE BOVA

Memorable human and animal
figures inhabit Joe Bova's
sculptural world, a world that
celebrates sensuality and
intimacy. His keen sensitivity
toward his subjects breathes
life and personality into them
all, whether woman or rabbit,
man or fox, and honors our
similar forms and movements.

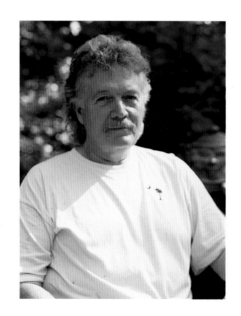

Doc's Anvil, 1984.
31 x 23 x 7 inches
(78.7 x 58.4 x 17.8 cm).
Ceramic.

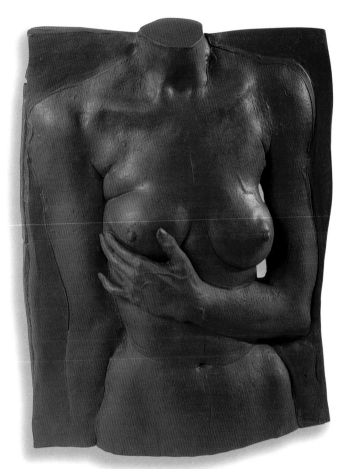

The Breast, 1984-85.
27 x 19 x 5 inches
(68.6 x 48.3 x 12.7
cm). Terra cotta;
terra sigilatta.

UNDER THE SKIN

I was drawing before I was talking. I remember holding up a drawing to show to my mother, but I was not able to speak words yet. I have been drawing ever since. When I was a kid I would draw all kinds of things, but especially animals. I would show them to my father for his approval. He was a fine natural talent himself and a tough taskmaster. He always found something in my drawing that could be improved, until one day I showed him one, and he said, that's really good, Joe. After that I stopped showing them to him and started trying to please myself. I think I was about 12 at the time. From then until the time I went to college, art for me was drawing.

In college, I knew I was going to be an art major, but I thought being an artist meant being a painter or maybe a sculptor. It wasn't

long before I discovered printmaking, and thought I had found a home. But then I stumbled upon clay. I was taking a course in watercolor painting that was taught in the pottery studio. When some students came in and began throwing on the wheel, I was fascinated. I had never seen this before. It seemed magical: the vessel appeared to make itself, growing from a mound of clay, guided by the gesture of hands. I was spellbound, as if watching a snake charmer coax a serpent from the basket with music. I thought, Throwing a pot is better than drawing! It is "real," not the representation of a thing, but the thing itself. It was as free as drawing and as direct, but in a solid form, and concrete. From that moment on I thought about pottery as drawing in three-dimensional space—I was no longer a flat-worlder! And I thought I would come back to the pottery studio tomorrow and make myself a dinner set. Needless to say, the dinner set waited a few months, but I was able to raise a cylinder the first time, and I was completely seduced and hopelessly in love with this material—clay. It has been a lifelong love affair.

That first touch was in 1967. I signed up for a ceramics course the very next semester, and while I was learning to handle clay, wedge, and throw, I also acted on impulses to make the figure, especially the human face. These tentative efforts were harbingers of the work I continue today. And like then, I still think in terms of the relationship drawing has to form. In *Midnight's Children*, Salmon Rushdie writes about our obsession with correspondences and similarities between apparently unconnected things, and our joy when we find them out. Rushdie is very close to expressing what I seek in working with clay and what I want my work to reveal to others.

Among the artists that I have admired the most is Giacomo Manzú (1908–1991), the Italian sculptor famous for his figurative bronze doors at Saint Peter's in Rome. His capacity for melding

drawing and modeling in clay captivates me, and it is what I struggle to attain in my own work. For example, if you look at the hands in the work on page 160, you will see one hand fully modeled and one evoked through drawing on the surface. This dialogue between the different modes, modeling and drawing, is compelling to me. The essence of good drawing is that there should be vitality in the mark making. Drawing interests me the most when the marks are not subordinate to the image. I want to see the image live through the marks. When this kind of duality and simultaneity happen—marks and image separately visible but unified by mutual dependency—then a work usually has the greatest effect for me. It resonates. Historically in painting, the Renaissance Venetians were masters of this (for example, Titian and Tintoretto), where flesh and finger, cloth and coat, are all embodied in a brush stroke. This is what I want my work in clay to exhibit. I try to exploit the plastic quality of clay in such a way that if an analogous word to "painterly" existed, it would be "clayerly."

The I Ching says, "The most perfect grace consists not in external ornamentation, but in allowing the original material to stand forth, beautified by being given form."

This cast of the I Ching is as close to a "truth" as I know about my work in clay. I believe that making art and understanding art require intellectual rigor, yet each requires a somatic experience. Therefore the evidence of my hand, visible in the clay, should resonate with the image and the viewer so that one body knows the other. I want the clay to "stand forth" recognized for what it is, while it also conveys other realities: clay as clay, clay as skin. My early work had significant applied color; I used china paints directly

Clues, 1979. 15 x 1 x 14 inches (38.1 x 2.5 x 35.6 cm). White earthenware; china paints.

Yves, 1997. 24 x 9 x 12 inches (61 x 22.9 x 30.5 cm). Stoneware; salt glazed with barium blue glaze. Collection of Pat Sullivan, Spokane, WA. *Photo by Triesch Voelker.*

on unglazed white ware. Eventually, because of the influence of early historical work (Etruscan, Haniwa) I became more interested in the clay itself conveying, through the coaxing of my hand, the figure. That is why I abandoned applied surface color and glazes for many years.

My work has always been figurative, sometimes human and sometimes animal. Even when I made pottery, it was about the figure. The fact that languages throughout the world use anthropomorphic terms to define the elements of pottery acknowledges an elemental human way of thinking. Pots everywhere and in all times have lips and shoulders and necks and bellies and feet. It is a short step for the inside hand to push out the belly of the pot while it spins on the wheel and the outside hand to feel the swell as someone's belly between hips. I think in terms of the body. I feel in response to the body. I act in knowledge of the body. When I am making a figure, pushing the clay out with my hand inside, my gesture is little different from the potter. Living in this world we share with each other (and with animals), I believe

our forms and movements are powerfully similar. Like potters from the beginning, I understand and affirm the persistence of anthropomorphic and zoomorphic impulses.

Throughout my career I have alternated between making animals and making the human form, and also combining them. Animals have always enthralled me. Growing up in Texas in a family of outdoorsmen, I learned to hunt and fish at an early age. Before I was 12, I was killing and skinning squirrels and rabbits, and my mother would cook them up for dinner. Then, too, we raised rabbits—pedigreed New Zealand Whites. I think this was a residue of my father's Italian heritage. He would quip, "Remember a rabbit is just four drumsticks!" Anyway, it was a serious second business for my family, and "Bova Rabbitry" occupies a significant place in the landscape of my adolescent memories. Tattooing serial numbers in their ears. Feeding and watering them. Smelling hay, fur, feed, and urine. Butchering and eating. I am probably one of the few kids who grew up in Texas eating more fried rabbit than fried chicken. Later,

when I started making clay rabbits, the thought occurred to me—I used to take the rabbit out of his skin, and now I put him back in.

When I work, sometimes I make the same thing again and again, but change it in some way each time. This is not uncommon for anyone who works in clay and is similar to the way many artists work. Potters, for example, if making cups, effect a subtle change in attitude or position of the handle so that each of many is unique. There was a time during the first decade I taught in Louisiana that I made alligators—lots of them. Although I was making other figures too, some people began to think of me as the alligator guy. Making the first rabbit waited until I had returned from Cortona, Italy. Binge working at times, I made enough rabbits for people to ask me why did I make only rabbits? But there were always other subjects—snakes, frogs, turtles, pigs, cats, and dogs.

Cynthia Bringle and I have been friends for nearly 30 years. In 1982 we spent a few weeks as guest artists at The Appalachian Center for Crafts in Tennessee. Cynthia had made a large pitcher, and she challenged me to do something with it. I ended up doing something conventional, making a face on the pouring side of the pot. Cynthia liked it enough to keep it in her studio back at Penland. I would see it when visiting her, but for years we never ventured to collaborate again. Then in 1995, I dropped by the class she was teaching at Penland. When I walked in, the place was empty. On one of the tables I saw a large, freshly thrown pot. I knew she had made it. It had that wonderful soft, moist-but-not-wet, fullness-before-shrinking look that most potters I know wish would stay with the pot all the way through the firings. I could not resist it. I walked over and quickly made a face out of the side of it. Unlike the first face I had made on Cynthia's pot in Tennessee, this one embodied the "clayerly" execution I had worked to develop over the years, and while the first one had a stuck-on-the-side-of-

Joe Bova and Cynthia Bringle, *Face Pots*, 1999. 20 inches (50.8 cm). Stoneware.

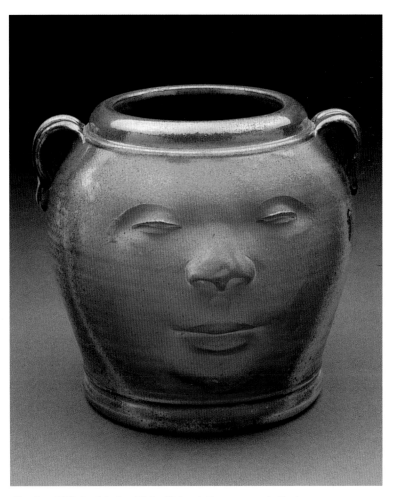

Glowface, 1999. 9 x 9 inches (22.9 x 22.9 cm). Stoneware; soda fired.

Shark Cup, 2000.
5 x 8 inches (12.7 x
20.3 cm). Porcelain.
Collection of Emil
Bova, Palo Alto, CA.
Photo by Dana Moore.

the-pot look, this one looked as if it grew from the pot itself. I knew Cynthia would come looking for me. Later, when she found me, the first thing she said was, "Joe, we have to make more of these!" And so we did, so we have, and so we do. Between 1995 and 1997 we collaborated as often as we could, and in 1997 we exhibited more than 50 of them in a two-person show we had together.

I use a kind of repoussé technique of pushing out from the inside to describe the specific form of face or figure. My techniques include almost any way that clay can be shaped, including using the potter's wheel, but more than anything I want the form to appear as if it grew from the material source, or that it made itself. I would like the viewer to wonder, as H.D.F. Kitto did in his book, *The Greeks*, when writing about the making of an elegant piece of pottery, "How on earth is it done? Some god must have invented it." I want it to be like that snake rising out of its basket.

All the work is made hollow, as it is formed— not hollowed out later. Few of the features are added to a basic form. When possible, for example, ears are "milked" from the wall of clay that provides the basic form from which the other features of a figure are shaped. I believe the viewer is able to discern this made-from-the-inside-outness, and perceives the form as pushing out toward him. I want the edge where form and space meet each other to be activated by this perception. I intend to convey an instant of time between rest and motion, as if they were about to move or had just stopped moving.

I try to imbue animals with enough attitude that the viewer will identify some human characteristic in them, thereby comprehending the

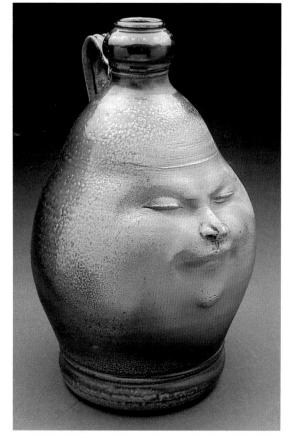

Genie Jug, 1999.
15 x 10 inches
(38.1 x 25.4 cm).
Stoneware;
soda fired.

surrogate role animals frequently play for us. I want the human figures to be understood as meditatively transactional. I expect the viewer to surrender to the piece in some contemplative way and to be suspended and lost to this world at least momentarily. I once read that "entertainment makes no demand for psychic work—art does." For me, this means the most demanding art involves the human image in an exchange of psychic understanding. Transporting the viewers to some place away from themselves with the work is a reason for the work.

My oscillation between animal and human figuration I attribute to my Gemini nature. This duality shows up in my palette too. During the 1980s, I mostly fired cool terra-cotta red and monochromatic. Investing in the plastic expressiveness and surface richness of clay in the 1990s, it seemed only natural to eschew glazes for vapor firing; and so, like so many others, I fired salt and soda. Back at Penland in August of 2001, I made a piece I titled *Listening to Blue*. It will be the first of a series of figures to use color directly and symbolically. Technically this means cone 10/11 and soda and salt fired, but with applied slips and glazes. And though I am no longer interested in straightforward low-fire, I am interested in multi-firing. In some cases, this work will have overglaze luster and china paints after the high-fire. I love heat. Maybe my temperature was set at my Texas birth. I could have been vaccinated with a cactus needle. Now I want to make these figures of clay turn to stone with hues from high heat. I want them to be hot, hard, and chromatic.

The sustained collaboration with Cynthia has led me back to the potter's wheel and to a series of face pots of my own, such as *Genie Jug* and *Glowface*, which in turn led to a series of cups with saucers. I love functional pots. I love functional pots by really good pot-

ters best. My own interest in some kind of useful pot is iconic. The interior of a cup interests me as a space whose world hosts the imagination. Into this world my animals enter. It is an old game. Think of those English mugs with frogs down in them. But I believe mine are imagined (and made) like no others. I tell myself so, and settle for pleasing myself.

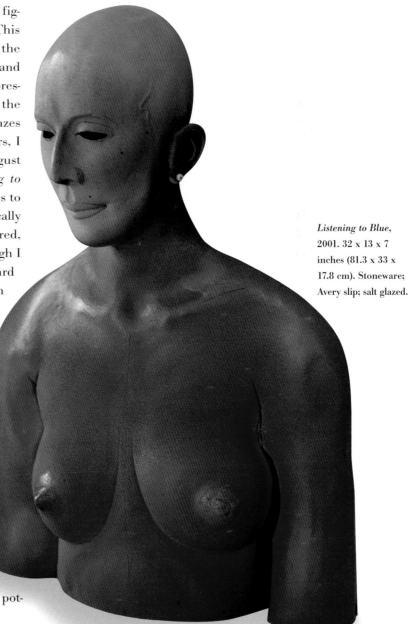

Listening to Blue,
2001. 32 x 13 x 7 inches (81.3 x 33 x 17.8 cm). Stoneware; Avery slip; salt glazed.

HANDS ON

*F*rom two clay slabs, Joe constructs twin reliefs of male and female forms. He uses repoussé to create volume in the figures and hand-building techniques to add detail. Once the reliefs are strong enough to stand, Joe then joins them, Janus-like, to one another.

FEMALE TORSO

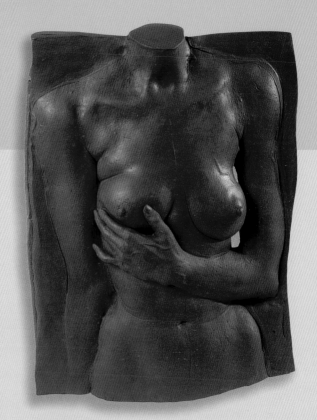

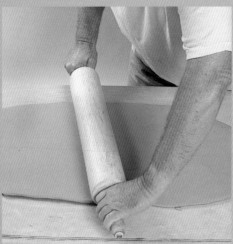

1. Rolling out a 12-pound (5.4 kg) slab to a thickness of at least ½ inch (1.3 cm) on a piece of plywood

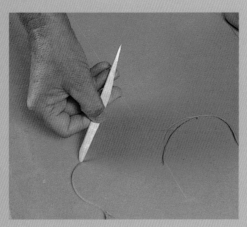

 2. Drawing on the slab with a wooden modeling tool. I like the tension between the two-dimensional effect I get by drawing on the clay, and the naturalistic, three-dimensional aspect I shape all in one piece.

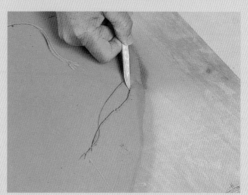

3. If you make a line you don't like, you can smooth it out later. I don't think you have to have taken anatomy lessons to be able to do work like this, but you have to have a good eye and good hands. You've got to have the goods and then develop them.

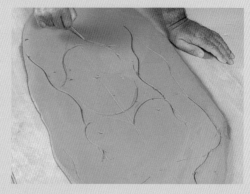

4. Finishing the sketched woman's torso

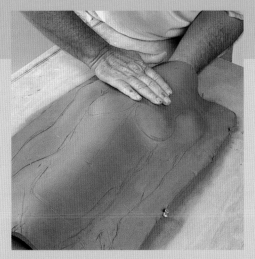

5. Place the slab on a turntable and start lifting; the clay should be fairly wet.
Pin the edges of the slab to the wood with push pins to prevent it from slipping flat again.

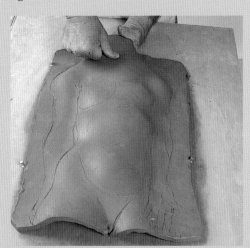

6. Forming the neck and throat. I work pretty hard for a clay surface—I like to explore what happens if you push or pull the clay.

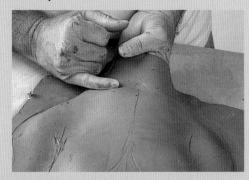

7. Forming the collarbone

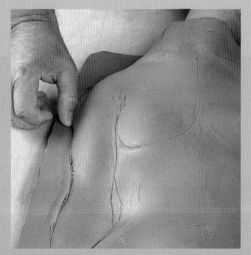

8. Forming the edge of the shoulder and arm. Clay is like skin, and if you put glaze on it, you cover it up. I like atmospheric firings for that reason.

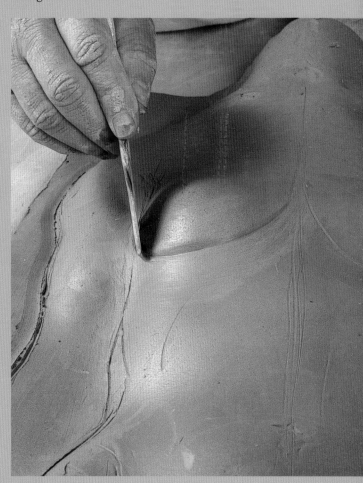

9. Defining the breast with a modeling tool. If I feel as if I'm about to push through the clay, let's say when I'm shaping the breasts, I'll add clay to the back side of the slab.

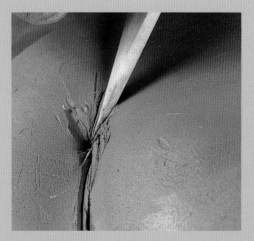

10. Defining the armpit area

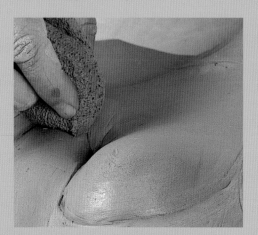

11. Using a sponge to smooth the area

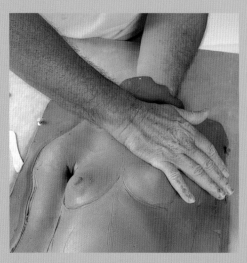

12. Creating the nipple by pushing a small button of soft clay into the slab from the back side—pushing out about half the thickness of the clay—without tearing through it

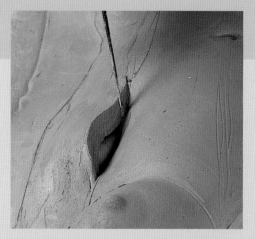

13. Using a fettling knife to cut through the clay between the arm and the torso

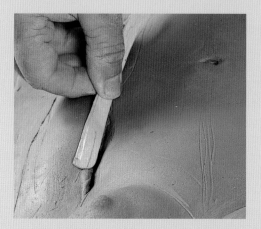

14. Rounding the edge of the arm with a wooden tongue depressor

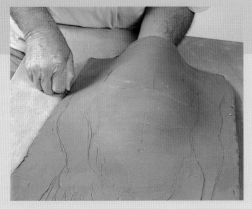

15. Having drawn the basic shape of the torso onto a slab of the same size and thickness, I lift the torso slightly and pin the slab to the wood.

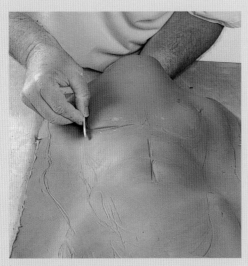

16. Using a tongue depressor to shape the breast, with my index and middle finger lifting from the back side

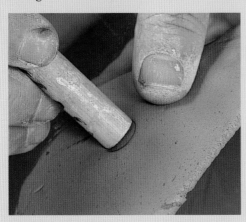

17. Experimenting with a wooden dowel on a scrap of clay to shape the nipple

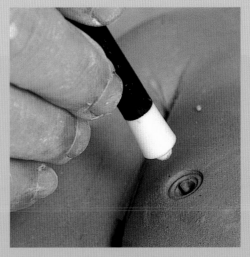

18. Using the paintbrush handle to create the nipple

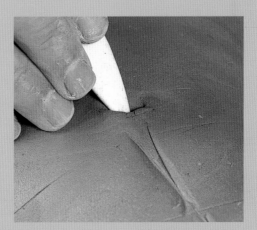

19. Using the tongue depressor to create the navel

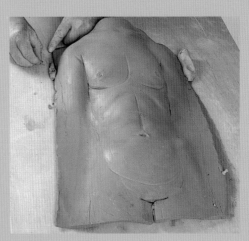

20. Using two scraps of clay, re-pinning the top of the torso to increase the uplift in the form while it air dries

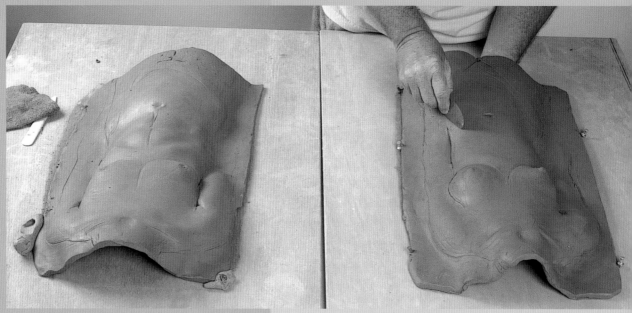

21. Male and female side by side, while I articulate the line on the woman's hip area with a metal rib

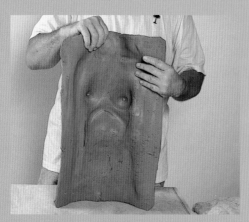

22. Lifting the female torso to a standing position: view of the inside

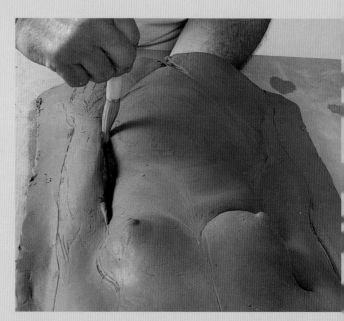

24. Scoring and adding slip to the inside edges of the cut in the arm so I can reshape it. I can work on the clay for a couple of hours like this without it getting too dry and inflexible.

23. View of the front

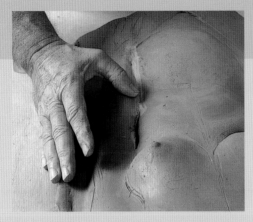

25. Closing and shaping the area where the arm meets the body

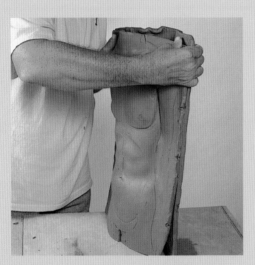

26. Scoring and adding slip to the inside edges of the female front and the male back

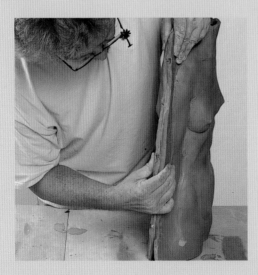

27. Pinching the sides together

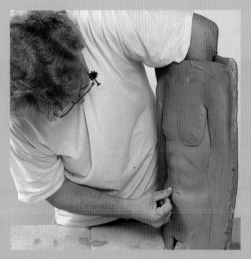

28. After evaluating how the piece looks, I put my hand back inside and push out the male stomach a little.

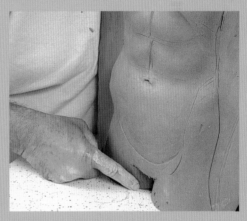

29. With the help of a long-handled wooden spoon inside the male torso, I articulate the pelvic area and the top of the legs.

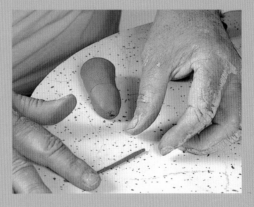

30. Having formed the penis from a coil of clay, I'm now fashioning thin coils to use as blood vessels.

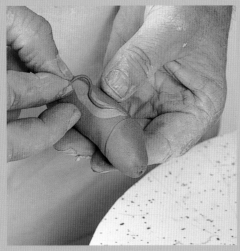

31. Adding the blood vessels

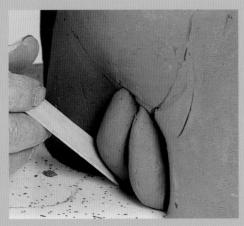

32. Adding two balls of clay to form the testicles

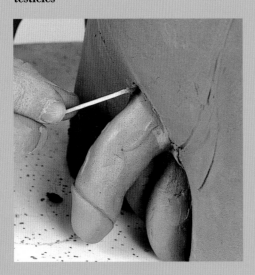

33. Using a tongue depressor to smooth the area where the male genitals join the body

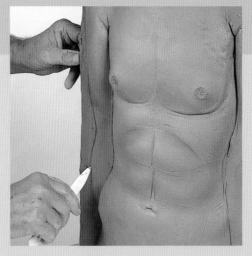

34. Deepening the line of the man's arm

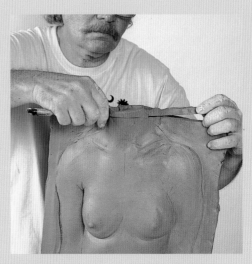

35. Trimming the neck with a knife

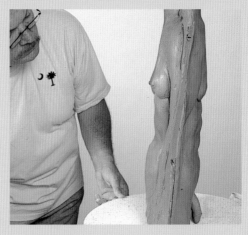

36. Turning the piece and evaluating it

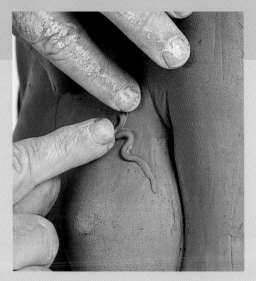

37. Adding a blood vessel to the woman's breast

38. The completed breasts, with moles and further detail on the nipples to add naturalism

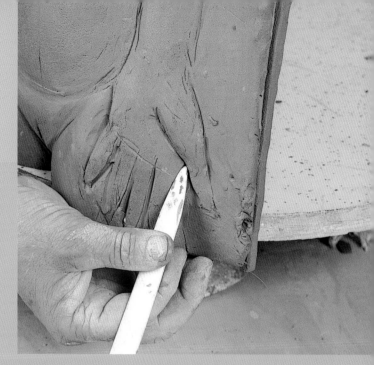

39. Beginning to articulate one of the woman's hands

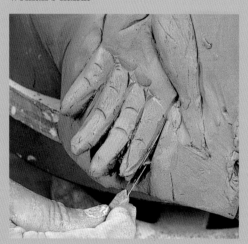

40. Using a modeling tool to pull the hand away from the slab and give it dimension. If I'm going to add a lot of three-dimensional detail, like on the hand, I'll usually add clay to the front.

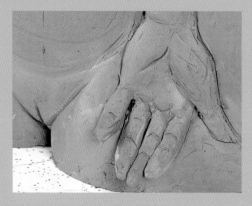

41. The hand awaits further refinement, but it's close to finished.

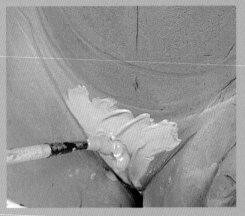

42. Brushing on slip that is the consistency of whipped cream

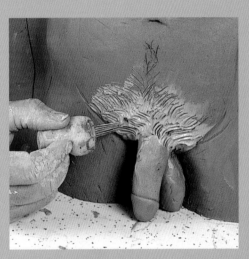

43. Brushing pubic hair on the male torso, then sculpting it with a cork into which needles have been inserted

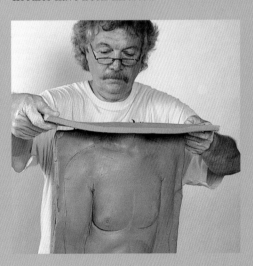

44. Measuring the thick slab piece that will close off the top of the piece

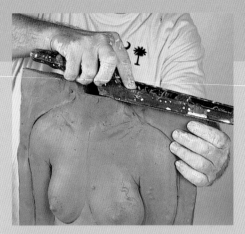

45. Using Surform to trim the top of the neck

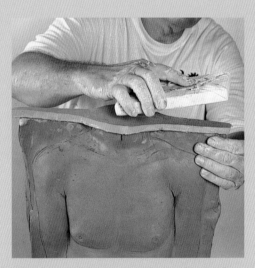

46. After scoring and applying slip on the top of neck, placing the slab on top, and paddling it securely in place.

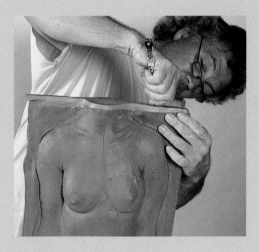

47. Trimming the slab to fit

48. The complete female torso. With the animal sculptures I do there can be more color, so I'll use glazes, but on my human forms I like monochromatic surfaces; terra sig works well, and I've used black, too.

49. The completed male torso

ABOUT THE ARTIST

JOE BOVA is a Professor of Art at Ohio University in Athens, OH, and served as the Director of the School of Art until 1997. He is a Professor Emeritus, Louisiana State University in Baton Rouge, LA, where he taught from 1971-1990. He has been a visiting artist at many schools, including New York State College of Ceramics at Alfred, University of Georgia's Cortona Italy Program, Haystack Mountain School of Crafts, and Penland School of Crafts. He served as a Trustee of Penland from 1991-1999, and is a Fellow and Past President of the National Council on Education for the Ceramic Arts (NCECA). His recent exhibitions include "Joe Bova, New Work," Kansas City Artists Coalition, Kansas City, MO; "Bird Beasts & Little Fishes," Santa Fe Clay, Santa Fe, NM; "Defining Moments in Contemporary Ceramics," Los Angeles County Museum; "50 Americans," First World Ceramic Biennale in Kyonggi Province, Korea, 2001; "Contemporary Chamber Pot Exhibition," The Pottery Workshop, Hong Kong; "Ceramics Monthly International Competition," Columbus, Ohio, 1999, and "Bova and Bringle," Blue Spiral Gallery, Asheville, NC. Bova has received many grants and fellowships, and his work has been featured in books, including *The Craft and Art of Clay* (Overlook Press, 1996) and *The History of American Ceramics* (Abrams, 1988).

GALLERY

In selecting the artists for this gallery, I relied on my instincts. This led me to think first of Arthur Gonzales, whose work I have long admired. One signature of his work is the usual inclusion of a found object used in a Picasso-esque manner. The simultaneity of dissimilar images and similar forms questions the nature of nature and the nature of reality. Arthur Gonzales has mastered this.

Gina Bobrowski's clay works are dreams manifested—if not dreams, then psychic and emotional adventures. It is her invention of form with drawing that affects me, and it is her engagement with animal imagery and human relationships that charms me. While some might see her work as illustration, for me it resonates as visual poetry.

This is true for the work of Adrian Arleo also. But while Bobrowski's work captures a kind of frenetic energy, Arleo's work is contemplative— even meditative. Her work is like prayer; in my perfect world every town would have a chapel with an Adrian Arleo figure in it.

Masterful, effortless, casual: all describe Ron Meyers' work. Ron working is a lesson in pure magical gesture. He is the snake charmer. I can think of no one else whose form and surface,

though separated in time, are as perfectly wed in all other respects. Gesture is signature in his work, best expressed in his painted figure pots. I have one in my home and each day it stops me for a moment.

Surrealism is owed a debt by many ceramists, and Tim Taunton and Triesch Voelker stand in that long line—although they are otherwise on different paths. I like the lightness of Taunton's work, yet he is like an anthropologist of icons and myths of our immediate past, along with today's moments that might be converted to myths later. There is closeness to literature and respect for craft in his work. Voelker's work has a dark side and exhibits a distinctly personal symbolism. The coil building with which this work is made (and it is large work) requires much time and commitment to purpose. Time as work and time as life become one.

James Tanner works are layered with mystery. The assertive color and bold intention of the staring face, the mask, embody the very meaning of mystery. What Voelker does with building form, Tanner achieves with surface and color. These homages to his African-American heritage are quietly (if not stealthily) asserted, yet they are not so specific as to be easily acknowledged by all viewers.

Spirit and soul is what Jenny Lind gives to her work. She meets nature on equal terms. More than property, horses are her friends. A garden is more than food; it is another expression of spirit life. If there is anyone I have known whom I suspected of being able to speak with plants and animals, it is Jenny Lind.

JENNY LIND, *Horse & Rider,* 1998. 18 x 18 x 7 in. (45.7 x 45.7 x 17.8 cm). Coiled stoneware; engobe; clear glaze dripped; cone 6. *Photo by Richard Faller.*

TIM N. TAUNTON, *Tao of Relativity,* 1998. 40 x 18 x 10 inches (101.6 x 45.7 x 25.4 cm). Coil-built earthenware with slate base; terra sigillata; slips; glaze; enamel; cone 04. *Photo by artist.*

TIM N. TAUNTON, *Mona de La Luna,* 1997. 26 x 15 x 6 inches (66 x 38.1 x 15.2 cm). Coil-built earthenware; terra sigillata; enamel; cone 04. *Photo by artist.*

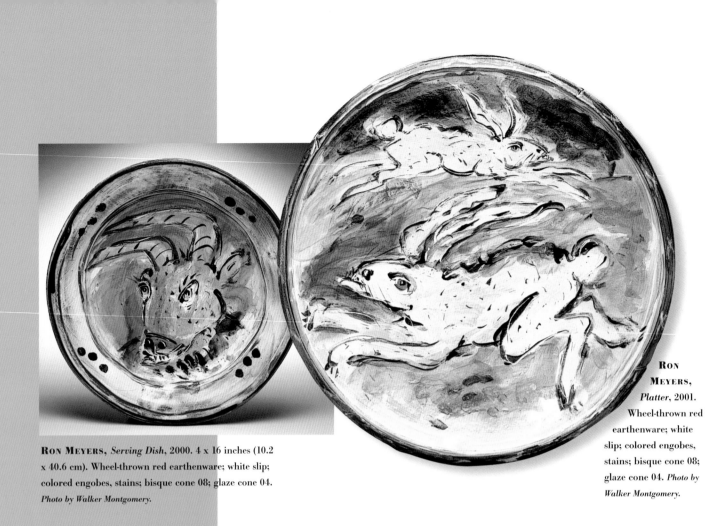

RON MEYERS, *Serving Dish*, 2000. 4 x 16 inches (10.2 x 40.6 cm). Wheel-thrown red earthenware; white slip; colored engobes, stains; bisque cone 08; glaze cone 04. *Photo by Walker Montgomery.*

RON MEYERS, *Platter*, 2001. Wheel-thrown red earthenware; white slip; colored engobes, stains; bisque cone 08; glaze cone 04. *Photo by Walker Montgomery.*

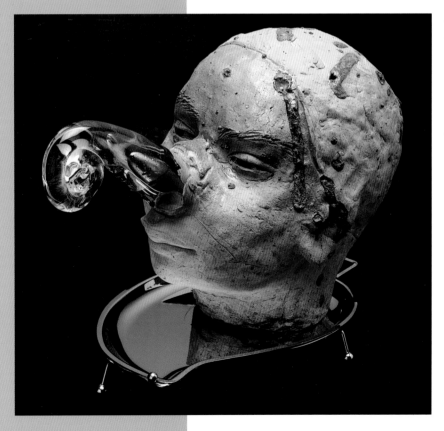

ARTHUR GONZALEZ, *Hundredth Monkey*, 2000. 13 x 11 x 24 inches (33 x 27.9 x 61 cm). Coil-built; engobe; glaze; mixed media; epoxy; cone 01 reduction. *Photo by John White.*

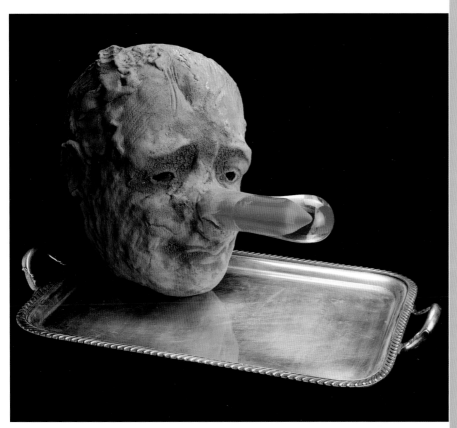

ARTHUR GONZALEZ, *Empty Pockets*, 2000. 14 x 24 x 15 inches (35.6 x 61 x 38.1 cm). Coil-built; engobe; glaze; mixed media; epoxy; cone 01 reduction. *Photo by John White.*

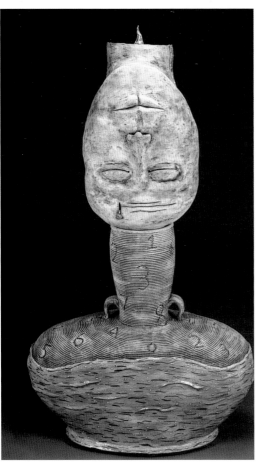

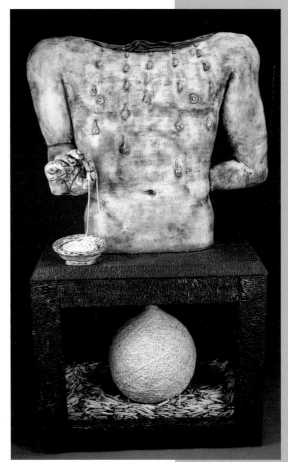

Bottom left:
TRIESCH VOELKER, *In the Presence of Time*, 1993. 49 x 29 x 13 inches (124.5 x 73.7 x 48.3 cm). Hand-built; mid-range firing with underglaze to glaze. *Photo by artist.*

Bottom right:
TRIESCH VOELKER, *Of a Liquid Nature,* (front) 1993. 51 x 29 x 19 inches (129.5 x 73.7 x 48.3 cm). Hand-built; mid-range firing; wood, string, staples, match sticks. *Photo by artist.*

JOE BOVA

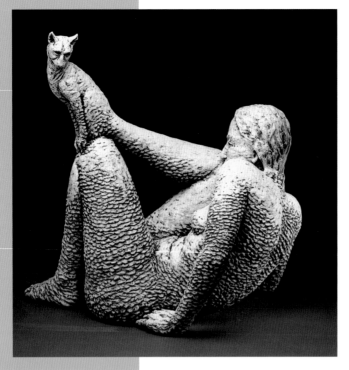

ADRIAN ARLEO, *Apparition*, 2000. 28 x 28 x 20 inches (71 x 71 x 51 cm). Clay; glaze, wax encaustic. *Photo by Chris Autio.*

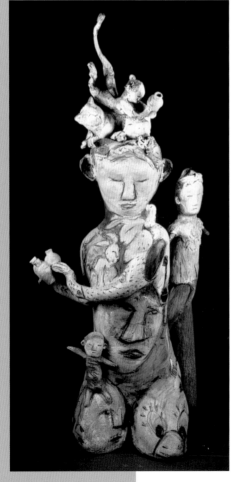

GINA BOBROWSKI, *Reservoir*, 2000. 50 x 22 x 13 inches (127 x 55.9 x 33 cm). Hand-built, thrown, and assembled terra cotta; wood, antler. *Photo by Triesch Voelker.*

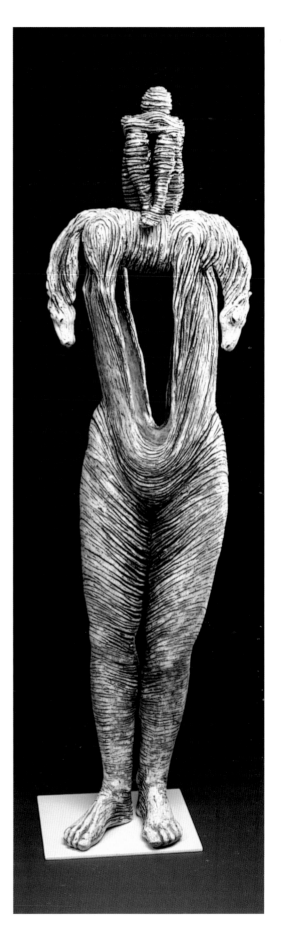

ADRIAN ARLEO, *Making Up the Mind*, 1999. 11 x 51 x 55 inches (28 x130 x 140 cm). Clay, mixed media. *Photo by Chris Autio.*

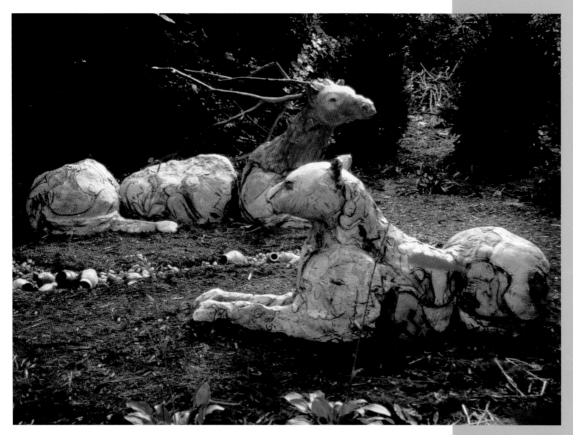

GINA BOBROWSKI, *Clearing: Drawn By Nature*, 1997-1998. 75 x 24 x 15 feet (22.5 x 7.2 x 4.5 m). Hand-built, thrown, and assembled ceramic; mixed media mosaic: bark mulch, coyote poles, copper, steel, river stones, wood, perennial wildflowers, naturalizing bulbs. *Photo by Triesch Voelker.*

JAMES L. TANNER, *Relative Existence*, 1986. 25 x 22 x 7 in. (63.5 x 55.8 x 17.8 cm).

JAMES L. TANNER, *Two Mothers*, 1991. 30 x 19 x 3 in. (76.2 x 48.3 x 7.6 cm).

SERGEI ISUPOV

In Sergei Isupov's mute
theater, his cast of morphing
man-to-beast figures pose in
a surreal stillness as they
shift from form to surface
and back again. Their
expressions and postures
simultaneously invite and
repel analysis and, despite
the minute attention to out-
ward detail, his figures seem
tuned to an inward chord.

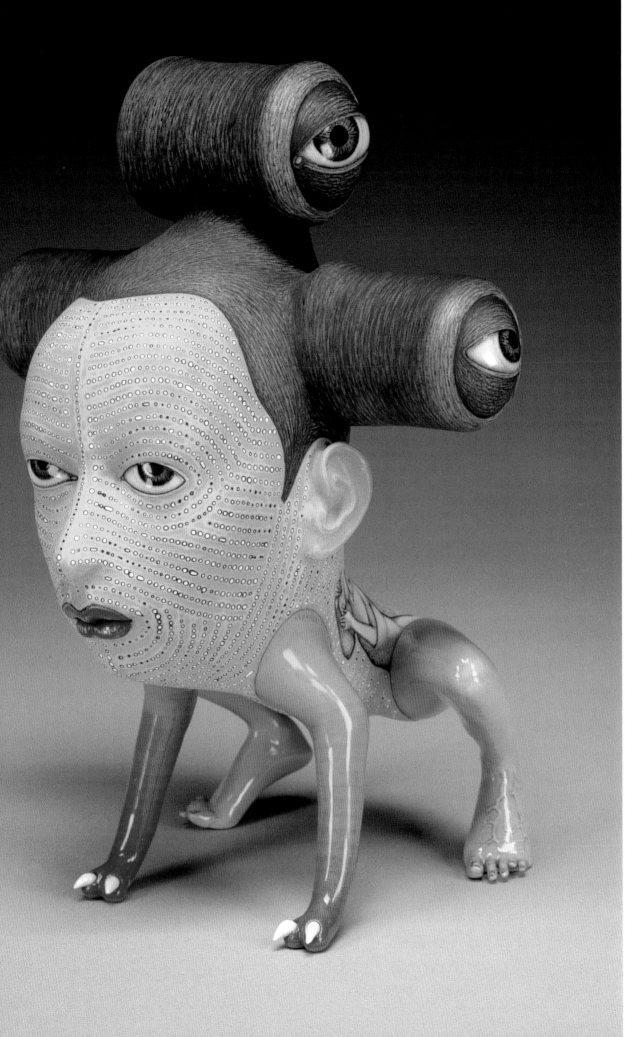

Miraculous, 2001.
½ x 7 x 8 ½ inches
(1.3 x 17.8 x 21.6 cm).
Porcelain.

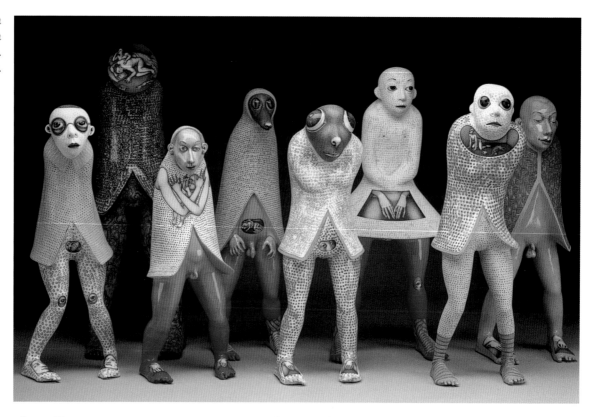

A LIFE IN THE STUDIO

Art builds me; I don't build art. I see that each work is a small world, yet once it's done, it's over. My relationship with it is over, and I start a new work. I have a relationship with the work only in the process; all my connections are in the process, which is made up of so many logical steps. So this is the truth: in building work, it's a small world. In life, it's the same thing, only over a longer period of time. And being in the studio is like being God. All artists are egocentric, because you yourself are the artist, the director, the worker—everything. Maybe this is not something that is popular to say, yet it is my privilege to see the world this way.

I like challenges. Working in clay is really deep, and has much to interest me: philosophy, technique—so much. My own process has two stages: form, and then decoration, which is the bigger part of the work. Our minds first grasp form, and decoration is secondary, yet I pay more attention to the decoration. I like to tell stories using symbols that are universal, so that when you look at my work you can tell yourself your own story, and interpret what you see in your own way.

The drawings for decoration take much, much longer than making the form. And yet it is with the drawings that I want to break the form. If I draw a figure on the form, there begins to be a conflict or a tension between the fact that the form contains two-dimensional drawings that themselves strive to be three-dimensional. There's contrast between soft surface and finished piece, male and female, birth and death. It's a symbolism of duality. So I don't do drawings; I make forms that are drawings.

My sketches are like a plan, but I have to stay flexible throughout the process, too. I keep the sketch on the table to keep my destination in mind. The two-dimensionality of the drawing doesn't describe the sculpture and the form; I

SERGEI ISUPOV

must always keep the plan in mind, yet be open to what is happening as I'm doing it. In school, I couldn't grasp this difference between working in two dimensions and working in three, but later on, through practice, I did. Now I don't think very hard about the difference between the flat piece of paper and the form in my mind. The sketches symbolize the form; I only need to draw the air around it, as Michelangelo described the act of sculpting as taking away everything that's not necessary.

My parents were artists, my mom a ceramic artist, so I started early. In the country of my birth, Estonia, this medium of clay was thought of as a "girl's art." I never took it seriously. I'd use it for souvenirs or birthday presents. But after painting school, I decided to study ceramics, and I found that I could solve technical problems quickly and easily. My hands know the clay.

It's important to be loose; life tells us where to go. To be too concerned, too serious, we might miss some important things—but that's hard to teach or even describe. I don't like to say that you must be born with this, but with art you need to start early. It must be a lifestyle. The thinking must be artistic without knowing it's artistic. My discipline of daily work came at a really early age; my parents insisted on it. If I wanted something, like ice cream, I had to earn it with art, say, five sketches for an ice cream, or do so many landscapes for a vacation to the Black Sea. But I did get a lot of compliments, too, and that gave me a big thrill; there were a lot of rewards.

It's become an obsession now; it all turned around, but I don't know at what point. In my country, being an artist is prestigious. You have a reputation—not money, since there's nothing in the stores—that defines what others think of you. In this way you are part of the intelligentsia, and it's a good living, working for the government. My father would get a government contract to produce an artwork which might

Nobody, 2000. 16 x 15 x 14 inches (40.6 x 38.1 x 35.6 cm). Porcelain.

Togetherness, 2000. 13 x 11 x 7 inches (33 x 28 x 18 cm). Porcelain. *Collection of the Arkansas Art Center, Little Rock, Arkansas.*

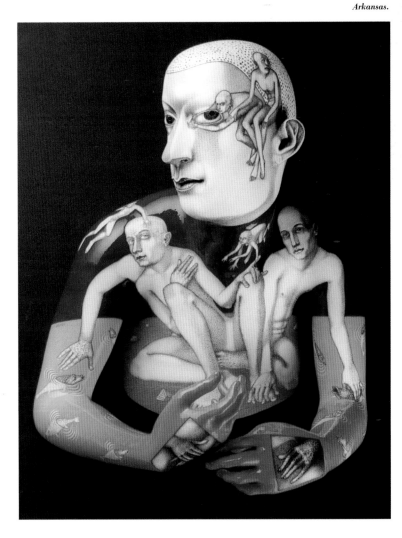

SERGEI ISUPOV

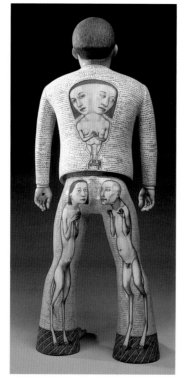

Floating, 2001. 22 x 8 x 6½ inches (55.8 x 20.3 x 16.5 cm). Porcelain.

Love Inspector, 2001. 20½ x 8 x 6½ inches (52 x 20.3 x 16.5 cm). Porcelain.

take him three months, then the rest of the year he was free to work independently.

Before I came to the States, I worked with various clays in different studio situations, and I didn't know what to expect of them. Here, though, there's so much consistency in the materials that it frees me to concentrate more on my art, on form, and not so much on the technical part.

I like the gentleness of my relationship with clay, because of its flexibility—it's a really cool feeling, like a date with a girl. I have to be careful of each move that I make, each thing that I do. This is hard to describe; it comes from experience. You must think about the process, sure, but your hands must also think, through the process of doing. This is why I work with one material, because then I know what to expect. I also like the risk of working with the fragility of the greenware, and the tension of that.

The methods and materials I use give me the greatest amount of control over the work I do. I use high-fire porcelain clay because it's a really strong material that doesn't break easily. With porcelain there is more risk in the kiln, but I'm paid back with a long life in the work, and it's reassuring to me that it will live for a long time. Porcelain's smoothness makes for easy painting because there isn't much grog in it. I also like the white material for the way it accepts the Mason stains that I use; all the colors are brighter on it.

I build all my work from slabs of different thicknesses rolled out on a slab roller, then I cut the pieces that I need. Putting those pieces together is like sewing with slip; when I build my work it's like making clothing, and I must be very exact. Again, the quality of the clay helps me get very smooth joins between the pieces of the construction. High-fire porcelain shrinks 9 to 12 percent in the kiln. Firing creates stress on the clay, so the construction needs to be stable in order to survive the firing. Achieving stabil-

ity can be tricky with my free forms, but the fact that they are hollow helps reduce the stress of the kiln. I can work from the inside when I need to, to patch the clay, or push it from the inside (to make a nose or eyes), and that ultimately gives me still more control over the form. With a solid piece of clay, you can only carve from the outside, and you lose the power to change your mind. Michelangelo took many risks; perhaps they gave him a high, to have to concentrate with such exactness. With my technique, I do get a high from the degree of concentration needed; because clay is fragile, I must pay attention.

Yet technique is not the most important thing for me. I don't want people to look at my work and see the sweat. I want people to hear what I want to say, not how I say it. I use the nude because it appeals to a broad range of people. Clothing goes out of fashion so quickly, but nudity is timeless. Yet I also desire to be a contemporary artist, through the form and the color that I use.

Most of all it's the form itself that tells me how to decorate it. When I've finished its construction, I first look at it from all sides. I finish that particular form completely, then immediately move on to sculpting another one. I must wait until the form dries, but then I can begin drawing on the greenware right away. In this way, I always have something on which to work. I may build five pieces in a row, then go back to the first one when it's dry enough and decorate it from start to finish. By that time, I may already have the ideas I need for the decoration of the next piece that's dry enough for me to draw on.

I enjoy finding the little nuances of how the colors change with glaze. I mix my stains in equal parts with clay, though some colors require different combinations—sometimes as much as 70 percent stain. I use a thin coat of

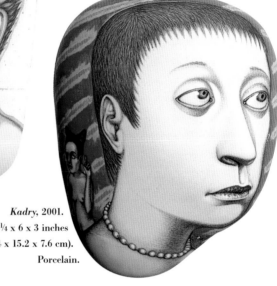

Alistair, 2001.
8 ¾ x 6½ x 2½ inches
(22.2 x 16.5 x 6.4 cm).
Porcelain.

Kadry, 2001.
7¼ x 6 x 3 inches
(18.4 x 15.2 x 7.6 cm).
Porcelain.

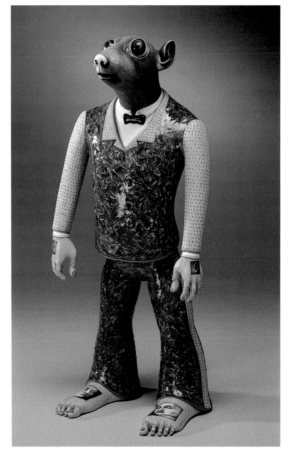

Friend, 2001.
13½ x 6½ x 5½ inches (34.3 x 16.5 x 14 cm). Porcelain.

To Keep in Touch,
2000. 18 x 16½ x 10
inches (45.7 x 41.9 x
25.4 cm). Porcelain.

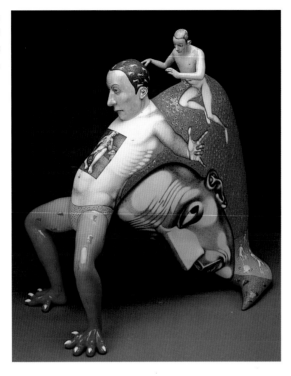

colored clay because it's easier to put on the greenware, and you can still change it or add layers of color. I like the way it sticks to the clay, too. Although it's possible to use a technique like this with a bisque-fired piece, somehow it doesn't feel right to me.

I must draw exactly, knowing where the color goes precisely. If I don't have a story to tell, I rely on technique. Sometimes the combination of colors tells me where to take the decoration, but sometimes I have a story to tell, and that guides me instead. My own sketches would help you, perhaps, understand how I do things. Picasso's sketches or watercolors show his thinking, and how he worked things out; they are more private, and I have gotten to know the rest of his work better that way.

I use wax resist to keep the underglaze colors apart, and I also use it to keep the glaze separate from the areas that I want to be matte. I fire the decorations at cone 06, then I apply transparent glaze with a brush, applying wax resist where needed; this process takes around six to eight hours. The second firing is cone 6 or 7, which is a little low for porcelain, but it helps the form remain stable. Technically, cone 7 is still high-fire, but those lower temperatures help keep the damage factor down. A higher firing will make the porcelain more translucent, but I don't need that quality in my work. Rules are okay, but I like to be more flexible.

To Go All Out, 2000.
17½ x 14 x 11½
inches (44.5 x 35.6 x
29.2 cm). Porcelain.

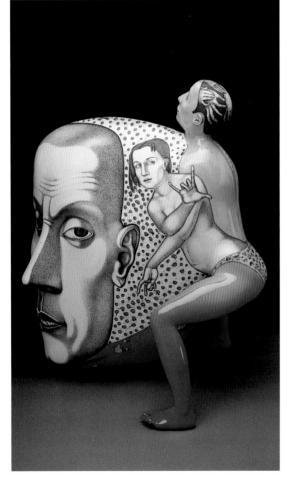

The possibility and flexibility of clay lets it be pushed in or out, and it transitions from soft to dry to stone. The form, texture, drawing, and painting that I do gives me a lot of ways to work with clay. It takes many steps for me to build a piece. I need to be exact, because once it's fired, it's done. In painting, it's not possible to know when it's truly done, but with clay I like the fact that when it's done, it's really done. And you don't have to frame it.

I run every morning. If I do what is hard to do, then I respect myself; the discipline helps me to respect myself. So, I just try to do my best in

the studio. Because I go every day, I'm high, and spiritually energetic. That keeps my interest in the work; my private life is very weak compared to my life in the studio. This is only my individual life—really small details—yet it has a lot of philosophical meaning for me. Art opens up something beyond the everyday: the spiritual, deeper things.

All photos courtesy Ferrin Gallery, Lenox, Massachusetts.

Dramatist, 2001.
19 x 7 x 5¼ inches
(48.3 x 17.8 x 13.3
cm). Porcelain.

Complementary,
20 x 21 x 9 inches
(50.8 x 53.3 x 22.9
cm). Porcelain.

HANDS ON

*I*n this series of photos, Sergei handbuilds a figurative sculpture from porcelain slab. He shows how he plans and executes his intricate narrative underglaze paintings, then selectively applies clear glaze to emphasize detail and protect the work.

1. Sketching ideas. Sketching also helps me plan the later construction process and keep the proportions correct.

2. Cutting a standard block of porcelain clay. The boards on either side help guide the cutting wire. Starting from the block means there won't be any air bubbles in the clay.

3. The slab roller controls the thickness and size of the slab. The size of the slab is never larger than I can manage with my two hands.

4. Beveling the edges of a cut piece of the slab. This makes for smooth joined seams.

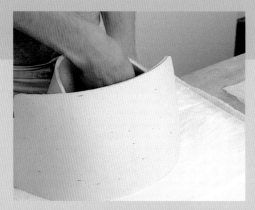

5. Creating the base of the sculpture. A plaster slab provides a smooth, flat surface for the work, but it's covered with a sheet of plastic at this point; otherwise, the plaster would flocculate (dry) the clay too quickly, causing cracks.

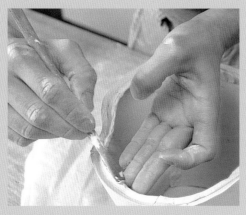

6. Building a lip with a soft coil of clay. Smoothing it later will help strengthen the join between the walls and base of the sculpture.

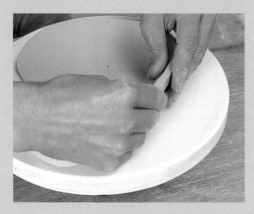

7. Curving the bottom of the base by turning and squeezing the edges of the slab

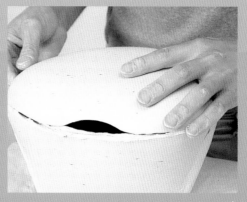

8. Joining the sides and bottom of the base together with slip

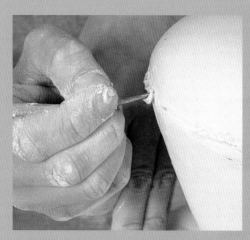

9. Pressing the sides and bottom together. If it's done carefully, the clay won't remember that it was once two pieces, and the oval shape will be stronger than a flat piece of clay.

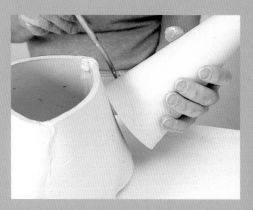

10. Determining the angle at which to join the leg to the base. The preliminary sketches continue to help me keep my design in mind at this stage.

SERGEI ISUPOV

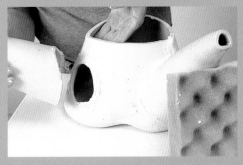

11. Joining the leg to an opening in the base. The excess clay inside the join will later be smoothed out and help strengthen the seam. The angled pieces are also supported by foam rubber, although the angle of the join is already quite strong.

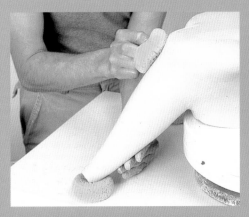

12. Completely finishing and smoothing the base. It won't be possible to make any further refinements in this part before the piece is dry.

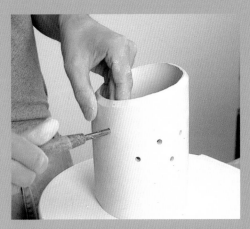

13. Constructing a supporting interior cylinder for the base. It will reduce the risk of warping in the S-shaped torso later, when it's in the kiln.

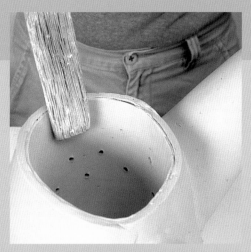

14. Smoothing the top of the cylinder and sides of the base together. The foam rubber supports aren't needed any more, because of the added strength that now comes from the supporting cylinder.

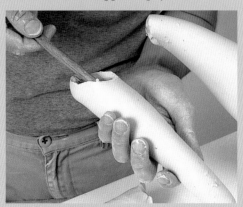

15. Shaping the lower half of the leg by pushing it from the inside

16. Building feet. They must be joined to the lower half of the leg before the leg is joined to the thigh.

SERGEI ISUPOV

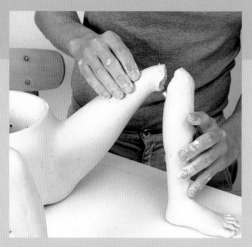

17. Joining the leg piece at the knee

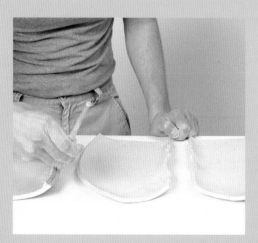

18. Three torso slabs. The profile that will be created later is here suggested by the wavy mirror-cuts along two of the edges.

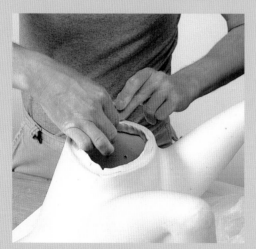

19. Building a lip from soft clay for the torso slabs. The lip will help join the seams later.

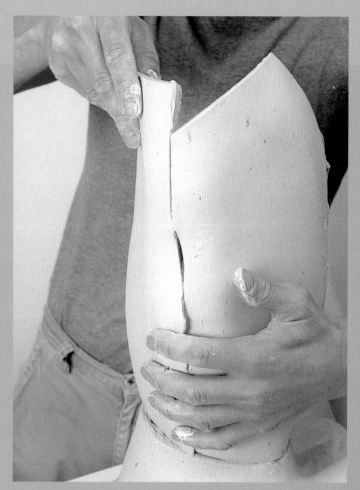

20. Putting the torso together with two of the three slabs. As the soft clay comes together, I might make some small changes, still in keeping with my original design. Here you can just see the beginning of the profile.

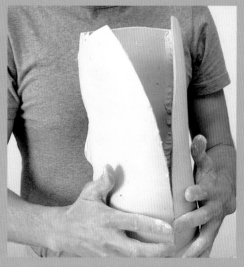

21. Adding the third torso slab

SERGEI ISUPOV

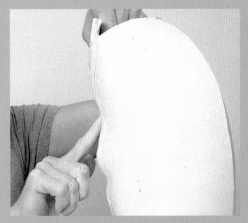

22. Smoothing the profile in the first torso seam. The features will be further defined by pushing the clay from the inside and by modeling on the outside.

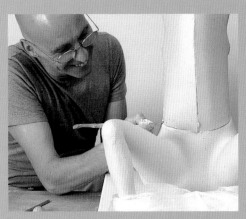

23. Smoothing the torso into the base of the sculpture

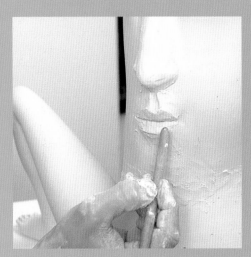

24. Adding soft clay features to the outside of the torso

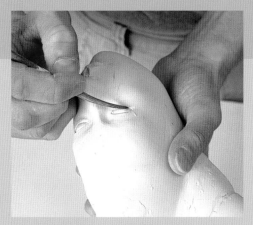

25. Finishing the head. The head is constructed from two curved slabs. The profile is cut along their edges, in a manner similar to that used for the torso. Slab-built cones were added for the hair.

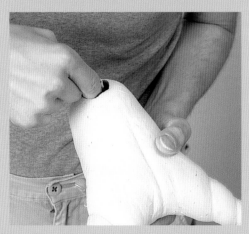

26. Adding coils to the inside wall of the neck

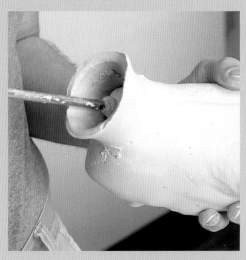

27. Swabbing the inside of the neck with slip

SERGEI ISUPOV

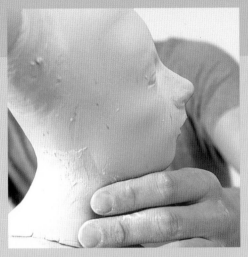

28. Finding the best position of the head and checking the size of the two openings

29. Adjusting the size of the opening in the torso

30. Drawing the design with a soft pencil. The form was first dried carefully under plastic, then sanded.

31. Delineating the design. Each line must be very clear and precise before painting can begin.

32. Erasing pencil marks with a stiff brush

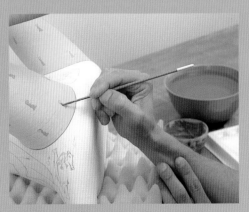

33. Painting the bottom requires that the sculpture be tilted and supported by foam. Stains are mixed with slip to create a thin, permanent coat of colored clay.

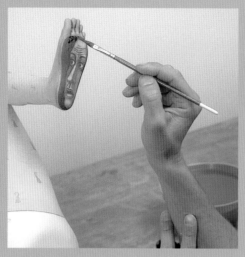

34. These bottom parts can't be glazed, but I decorate them with stains anyway.

35. Mixing subtle variations in color. This is a painstaking process. Some colors will be applied in three or four coats.

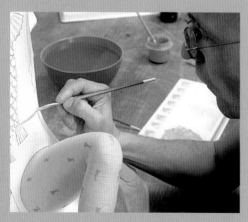

36. Starting to paint an area of color gradation. This level of blue is pale, but it will deepen and change higher up on the torso.

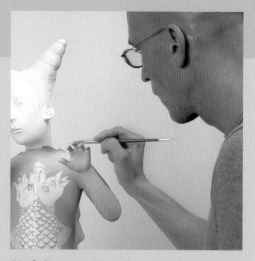

37. Color transition. Here the blue stain is mixed...

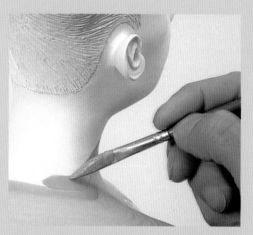

38. ...a little at a time with the skin color.

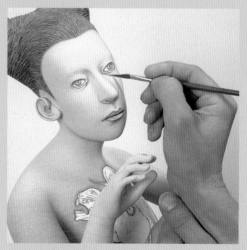

39. Sharpening details by adding darker strokes to the face

40. Sanding through several layers of different-colored stains

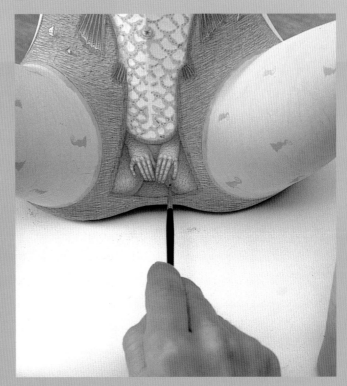

43. Painting many coats of thinned black stain. The application reminds me of watercolor.

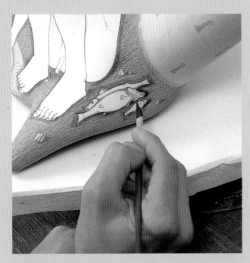

41. Applying wax resist. This helps me get sharp, clean edges where two different colors meet.

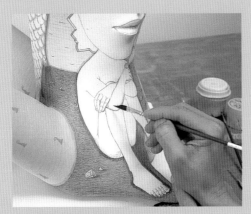

42. Applying thinned coats of stain for more transparent color

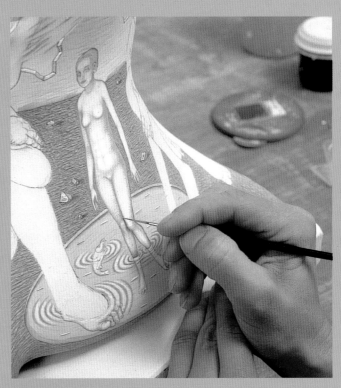

44. Adding a thinned, darker color for modeling in the figure

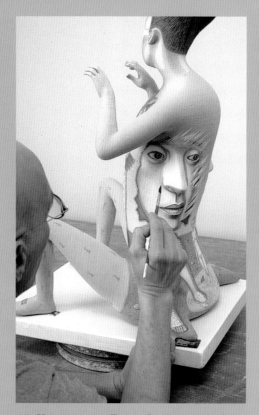

46. Wax resist application. Only the head of the fish, rising out of the water, will not be glazed.

45. Using a pointillist technique to apply thinned black stain for the facial details

47. Glazing technique. The piece is first bisque-fired to cone 06, then wax resist is carefully applied where a sharp delineation between shiny and matte surfaces is desired.

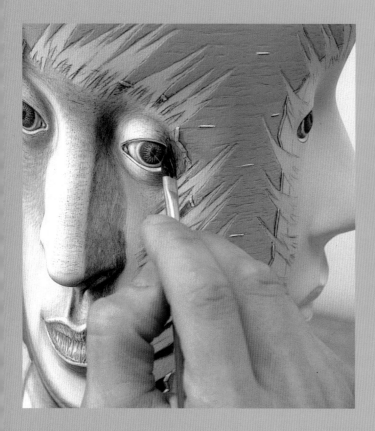

48. Two coats of transparent glaze are brushed on, then the piece is fired to cone 6. I don't need the clay to be translucent, and the lower temperature helps control warpage.

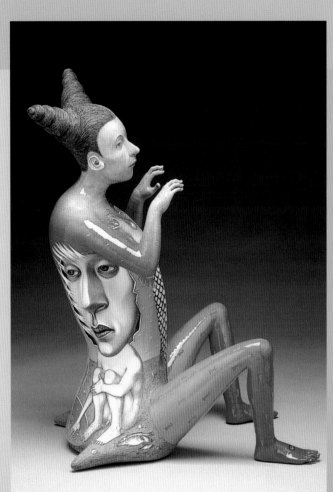

To Cast a Spell,
2000. 22½ x 15
x 12 inches
(57.2 x 38.1 x
30.5 cm).
Porcelain.

ABOUT THE ARTIST

SERGEI ISUPOV was born in Stavrapole, Russia, and now lives in Richmond, VA. He has taught at many art institutions, such as Rhode Island School of Design, and Penland School of Crafts. Among the places he has lectured are SOFA New York, and the Renwick Gallery of the Smithsonian Institute, which awarded him the Top Award for Excellence in its 1996 Craft Show. Other awards include "Best Young Estonian Artist," and a Director's Scholarship residency, International Ceramics Center, Kecskemet, Hungary. His list of exhibitions includes SOFA Chicago and New York; "Erotica in Ceramic Art II," Gallery Camino Real, Boca Raton, FL; "Everson Ceramic National, 2000," Everson Museum of Art, Syracuse, NY; "Confrontational Clay: The Artist as Social Critic," a touring exhibit, 2000-2001; and "Body Parts," Pewabic Pottery, Detroit, MI.

His work is featured in numerous museum collections, such as the Carnegie Museum of Art, Pittsburgh, PA; Los Angeles County Museum of Art, Los Angeles, CA; Oslo Museum of Applied Art, Oslo, Norway; and the Museum of Contemporary Ceramics, Summe, Ukraine. He has been profiled by several magazines, including *Ceramics Monthly,* 2000, and his work appears in books, including *Teapots Transformed: Exploration of an Object* (Guild Publishing, 2000). Many private collectors own his work, including Allan Chasanoff, and Sonny and Gloria Kamm.

GALLERY

*P*erhaps these artists think the way I do. They
seem to be storyteller-artists with philosophy
or psychology inside them. They manipulate my
mind, make me ask myself questions, and cause
me to be more connected with life. Sometimes an
artist will even change my direction. I admire the
underglaze painting on Kurt Weiser's mostly simple
forms. The attention to detail—the eyes, or feathers on a
bird—I like so much concentration in each piece; this
impresses me, this intensity. Patti Warashina plays easily
and spontaneously with the figure, exploring figurative art
as form. All her symbols are in the sculpture, rather than
in the decoration. The work is monumental, simple, sculp-
tural. Judy Fox's superrealistic clay figures of nude
children are from photographs, and the detail is won-
derful. They are really like parts of life, only static.
As an artist, she still has so much to choose from, even
though she's making a copy. The work makes me stop
and look: perhaps it's the nudity or the realism that is
fascinating and rich in symbolism. Justin Novak's work is
figurative; mostly sculpture; he decorates simply, and the
raku looks archaeological, yet his sculptural themes are so
contemporary. His figures are anatomically free, and this
freedom lets him tell a lot of stories. It's solid, interesting, a
symbol of my generation. Finally, Raymon Elozua has a
free style, inspired from life, and the early work seems
obsessive—qualities I like. These are landscapes with archi-
tecture; old cities with clay.

PATTI WARASHINA, *Vase Head:
Verdant Vestal,* 2000. 27 x 13 x 15
inches (68.6 x 33 x 38.1 cm).
Whiteware; pinched, coiled, molded,
slab construction; underglaze; glaze;
bisque cone 04; glaze cone 06. *Photo by
Rob Vinnedge.*

SERGEI ISUPOV

RAYMON ELOZUA,
*Sculpture of the
Abstract Expressionists:
9-1a*, 2001. 31 x 22 x 12
inches (78.7 x 55.9 x
30.5 cm). Terra cotta
over welded steel; glaze
cone 04. *Photo by artist.*

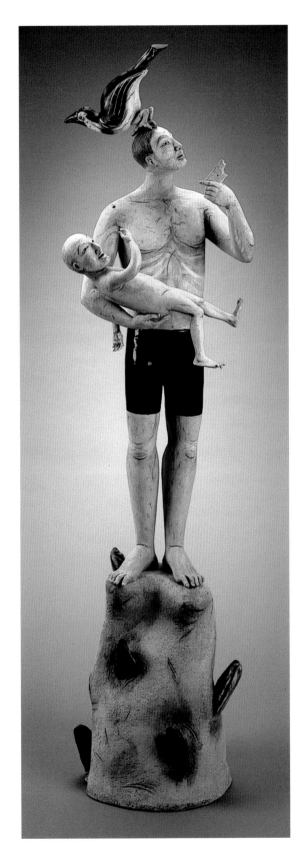

PATTI WARASHINA, *Feeder*, 2000. 68 x 17 x 18 inches (172.7
x 43.2 x 45.7 cm). Whiteware; pinched, coiled, molded, slab
construction; underglaze; glaze; bisque cone 04; glaze cone 06.
Photo by Rob Vinnedge.

RAYMON ELOZUA, *Sculpture of the Abstract
Expressionists: Re 17-1 word*, 2001. 23 x 31 x 11 inches
(58.4 x 78.7 x 27.9 cm). Terra cotta over welded steel; glaze
cone 04. *Photo by artist.*

JUSTIN NOVAK, *Disfigurine,* 2000.
15 x 12 x 12 inches (38.1 x 30.5 x
30.5 cm). *Photo by artist. Courtesy of
John Elder Gallery, New York.*

KURT WEISER, *Chihuahua,* 2001. 18 x 12 x 7 inches (45.7 x 30.5 x
17.8 cm). Porcelain; china paint. *Photo by artist.*

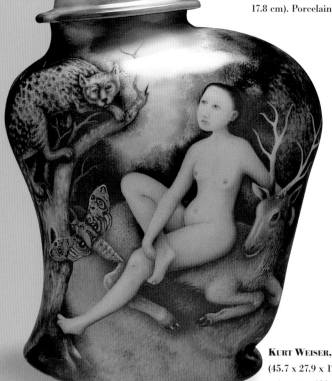

KURT WEISER, *Caucasia,* 2001. 18 x 11 x 7 inches
(45.7 x 27.9 x 17.8 cm). Porcelain cone 10; china
paint cone 018. *Photo by artist.*

SERGEI ISUPOV

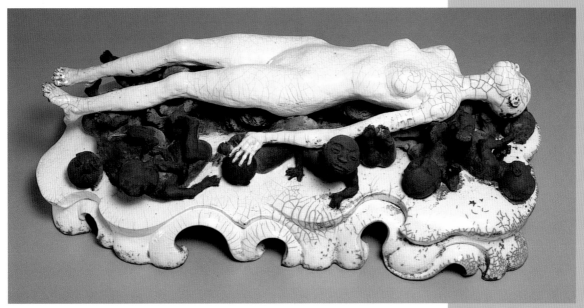

JUSTIN NOVAK, *Thomas II*, 2000. *Photo by artist. Courtesy of John Elder Gallery, New York.*

JUDY FOX, *Sphinx*, 1992-1994. 31 x 11 x 11 inches (78.7 x 27.9 x 27.9 cm). Terra cotta; casein. *Photo courtesy of PPOW Gallery, New York.*

JUDY FOX, *Atilla*, 1996. 31.5 x 21 x 11 inches (80 x 53.3 x 27.9 cm). Terra cotta; casein. *Photo courtesy of PPOW Gallery, New York.*

MARY BARRINGER

Mary Barringer creates
strong and simple forms that
hint of archeology. Her richly
textured surfaces illustrate
clay's ancient plasticity,
smooth, yet deeply tactile
and incised with deep, unify-
ing strokes. These dramatic,
active surfaces interact
strongly with light and
atmosphere, as if just
released from a long sleep.

Three Vases (detail) 1998. 12 x 5 x 4½ inche
(30.5 x 12.7 x 11.4 cm). Slab-built; layered slip
before and after bisque; thin glaze; electri
cone 6. *Photo by Wayne Fleming*

Fluted Bowl, 2000.
11 x 9½ x 2½ inches
(27.9 x 24.1 x 6.4
cm). Slab-built; lay-
ered slips before and
after bisque; thin
glaze; electric cone 6.
*Photo by Wayne
Fleming.*

THE WELL-BUILT SURFACE

Like many people, the experience that got me hooked on clay was tactile. The handling-building-throwing was its main attraction, and clay's transformation through fire, while magical, seemed like something to be mastered or prayed over, not a dance of give and take. Of course I realized it was necessary to fire—and easier to eat from—a glazed surface than an unglazed one, but the feeling of being in the driver's seat of my own ideas (and journeying through a very interesting place) deserted me when it came to glazes. Besides, I had started out in sculpture, and form was my primary interest. As long as I fired in reduction, I was able to think of the surface as a byproduct of the handbuilding process and the kiss of the kiln: in other words, to think of it hardly at all.

Switching to electric firing changed this, and brought me face to face with my ideas (or lack of them) about the surfaces of my work. The electric kiln provides almost no input to the fired results, except for the reassuring ones touted by school-supply catalogs: safe, reliable, easy to use, etc. It's the ultimate firing tool, ready to be used and do one's bidding (within limits), but with very little character of its own.

Thus, the responsibility to work out what surface effects will enhance the form, and how to obtain them, is thrown squarely onto the maker. With no movement of flame or atmosphere through the firing chamber, the fired surface will look bland and dead unless one makes some sort of choice about it. The pasty work that came out of my early electric firings made me admit how little I had considered the surface part of the making process. In fact, I felt less and less involved as the work moved toward completion. The energy of touch conveyed my ideas directly to the clay; once the work went into the kiln, it was literally out of my hands. I trusted the personality of the fire to carry the pieces through to their finished state, which is why a firing process with so little personality seemed so unkind to my work.

The problem, it seemed, was both chemical (not enough action in the firing chamber) and spatial. The time sequence and layout of most studios exacerbate a common condition: that making pots and completing them are very separate processes. They take place at separate times—often weeks apart—and sometimes in different parts of the studio. The ideas that flowed at the making stage are difficult to hold

on to as the work travels through its phases, and the fact that glazes change so completely when fired only heightens the gap between the directness of making and the somewhat abstract experience of glazing.

In my work, this gap has come to be filled by slips. Glaze decisions come late, often when the piece seems, or is, unalterable, and long after the excitement of the soft or leather-hard clay has receded. But slips can be used when ideas about the piece are still evolving. Chemically, slips occupy a midpoint between the plastic but refractory clay and the melted glaze. This allows them to be used compatibly with the raw, still-shrinking clay, but also to affect the action of the glaze, or even to be a finished, vitreous surface on their own. For someone firing in an electric kiln, this creates a zone for the interplay of materials under heat, thus hugely increasing the richness and complexity of the fired surface. But for anyone, firing in any kind of kiln, the use of slips will take the "surface work" back in the process, closer to the time and idea-state of forming. Anyone who feels alienated or baffled by the

prospect of a tableful of bisqueware can bring the two ends of their making process closer with the use of slips.

My own ideas about the surfaces of my work have evolved considerably since I started using slips. When I was firing in reduction, I did little to the surface beyond heightening the texture or emphasizing certain areas; now the surface work is intrinsic, not only to the finished appearance of the piece but to the way the idea develops as I work. I describe below the sequence I currently use, but it's worth emphasizing two general points that would apply to any building or firing process.

The first is that I introduce texture almost at the very beginning—sometimes, with slab pieces, before the forming. This disrupts my tendency to consider form separately from surface, and forces me to see, think about, and deal with the surface as the piece is taking shape. It's easier, I find, to smooth a textured surface, if that is what the piece requires, than to begin adding texture to something that is already substantially complete. Knowing my

Two Creamers, 2001. 4½ x 4 ½ x 2½ inches (11.4 x 11.4 x 6.4 cm). Slab-built; layered slips before and after bisque; thin glaze; electric cone 6. *Photo by Wayne Fleming.*

MARY BARRINGER

Three Vases, 1998. 12
x 5 x 4½ inches (30.5
x 12.7 x 11.4 cm).
Slab-built; layered
slips before and after
bisque; thin glaze;
electric cone 6. *Photo
by Wayne Fleming.*

tendency to build first and decorate later, this helps me integrate my thinking as I work.

The other strategy vital to my process is using materials and techniques that allow me to respond to the piece as I go along. This is a highly personal matter: some people work very precisely in the conceptualizing stage, then they let the clay, glaze, or kiln do its work in an unpredictable manner. Others tighten up as they go along, and there are many individual approaches along this continuum. In clay we all use both intent and unpredictability, deploying them at different points in our working process. The material demands a certain degree of mastery, but also imposes a certain amount of uncertainty. Where to be clear and in control about what one is after, and where to allow unexpected developments to enrich or complete the idea, are choices we make accord-

ing to our natures and our tolerance for or dependence on random occurrences. For me, much of the pleasure in working is in the unfolding of an idea in surprising ways. I begin with a fairly vague notion of what I am going to make; what happens while I am working pushes that vague idea to a final form—ideally a more interesting one than I started with. In order for this to work—for process to enlarge the concept—I have to use techniques that allow some flexibility, some way to incorporate the input from working into the piece. This has led me over the years to move from using coils exclusively to using different handbuilding processes for different pieces, depending on the desired form and the way I want the idea to evolve.

In the early stages, I rely quite a bit on chance to generate the seed of an idea. Within general

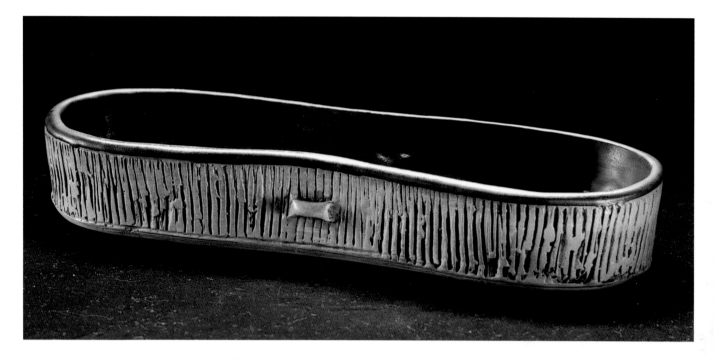

Long Basin, 2001. 2 x 12 x 4½ inches (5 x 30.5 x 11.4 cm). Coil-built; layered slips before and after bisque; thin glaze; electric cone 6. *Photo by Wayne Fleming.*

parameters—platter, creamer, bowl—the idea for the next step may come from the shape of the thrown-out slab, or the way the light falls on a roughly coiled wall. Usually I apply some sort of overall texture to the piece quite early in the process: right on the slab before I lay it in the mold, or all over the coiled piece once I've built the basic form. This injects the issue of the surface into my thinking as I'm building, and sometimes helps me to see possibilities that I might not have noticed: an edge, or a shape in the center, or an unexpected emphasis. And if I change my mind in the course of working, I can always smooth or erase the texture. I try to allow for much back-and-forth—between the evolving piece and me, and among the various elements of it—in order to tap into the unforeseen possibilities that lie in the clay and the tactile experience of handling it. And while surface considerations come into my working process early on, the refinement of the edges and the transitions in the form continue almost to the end. The technical term for this is "futzing," and it goes on until I feel the piece works from all angles and in all its parts.

Once the pots are leather-hard, I begin to apply the slips and focus more closely on the rela-

Oval Platter, 2000. 9 x 17½ x 2 inches (22.9 x 44.5 x 5 cm). Slab-built; layered slips before and after bisque; thin glaze; electric cone 6. *Photo by Wayne Fleming.*

tionship between the surface and the form, either continuing to refine the elements that are already there, or altering the relationship between them. For instance, the contrast between textured and smooth areas initially reads as a tactile, physical one. If I apply a dark slip to the texture and use a light slip overall, the relationship between them will also read as one of value—of dark and light contrast. If instead I use slips that are close in value—say white and cream—the contrast between those areas of the piece will be underplayed in favor of a more uni-fied surface, whose textural elements only emerge upon closer viewing or handing. Thus I have at this stage another opportunity to decide what I want to emphasize in the piece—or to allow what is there to direct me.

At this stage I can also remove color or whole areas, using subtraction as a drawing tool to highlight texture, emphasize edges, or draw an image. My favorite tools for this are plastic scrubbies in different grades of coarseness (3M makes the best ones), toothed scrapers, or a bamboo pen. Because the clay is still a bit moist, many of the markings and texturings that happen in the building process can still be used, and the ideas that are sparked by making can freely flow onto the surface.

I usually apply two layers of slip to the leather-hard ware. The colors that go on at this point will act as a kind of underpainting, influencing the cast of subsequent layers. A dark slip, or a choice of an iron-based versus a cobalt-contain-ing one, will noticeably affect the final col-oration, even if the overall tone is light, through the chemical interactions that take place in the firing.

After the bisque, the final stage of "glazing"—actually applying more slip and perhaps glaze—offers yet another set of choices about the piece. At a minimum, I would probably want to apply another layer of vitreous engobe or glaze to create a richer fired surface in the electric kiln. But I usually feel that I'm not quite done with the piece, and that the addition of further thin layers will allow me to nudge the work toward its final state. Of course I'm not literally

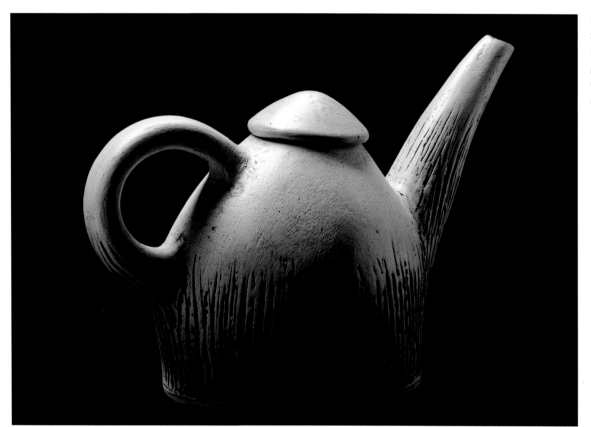

Teapot, 1999.
Slab- and coil-built;
multiple slips, thin
glaze; electric cone
6. *Photo by Wayne
Fleming.*

changing the form at this point, but I can shift the visual weight, bring out certain parts, or add another layer of drawing. In addition to the color of the slips, I can use both color and degree of melt in the glazes to build up, articulate, or unify the surface. I may use a glaze full strength for its own visual quality, or thinned down as a way to modify the slip color; or I may juxtapose areas that are more and less shiny.

Using glazes to get the results you want, of course, requires experience and careful note-taking, whereas slips give much more direct information while you're applying them about how they'll look once they're fired. They stay put, and change less than glazes, so you can build them up more as a painter would, using what happens under your brush as a guide to further steps.

In this way I work along, building up and subtracting, masking off areas for crisper delineation, or using a thin glaze layer for a slight sheen and tactile pleasure. The process is intuitive and very labor intensive, and I can't deter-

mine when I'm finished until it looks right to me. My intuition is not always borne out by the fired results, but it is more important to me—and more interesting—to stay engaged in discovering something right up to the end than to follow a formula and proven sequence. I am never simply applying glaze in order to finish a piece, but building on what I have already done and staying alert to what I might yet discover.

MARY BARRINGER

HANDS ON

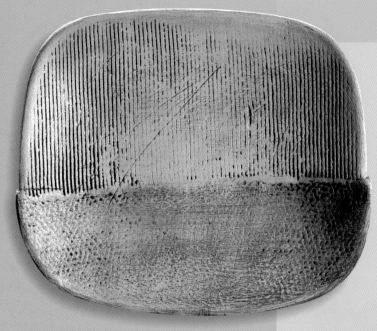

Platter, 2001. 8 x 9½ x 1 inch (20.3 x 24.1 x 2.5 cm). Slab-built; layered slips before and after bisque; thin glaze; electric cone 6. *Photo by Wayne Fleming.*

Mary creates a press-molded platter, then demonstrates the techniques she uses for surface decoration, building and unifying layers of slip application with marks made on the clay.

1. Applying texture with a toothed blade. The texture is continued to the back.

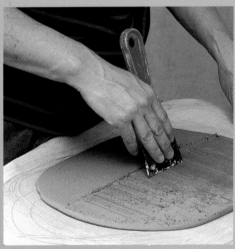

2. Applying texture with a textured roller

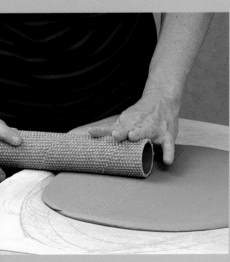

3. Laying the slab into a bisque mold

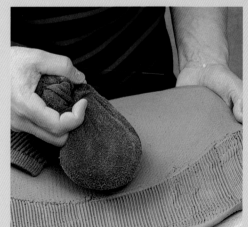

4. Pounding the slab with a grog-filled sock to press it into the mold

MARY BARRINGER

5. Trimming the edge of the plate

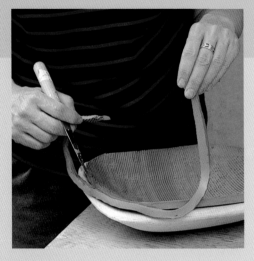

6. Removing the leather-hard plate from the mold

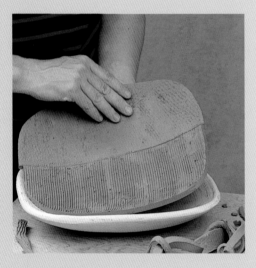

7. The back side still holds the texture.

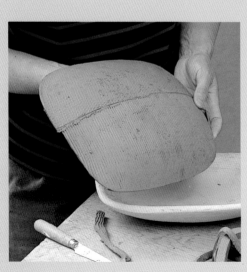

8. Refining the texture and drawing on the surface

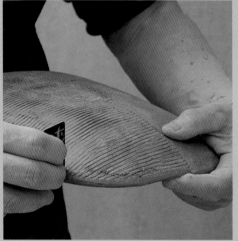

9. Finishing the rim

10. The leather-hard piece, ready for slip

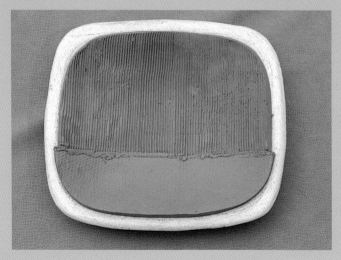

MARY BARRINGER

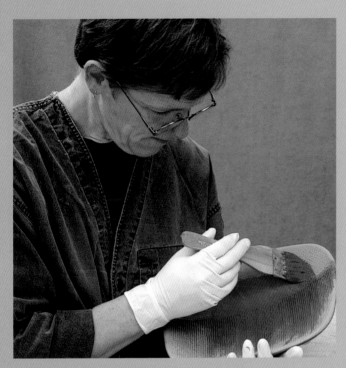

11. Applying black slip over the entire surface

12. Selectively removing slip with a scrubbie

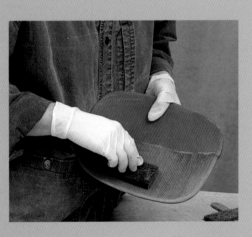

13, This emphasizes texture and lightens the rim.

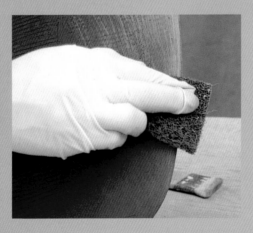

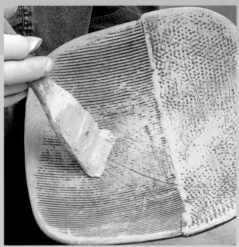

14. A thin layer of light slip is applied on both sides, taking care not to fill in the texture.

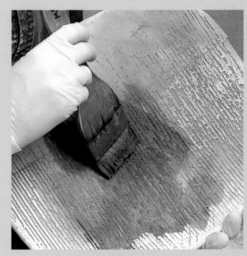

15. After the bisque firing, blue-black slip is brushed on in a thin layer...

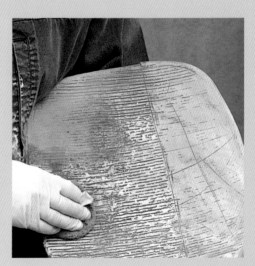

16. ...then thinned with a sponge, to give a slight bluish cast to the piece.

MARY BARRINGER

17. Alternating layers of dark and light slip are laid on.

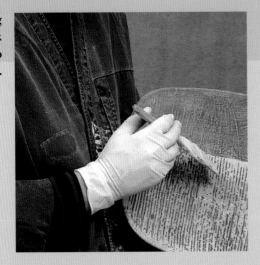

18. This creates more depth and more contrast between different areas of the piece.

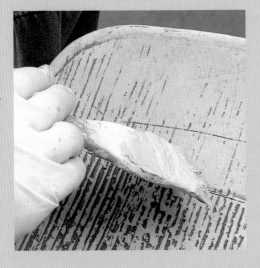

19. Finally, a thin overall layer of glaze is brushed on, to deepen the colors and give a low sheen, as well as tactile appeal.

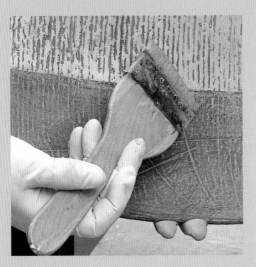

ABOUT THE ARTIST

MARY BARRINGER, who lives in Shelburne Falls, MA, has been a studio artist since 1983. Her teaching credentials include James Renwick Alliance, Smithsonian Institution, Washington, D.C.; School of the Museum of Fine Arts, Boston, MA; 92nd Street Y, New York, NY; and Penland School of Crafts. She has been a visiting artist at numerous schools, including the University of Nebraska, Lincoln, NE, and the University of Florida, Gainsville, FL.

She has exhibited widely at such galleries as Lill Street Gallery, Chicago, IL; The Clay Place, Pittsburgh, PA; and Pewabic Pottery, Detroit, MI. Recent one- and two-person shows include "New Work from a New Place," Baltimore Clayworks, Baltimore, MD; and "Drawings and Objects," Fresh Pond Clay Works, Cambridge, MA. Among her juried and group shows are "A Glimpse of the Invisible," Arlsada Center, Arrada, CO; "Abstract Craft," Southwest Center for Art and Craft, San Antonio, TX; "Strictly Functional," Market House Craft Center, Ephrata, PA; and "13th Anniversary Show," Contemporary Porcelain, New York, NY. She has been awarded a New England Foundation for the Arts artist's fellowship, and her work is part of many public and private collections. Her work has been featured in such books as *The Spirit of Clay* (Pebble Press, 1995) and *Electric Kiln Ceramics* (Chilton, 1993).

GALLERY

*T*he work of these artists illustrates various uses of slip as a surface strategy. Some, like Ron Meyers and Susanne Stephenson, have used it in a painterly way, exploiting slip's clay-based stability to add freely drawn marks that retain, through the firing, the juiciness of clay's plastic state. For Matt Metz and Patrick Siler, on the other hand, the same stability makes possible the crisp edges and defined layering of their carved and stenciled images. Though resulting in an entirely different feeling, here too the slip layer visually links the fired surface to its earlier malleable state. Finally, Steve Heinemann exploits the physical compatibility of clay body and slip to build out from the walls of his pots, creating a complex surface that seems part of, rather than on top of, the built structure.

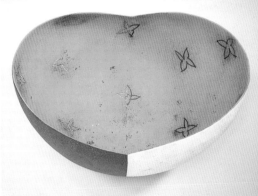

STEVE HEINEMANN, *Untitled*, 2000. 10 x 11 x 24 inches (25.4 x 27.9 x 61 cm). Slip-cast earthenware; layered slips, stains, glazes; multiple firings in low temperature range (cones 02-06). *Photo by artist.*

STEVE HEINEMANN, *Divided Floral*, 2000. 14 x 20 x 26 inches (35.6 x 50.8 x 66 cm). Slip-cast earthenware; layered slips, stains, glazes; multiple firings in low temperature range (cones 02-06). *Photo by artist.*

RON MEYERS, *Casserole*, 2000. 8 x 12 inches (20.3 x 30.5 cm). Wheel-thrown earthenware; inscribed drawing; tile 6, Avery slip; bisque cone 08; low-fired salt cone 04. *Photo by Walker Montgomery.*

RON MEYERS, *Tureen*, 2000. 9 x 20 x 9 inches (22.9 x 50.8 x 22.9 cm). Wheel thrown and altered earthenware; bisque cone 08; low-fired salt cone 04. *Photo by Walker Montgomery.*

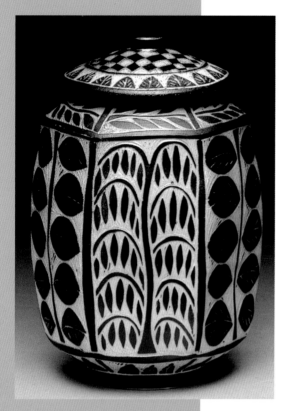

MATTHEW METZ, *Jar,* 2000. 12 x 5 x 5 inches (30.5 x 12.7 x 12.7 cm). Wood-fired porcelain; salt-glazed terra sigillata; sgraffito; glaze cone 10. *Photo by Peter Lee.*

MATTHEW METZ, *Vase,* 2000. 15 x 6 x 6 inches (38.1 x 15.2 x 15.2 cm). Wood-fired porcelain; salt terra sigillata; sgraffito; glaze cone 10. *Photo by Peter Lee.*

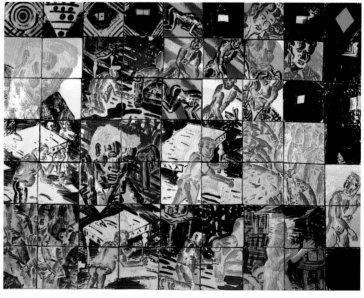

PATRICK SILER, *Gesturing Men Wall,* 1988. 98 x 126 x 2½ inches (248.9 x 320 x 6.4 cm). Press-molded stoneware tiles; vitreous slips; single-fired cone 5. *Photo by Paul Pak Lee.*

PATRICK SILER, *The Droll Divers of Vitropolous,* 1989. 40 x 16 x 11 inches (101.6 x 40.6 x 27.9 cm). Leather-hard slab construction stoneware; cut paper stencil images, vitreous slips; single-fired cone 5. *Photo by E. G. Schempf.*

A SHORT HISTORY OF PENLAND SCHOOL OF CRAFTS

Penland School of Crafts is a national center for craft education, located in the mountains of North Carolina. Penland's mission is to promote individual and artistic growth through crafts. The school hosts one-, two-, and eight-week workshops in books and paper, clay, drawing and painting, glass, iron, metals, photography, printmaking, textiles, and wood. The school also sponsors artists' residencies, a community education program, and a craft gallery representing artists affiliated with the school.

Penland was founded by Lucy Morgan, a teacher at an Episcopalian school that once occupied several buildings which are still part of Penland. In 1923, she organized the Penland Weavers, to provide looms, materials, and instruction to local women and market their handwoven goods. She invited noted weaving expert Edward F. Worst to teach, and when requests for instruction came from other parts of the country, Penland School was born. Soon after the first students arrived in 1929, other crafts were added, and the school began to raise funds, acquire property, and construct buildings.

When Lucy Morgan retired in 1962, she was succeeded by Bill Brown. During Brown's 21-year tenure, new media, such as iron and glass, were added to the program, and the school began offering eight-week sessions in the spring and fall. Brown also started the resident artist program, which provides low-cost housing and studios to craft artists who work at Penland for several years, and he began a work-study scholarship program to make Penland accessible to a broader range of students.

Today the school encompasses 43 buildings located on 400 acres of land. Each year approximately 1,200 people come to Penland for instruction and another 12,000 pass through as visitors. The community education program brings first-hand craft experience to hundreds of local school children.

Penland has no standing faculty; its instructors include full-time studio artists as well as teachers from colleges and universities. Students live at Penland and take only one class at a time, allowing them to learn by total immersion—the ideas and information gained in a two-week session can take a year to absorb and process.

The school has also become the focal point for a lively community of craft artists, thanks in part to the resident program, which has encouraged many artists to settle in the area. The presence of so many nearby studios greatly enhances the quality of the student experience.

Students come from all walks of life. They range from 19 to 90 years of age and from absolute beginners to professional craftspeople. Some see Penland as a productive retreat, some as a source of inspiration for their personal creative life, and others as a place to exchange vital information about material, technique, and process. What brings them all together is a love of materials and making, and the often transformative experience of working with intensity and focus in a supportive community atmosphere.

Robin Dreyer

ACKNOWLEDGMENTS

Lark Books is proud to have collaborated with Penland School of Crafts to bring *The Penland Book of Ceramics* to fruition. The fulfillment of such a joint project is due in no small measure to the extraordinary contributions made by the many wonderful people who are connected, in one way or another, to Penland School of Crafts.

Recognition, first, must go to artists Linda Arbuckle, Mary Barringer, Joe Bova, Cynthia Bringle, Clara "Kitty" Couch, Sergei Isupov, Nick Joerling, Angelica Pozo, Michael Sherrill, and Tom Spleth. Their cheerful willingness to commit and deliver both written and visual material, and to endure the pressure of publishing deadlines, while teaching workshops, lecturing, exhibiting, and, yes, continuing to produce their own creative ceramic work, is nothing short of remarkable. We applaud you.

Jean McLaughlin, Director of the Penland School of Crafts, enthusiastically endorsed the book, and other key Penland staff members, were instrumental in bringing the book to fruition. Our thanks to the steady hand of Dana Moore, Penland Program Director. She made the initial contacts with the artists, and acted as the school's liason throughout the many months of production; Robin Dreyer, Communications Manager, also provided much helpful insight with his review of the manuscript; Meredith Brickell, ceramics artist and former Penland Core student; John Britt, Clay Program Coordinator; and Kathryn Gremley, Exhibitions Manager for the Penland Gallery, also reviewed the text.

Val Cushing, Professor Emeritus of Ceramic Art at New York State College of Ceramics at Alfred (New York) University, and Pete Pinnell, Associate Professor of Art at the University of Nebraska at Lincoln, took time to act as technical manuscript consultants. A number of artists' representatives provided slides for the individual invited-artist galleries; special thanks to Leslie Ferrin Gallery, Lenox, Massachusetts, and Garth Clark Gallery, New York City, for their efforts.

Lark Books art directors Kathy Holmes and Dana Irwin, along with photographer Evan Bracken and a number of other freelance photographers around the U.S., helped shape the book's unique visual look. Lark assistant editor Veronika Gunter pitched in far beyond the call of duty in the Herding Cats Department. The contributions of these talented professionals are evident on every page.

Deborah Morgenthal
Suzanne J.E. Tourtillott
Editors

For more information about Penland School of Crafts, call (828)765-2359 or visit www.penland.org.

CONTRIBUTING PHOTOGRAPHERS

Randy Battista, of Media Image Photography, Inc., in Gainesville, Florida, took the how-to photographs and portrait of Linda Arbuckle.

Wayne Fleming, of Hartford Connecticut, photographed Mary Barringer working in her studio.

Thomas Kojcsich, of Richmond Virginia, illustrated Sergei Isupov's working process.

Dan Milner photographed Angelica Pozo making tiles in her Cleveland, Ohio, studio.

CONTRIBUTING ARTISTS

David Alban
Cleveland, OH, USA
Page 44

Carlos Alves
Miami, FL, USA
Page 44

Dan Anderson
Edwardsville, IL, USA
Pages 67, 68

Stanley Mace Andersen
Bakersville, NC, USA
Page 106

Adrian Arleo
Lolo, MT, USA
Page 166

Peter Beasecker
Dallas, TX, USA
Page 127

Joseph Blue Sky
Akron, OH, USA
Page 45

Gina Bobrowski
Corrales, NM, USA
Pages 166, 167

Bill Brouillard
Lakewood, OH, USA
Page 104

John Byrd
Hendersonville, LA, USA
Page 67

Alan Caiger-Smith
Aldermaston, Berkshire,
United Kingdom
Pages 104, 106

Aurore Chabot
Tucson, AZ, USA
Page 47

Linda Christianson
Lindstrom, MN, USA
Page 128

Jimmy Clark
Philadelphia, PA, USA
Page 25

Bruce Cochrane
Mississauga, Ontario, Canada
Page 105

Paul Dresang
Edwardsville, IL, USA
Page 69

Kathleen T. Egan
Burnsville, NC, USA
Page 22

Raymon Elozua
New York, NY, USA
Page 187

Cary Esser
Kansas City, MO, USA
Pages 43, 45

Susan Filley
Mt. Pleasant, SC, USA
Pages 126, 127

Judy Fox
New York, NY, USA
Page 189

Susie Ganch
Penland, NC, USA
Page 89

Andrea Gill
Alfred, NY, USA
Page 106

Arthur Gonzalez
Alameda, CA, USA
Pages 164, 165

Silvie Granatelli
Floyd, VA, USA
Pages 126, 127

Becky Gray
Burnsville, NC, USA
Page 24

Steven Heinemann
Richmond Hill, Ontario,
Canada
Pages 87, 88, 203

Mark Hewitt
Pittsboro, NC, USA
Pages 141, 143

Deborah Horrell
Portland, OR, USA
Page 89

Steve Howell
Gainesville, FL, USA
Page 107

Woody Hughes
Wading River, NY, USA
Page 128

Doug Jeck
Seattle, WA, USA
Page 67

Joyce Kozloff
New York, NY, USA
Page 47

Gretchen Kramp
Hamtramck, MI, USA
Page 45

Anne Kraus
New York, NY, USA
Pages 86, 87, 88

James Lawton
Bluffton, SC, USA
Page 129

Jenny Lind
Pecos, NM, USA
Pages 162, 163

Suze Lindsay
Bakersville, NC, USA
Page 129

Matthew Metz
Houston, MN, USA
Page 204

Ron Meyers
Athens, GA, USA
Pages 164, 203

Marlene Miller
Washington, IL, USA
Page 44

Alice Ballard Munn
Greenville, SC, USA
Page 23

Justin Novak
New York, NY, USA
Pages 188, 189

Jeff Oestreich
Taylors Falls, MN, USA
Page 128

Matthias Ostermann
Montréal, Quebec, Canada
Page 106

Walter Ostrom
Tantallon, Nova Scotia,
Canada
Pages 104, 105

Ben Owen III
Seagrove, NC, USA
Pages 140, 141

Carrie Anne Parks
Riverdale, MI, USA
Page 47

Dale Pereira
Toronto, Ontario, Canada
Page 107

Liz Quackenbush
Pleasant Gap, PA, USA
Pages 103, 105

Karen Allen Reed
Mars Hill, NC, USA
Pages 21, 22

Don Reitz
Clarksdale, AZ, USA
Page 141

Mary A. Roehm
New Paltz, NY, USA
Page 143

Brad Schwieger
Athens, OH, USA
Page 128

Mark Shapiro
Worthington, MA, USA
Page 68

Randy Shull
Asheville, NC, USA
Page 66

Patrick Siler
Pullman, WA, USA
Page 204

Michael Simon
Colbert, GA, USA
Page 129

Susanne G. Stephenson
Ann Arbor, MI, USA
Page 202

David Stuempfle
Seagrove, NC, USA
Page 142

James L. Tanner
Janesville, MN, USA
Page 167

Tim N. Taunton
LaGrange, GA, USA
Page 163

Triesch Voelker
Corrales, NM, USA
Page 165

Peter Voulkos
Oakland, CA, USA
Pages 142, 143

Patti Warashina
Seattle, WA, USA
Pages 186, 187

Donna Webb
Akron, OH, USA
Page 45

Kurt Weiser
New York, NY, USA
Page 188

Red Weldon-Sandlin
Decatur, GA, USA
Page 69

Wynne Wilbur
Gainesville, FL, USA
Page 107

Isaiah Zagar
Philadelphia, PA, USA
Page 46

INDEX